Sydney R. Walker

Teaching Meaning in Artmaking

Davis Publications, Inc., Worcester, Massachusetts

ART EDUCATION IN PRACTICE SERIES

Marilyn G. Stewart

Editor

Sydney R. Walker

Teaching Meaning in Artmaking

Series Preface

Follow an art teacher around for a day—and then stand amazed. At any given moment, the art teacher has a ready knowledge of materials available for making and responding to art; lesson plans with objectives for student learning; resources for extending art learning to other subjects; and the capabilities, interests, and needs of the students in the art room. Working with a schedule that sometimes requires shifting several times a day from working with students in preschool to those in elementary, middle, and high school, the art teacher decides what to teach, how to teach it, whether students have learned it, and what to do next. The need for rapid decision making in the artroom is relentless.

The demands continue after school as the art teacher engages in assessment of student learning, curriculum planning, organization of materials, and a wide range of activities within the school community. Although most teachers want to be aware of and to integrate into their teaching new findings and developments within their field, they are pressed to find the time for routine, extensive reading of the literature.

Art Education in Practice provides the art teacher, museum educator, student, scholar, and layperson involved in art education with an overview of significant topics in art education theory and practice. The series is designed to meet the needs of art educators who want to know the issues within, the rationales provided for, and the practical implications of accepting curricular proposals presented from a variety of scholarly and political perspectives.

The emphasis of the series is on informed practice. Each text focuses on a topic that has received considerable attention in art education literature and advocacy statements, but one that has not always been accompanied by clear, concise, and accessible recommendations for the classroom. As new issues arise, books will be added to the series. The goal of the series is to complement the professional libraries of practitioners in the field of art education and, in turn, enhance the art-related lives of their students.

Editor's Introduction

As a parent, I have witnessed a parade of art projects enter into my home over the years. From the plaster plate with the imprint of my preschooler's hand to the papier-mâché clown mask crafted by my middle-school-age son, these objects have found their way from temporary display places around the house to boxes in the attic marked "Ben and Katie's Art." The artworks hold much meaning for me—the proud, nostalgic parent. I wish they had more meaning for my now grown children, who have long since forgotten them.

Like children in art classes around the nation, my offspring had excellent art teachers. All art teachers take pride in the projects they plan for their students. They share ideas with each other, collecting ideas for using new materials and techniques, relating art projects to the work of individual artists and the art of other cultures, and connecting the art curriculum to other subject areas. Art programs are packed with studio experiences in which students explore materials to create a wide range of products. Even with the recent curricular focus on the study of and response to artworks made by others, studio production rests at the core of most art programs. Of all of the art disciplines addressed in a comprehensive approach to the study of art, however, the teaching of artmaking has received the least scholarly attention. Perhaps this is because most art educators came to the field through our own artmaking experiences, and we feel most comfortable here.

In *Teaching Meaning in Artmaking*, author Sydney Walker asks us to pause and examine what art production is all about. Drawing upon her investigation of the artmaking processes of professional artists, Walker emphasizes the need to help students construct meaning through the exploration of what she calls "big ideas." She notes that artists rarely proceed by making one conceptually isolated product after another. Instead, they grapple with broad, important issues, ideas, and questions through a series of explorations. They tend to probe these ideas at increasingly deeper levels, asking new questions and acquiring more knowledge in the process. Their search is personal and is often informed by research. They create problems and challenge themselves to address them within self-imposed boundaries.

Artists are aware of their work as part of one or more traditions in artmaking, and they are aware of the work of their colleagues—past and present. Their artmaking is meaning-filled, and the meaning of the resulting artworks is as multi-layered as the processes involved in creating them. Walker maintains that art students' lives, as well as their studio experiences, will be enriched when informed by an understanding of artmaking as meaning making.

Filled with ideas about what it means to teach and to understand, this book invites repeated visits. Reflection about the ways in which artists work is woven throughout the chapters, as are thought-provoking questions and practical strategies for readers to consider and use. By "unpacking" the artmaking process, Walker both demystifies and deepens it. With her guidance, art teachers and their students will engage in artmaking with the promise of its meaning staying with them for years to come, even when the completed products have long ago been put to rest.

Marilyn G. Stewart

Publisher: Wyatt Wade
Editor-in-Chief: Helen Ronan
Production Editor: Carol Harley
Manufacturing: April Dawley, Georgiana Rock
Copyeditor: Lynn Simon
Design: Jeannet Leendertse

Library of Congress Catalog Card Number: 2001088506
ISBN: 87192-583-4
10 9 8 7 6 5 4 3 2 1
Printed in the United States of America

In memory of Betsy.

Acknowledgments

This text is the result of the teaching experiences of many art teachers who have generously shared their classroom insights with me. Art teachers at the elementary, middle, and high school levels Sharon Clohessy, Cindy Monetta-Copperthite and their many Virginia Beach colleagues; Sandra Packer (Canal Winchester, Ohio), Rebecca Hartley-Cardis (Cardington, Ohio), Janice Kuchinka (Dublin, Ohio) were a major source for informing my understanding about what works in the classroom. My own undergraduate art-education students at Ohio State University over the course of four years allowed me to test my ideas, document their work, and mine their thoughts about artists, artmaking, and the classroom. I am indebted and grateful to all of them.

The practices of professional artists have set the framework for my ideas about teaching artmaking and my friendship with artist Dee Van Dyke (Blue Water Bay, FL) has not only informed these ideas, but her unflagging support for my work as an art educator has been equally important. Artist Sandy Skoglund (New York City) has been central in expanding my understanding about the ways that professional artists work, live, and think. Many ideas from our conversations about art and life have found their way into the pages of this text. I also wish to thank Jerome Zivan for the opportunity to interview five mid-career southern artists, Katherine Mitchell (Atlanta,Ga.); Tom Francis, (Atlanta,Ga.); Dee Van Dyke; Herbert Creecy (Barnesville, Ga.); and Jennine Hough (Atlanta, Ga.) for Zinc Gallery. The diversity of these artists greatly added to my knowledge of the practicing artist.

I would like to thank Marilyn Stewart, series editor, for suggesting and promoting the idea that I write a book on artmaking for the series. Writing the manuscript has offered a wonderful opportunity to conceptualize and think through many of the ideas that have been emerging in my own teaching for a number of years. During this process, she has been a much needed support and cheerleader. Finally, I owe thanks to Davis Publications, for permitting me to become part of the *Art Education in Practice Series*.

Sydney Walker

Table of Contents

Chapter *3*

Chapter *4*

Chapter *5*

Chapter *6*

Chapter *7*

Introduction

Sculptor Joel Shapiro once remarked: *"Design just does not interest me. . . The process does and the development of the idea."* [1]

Why have students make artworks? [2] Although artmaking is the primary enterprise in most elementary, middle, and high school artrooms, do art teachers ever ask themselves "Why am I having students paint landscapes, fashion clay pots, construct collages, and render self-portraits?"

In 1943, Abstract Expressionist painters Mark Rothko, Barnett Newman, and Adolph Gottlieb, in a letter to the *New York Times,* declared: "There's no such thing as a good painting about nothing." [3] As a former art teacher, an art-education professor, and a painter, I also feel that artmaking is foremost a meaning-making endeavor and that students—besides manipulating media, developing technical proficiencies, or learning good design principles through their artworks—can and should explore and express meaning. The intent of this text is to explore artmaking as a meaning-making endeavor, which is exemplified by the work of professional artists and may be translated into classroom practice.

From Creative Self-expression to Meaning Making
In contrast to meaning making, the creative self-expression approach to art education, which dominated from the 1940s until recently, offered a limited notion of the complexity of the artmaking process. Students created from intuitive urges that required little overt instruction. The primary responsibility of art teachers was to provide students with opportunities to encounter various kinds of media and techniques. A more recent approach—compre-

hensive art education—offers a more complex understanding of the artmaking process. Scholars Clark, Day, and Greer describe this development:

> In the early 1960s, at the height of the popularity of creative self-expression, several conferences were held at which art educators questioned the fundamental assertions of the self-expression approach and suggested alternatives. Since then, theorists, scholars, and researchers have developed a body of literature that has moved consistently away from the creative self-expression approach. [4]

Comprehensive art education contends that, in addition to art production, art instruction should embrace art history, art criticism, and the philosophy of art. Implementation of comprehensive art education not only expands the content of art instruction but also—according to Clark, Day, and Greer—significantly alters the notions of such factors as the learner, the teacher, creativity, and adult art within the context of the classroom.

Whereas in the creative self-expression approach, the focus had been on developing creativity, self-expression, and an integrated personality; in the knowledge-based comprehensive approach, instruction has become less about nurturing and more about teaching valid art concepts at the student's level. Adult art, no longer seen as inhibiting self-expression, becomes of primary significance for student expression. Creativity is no longer an innate attribute that requires only encouragement and opportunity, but, instead, one that benefits from overt instructional intervention.

The knowledge-based approach of comprehensive art education offers a less romanticized view of stu-

dent artmaking, contending that instructional intervention is both desirable and necessary. Based on this approach, this text embeds artmaking instruction within a context of learning that derives from an integration of art criticism, art history, and the philosophy of art, thereby informing students' artistic expressions.

Artmaking Informed by Big Ideas

The approach in this text also extends somewhat beyond comprehensive art education to embrace a more interdisciplinary character, through an emphasis on big ideas—the overarching notions that reach beyond any particular discipline. As discussed in Chapter 1, big ideas are broad, important human issues. Examples of big ideas are power, identity, community, nature, and conflict; and big ideas such as these have become useful tools for linking the various subject areas in the interdisciplinary curriculum efforts of the last decade.

Professional artists' use of big ideas to motivate and direct their artistic expression provides another reason for focusing art learning on them. In this text, sculptor Claes Oldenburg, in his colossal monuments, pursues the big idea of changed meanings in everyday objects; installation artist Sandy Skoglund explores the big idea of human behavior in contemporary society; and sculptor George Segal expresses

the big idea of alienation in the urban environment. The big ideas in these and other artists' work are so significant that they sustain the artists over years of artmaking. And, all importantly, the focus of *student* artmaking around big ideas makes the process relevant. By using big ideas, students find that artmaking is more than creating an interesting design or learning a particular technique with a specific medium: artmaking also becomes an expression of important ideas related to their own life and the lives of others.

Organization of the Text

So as to develop the reader's understanding of the artmaking process and the importance and function of its parts, each chapter in the text focuses on one component. Chapter 1 explores the concept of big ideas and lays the foundation for the subsequent chapters; Chapter 2 considers the importance of establishing personal connections to big ideas; Chapter 3 argues for building a knowledge base for big ideas; Chapter 4 investigates problem solving with big ideas; Chapter 5 looks at the setting of aesthetic boundaries with choices of media, formal qualities, subject matter, styles, and techniques to express big ideas; Chapter 6 examines the use of big ideas in designing artmaking instruction into a holistic learning experience for students; Chapter 7 addresses less concrete aspects of the artmaking

The Artmaking Process

Big Ideas	Problem Solving	Knowledge Base	Personal Connections	Boundaries	Ways of Working
conceptual foci	conceptual technical visual practical	general artistic technical	past experience individual interest social context heritage	formal choices technical choices media styles subject matter	risk taking playing experimenting delaying closure

process (such as risk taking, postponement of meaning, and experimentation) that have implications for classroom instruction, and offers guidance to teachers for implementing the artmaking process in a manner that encourages inquiry and discovery. All the chapters explicate these practices with big ideas by artists, in artworks, and in classroom artmaking.

Characteristics of Constructivist Teaching[5]
Authentic activities (instruction that has strong connections to the real world) Student collaboration Active learning Deep knowledge of a topic or discipline Use of prior knowledge Increasing complexity of understanding Access to content experts

A Constructivist Approach
Highly visible in current school reform literature is the notion that students be engaged with understanding and meaning making. This constructivist approach to teaching and learning argues that the goal of teaching is students' understanding and that students *construct* knowledge, not simply reproduce it through memorization, recall, or routinized application.[6] Artmaking conceived as an exploration and expression of big ideas reflects a constructivist approach. The implications of this are that students *not* produce artworks from rote formulas or create products that have little meaning beyond the exploration of media or the development of technical skills, but, instead, that students make artworks to investigate and express ideas; and, based upon constructivist practices of authentic learning based upon the real world, that students model their artmaking on that of adult artists and thereby learn how adult artists make art. The goal, however, is *not* to develop students into professional artists, but to structure classroom artmaking into a more meaningful activity, one based upon real-world authenticity.

Professional Artists' Practices in the Classroom
Comprehensive art education advocates instructional modeling based on the professional practices of art critics, art historians, aestheticians, and artists as a way for students to learn about art. For instance, art critics describe, analyze, interpret, and evaluate artworks; and the adoption of these same practices as standard procedures for conducting art criticism in the classroom encourages students to become more-skilled viewers of art. In theory, the professional artist's practices should have become a rich resource for classroom instruction but, to a large extent, this has not occurred. Therefore, the purpose of this text is to consider the professional artist in light of practices that can have significance for classroom artmaking.

The professional artists examined in the text are contemporary artists working in the context of current ideas, trends, values, and beliefs that inform a particular art world—the one most often addressed by Western professional critics and art historians. This is not to say that other art worlds—those that are community-based or self-taught or non-Western—cannot contribute models for classroom artmaking, but that such worlds exceed the scope of this text. Additionally, the selection of contemporary artists reflects my belief that students find contemporary artworks more compelling than those of the past. I have found that students are often more open and ready to embrace the unaccustomed, and frequently are not as disturbed as adults by new art forms and practices. Further, although contemporary artworks often challenge traditional artistic forms, they are more likely to depict visual imagery and

subject matter that students find familiar, providing useful connections to the artworks.

Research for the Text

In conducting research into artmaking practices at the elementary, middle, high school, and university levels, I observed classroom practice, held formal interviews, conversed informally with art teachers and art-education students, and instructed graduate and undergraduate studio methods courses with the ideas that inform this text. Other research—which I most often conducted through published artist interviews and art criticism—involved examining the works and practices of professional artists, especially those of international installation artist Sandy Skoglund.

From this body of research about the professional artist, I derived practices that have meaning for the classroom. The questions I pursued revolve around the artist's exploration and expression of meaning: What allows the artist to explore and investigate ideas? What permits the artist to find new perspectives and insights, push boundaries, and delve into ideas at deeper levels? How does the artist emphasize the process over the product? How does the artist make artistic decisions? Such questions—and professional artists' answers to them—developed my understanding of the artistic process and how professional artists use it to create not only products, but meaning too. My desire is that this text, which resulted from this research, will serve not as a recipe or a formula for designing classroom artmaking, but as a guide for implementing artmaking as a meaning-making endeavor in the classroom.

Notes

1 Barbaralee Diamondstein, "Brice Marden," *Inside the Art World: Conversations with Barbaralee Diamondstein* (New York: Rizzoli, 1994), p. 271.
2 See the author's article, S. R. Walker, "Why have students make artworks?", *Art Education*, September 1996, 11–17.
3 M. Rothko, B. Newmann, & A. Gottlieb, Letter to the *New York Times*, 1943.
4 G.A. Clark, M.D. Day, and D. Greer, "Discipline-based art education: Becoming students of art," *Journal of Aesthetics*, 21, 2, Summer 1987, p. 133.
5 These characteristics were compiled by the author as a general guideline to current educational understandings of a constructivist approach to teaching and learning. The list is not comprehensive (other characteristics could be added), nor is it meant to imply that constructivist teaching and learning must always include all of these characteristics.
6 The reform literature is extensive. A useful bibliography can be found in F.M. Newmann & Associates, *Authentic Achievement: Restructuring Schools for Intellectual Quality* (San Francisco: Jossey-Bass, 1996).

Chapter

1

Big Ideas and Artmaking

"I think that painting or the kind of painting I prefer to explore, is about unknowns or looking for questions more than answers."

—artist Brice Marden[1]

Big ideas—broad, important human issues—are characterized by complexity, ambiguity, contradiction, and multiplicity. Whether stated as single terms, phrases, or complete statements, big ideas do not completely explicate an idea, but represent a host of concepts that form the idea. For example, the term conflict may represent a number of concepts, such as power, personal and social values, justice and injustice, and winners and losers.

Because they provide artmaking with significance, big ideas are important to the work of professional artists—and of students if student artmaking is to be a meaning-making endeavor rather than simply the crafting of a product. Big ideas are what can expand student artmaking concerns beyond technical skills, formal choices, and media manipulation to human issues and conceptual concerns. Big ideas can engage students in deeper levels of thinking.

Examples of Big Ideas

- dreams and nightmares
- life cycles
- reverence for life
- interdependence
- individual identity
- aging
- power
- community
- life and death
- emotional life
- heroes
- family
- idealism
- ritual
- views of reality
- conflict
- social norms
- spirituality
- celebration
- uncertainty
- relationships
- suffering
- human diversity
- materialism
- nature and culture
- utopias
- fantasy
- social order

Developing Big Ideas

Artists generally experiment with several directions before settling on a big idea that will sustain their attention over an extended period. Students too need opportunities to learn about an idea, build an adequate knowledge base for working with it, examine the idea in the work of other artists, and find personal connections to the idea.

Personal interest plays a significant role in directing the artist's choice of ideas. Becoming personally connected to a big idea is highly important for artmaking; otherwise, artmaking can become merely an exercise in problem solving.

From Big Ideas to Artmaking

Big ideas drive an artist's artmaking over time. They extend beyond individual artworks and encompass large portions, if not all, of an artist's body of work. Big ideas represent the artist's overall purposes for artmaking, and they tell—in broad conceptual terms —what the artist is about.

Theme or Big Idea?

An artist's theme may or may not be the same thing as his or her big idea. If a theme persists throughout an artist's body of work, then it is the same as the artist's big idea. For example, alienation consistently inhabits the tableau installations of sculptor George Segal. Whether Segal depicted a street corner, a diner, or a bedroom, his work is about human alienation in the urban environment. Thus, Segal's theme and big idea are the same.

On the other hand, Abstract Expressionist Robert Motherwell pursued the theme of death in over 100 paintings in his series *Elegy to the Spanish Republic* (1948–97), but this theme is not characteristic of his entire body of work; it does not encompass his overall big idea. Rather, Motherwell's overall purpose and

big idea is the exploration of human emotions; the human emotions in response to death is only one part of a wider range of human feeling that Motherwell investigated.

Subject Matter or Big Idea?

Subject matter is the artist's topic, whereas big ideas are the artist's concepts. Consider the work of three artists. Van Gogh's subject matter included landscapes, portraits, and still lifes. His big idea was the portrayal of human emotions. Pop Artist Andy Warhol created silkscreened images of Campbell's soup cans, Coca-Cola bottles, dollar bills, and Marilyn Monroe and other famous people. These were Warhol's subject matter, but his big idea was the denouncement of the sacred values and ideals of high art, which accepted only certain topics as appropriate subject matter. Henri Matisse painted interiors, still lifes, and female models, but his big idea was the depiction of an ideal world untroubled by the imperfections of the real world.

Distinguishing between an artist's subject matter and big idea is often difficult, but the designer of classroom artmaking needs to clearly understand the distinction between them. By answering "What is the artist's work about?" we can say, for instance, that van Gogh's paintings are about landscapes, portraits, and sunflowers; but they also are about human emotion.

We can answer the same question about student artmaking, by saying that it is about certain subject matter, but also about big ideas that extend beyond the subject matter. The big idea assumes primary importance, whether in a professional artist's work or in student artmaking. The big idea provides the conceptual ground for artmaking; the subject matter serves as the context for examining the big idea.

A Starter List of Big Ideas and Artists

Can your students name three artists who work with the big idea of identity? A good way to enable understanding of big ideas is to look at examples of artists and their big ideas. A starter list of artists who work with several big ideas is on page 140. Encourage students to make their own lists, or work on a class list collaboratively.

Fascinating Facts

After Jennifer Bartlett spent six years and $100,000 of her own money to create a proposal for a three-acre garden in Battery Park City, at the lower end of Manhattan where she lived at the time, the plan was canceled by Governor Cuomo. As a response, Bartlett moved to Greenwich Village and built her own three-level, all-season series of garden "rooms" on the roof and terraces of her new house.

Jennifer Bartlett: Use of a Big Idea

Gardens are the subject matter of Jennifer Bartlett's series *In the Garden*, but they are not her big idea. Her big idea—one that she has used in numerous artworks with a variety of subjects, such as houses, boats, oceans, and landscapes—is the exploration of the use of rules and systems.

In the Garden

In the winter of 1979, Jennifer Bartlett found herself in a dreary French villa that she had temporarily traded for her SoHo loft-apartment, in New York City. Committed to living in Nice for a year, Bartlett was distressed by the villa's cold, damp interior and the inhospitable weather. Rain fell almost every day. Never having been to the south of France, she envisioned constant sunshine, beaches, and living well—not a gloomy villa on the wrong side of town; a windswept, frostbitten garden; and endless rain. Eventually, she surveyed the possibilities and saw promise in a dining-room window that reached to the ground. Through it, Bartlett saw a garden. Not

1.1 Jennifer Bartlett, In the Garden, #20, *1979–80. Watercolor on paper, 19 1/2" x 26" (49.5 x 66 cm). Courtesy of the artist.*

very impressive, the garden consisted of a leaky swimming pool, five dying cypress trees, a cheap plaster statue of a boy, unkempt beds of rosebushes, and one or two pieces of garden furniture. In spite of the uninspired view, Bartlett began to draw it and eventually produced a spectacular series of nearly 200 drawings, in different media.

The subject matter of gardens has both artistic and personal significance for Bartlett: in her work, she depicts them and such other natural elements as landscapes and bodies of water; for her home and studio in Battery Park, she created a lavish, tiered rooftop garden comprised of a maze, a shrub garden, a grape arbor, a grass garden, and a summer rose garden.

To inform our analysis of Bartlett's big idea, it is helpful to look at her earlier work. A study of Bartlett's breakthrough work *Rhapsody* (1975) reveals that systems and rules have concerned her and informed her work. Says Bartlett: "I've always liked rules . . . I figure out ways of breaking them."[2] Bartlett created *Rhapsody*, a work incorporating a 1-foot-square grid pattern of enameled steel plates, as a carefully calculated set of variations on a design motif. Patterns represent a basic component of design systems.

Thus, when Bartlett began the drawings for *In the Garden*, she characteristically imposed a system and set of artistic rules. Her rules called for beginning each drawing with a view of the "awful little garden" and executing each drawing onto the same-size paper.

To break or bend these rules, Bartlett produced the drawings in numerous variations of style—from Abstraction to Realism—in ten different media. The exhibit of the series at the Paula Cooper Gallery, in New York City, demonstrated not only the artist's adherence to rules but also her simultaneous bend-

1.2 *Jennifer Bartlett,* In the Garden, *#129, 1979–80. Conté crayon on paper, 26" x 19 1/2" (66 x 49.5 cm). Courtesy of the artist.*

ing of them; and the result—depending on view-point—was both 200 individual gardens and 200 variations of the same garden.

Bartlett produced a series that appears both planned and unplanned: there is no obvious order, sequence, or rationality to the style, media, or spatial changes; yet the series connotes an underlying logic, one that suggests something other than random choices. It is as though an invisible system inhabits the series. The simple rules for producing each drawing from the same garden onto the same-

Inside the Classroom

The following criteria, recommended by Heidi Hayes Jacobs, provide practical guidelines for developing essential questions for big ideas.

Criteria for Essential Questions

Questions should:

- reflect conceptual priorities.
- be distinct and substantial.
- be broad and umbrella-like.
- not be repetitious.
- be realistic in terms of time allocated for the unit or course.
- be in a logical sequence.
- be in language that is comprehensible to all students.[3]

One added recommendation is to limit the number of essential questions to no more than three or four. This limitation encourages broad, encompassing questions. There can be any number of sub-questions, but too many primary questions is cumbersome.

Teaching Tip

Don't let enthusiasm for an artist's work or a special learning opportunity (such as a field trip or artist residency) overshadow meaningful connections to a big idea. If the big idea and special opportunity are mismatched, it would be a disservice to students to forge tenuous links.

size paper created sufficient similarities among the drawings to suggest a systemic approach and to constrain the differences. Art critic John Russell wrote:

It is upon feeling... that In the Garden *relies for its hold upon us. But it is important all the same to know that this is a systematic and not an improvisational sequence [emphasis added]. Anyone who saw* In the Garden *installed and took the trouble to look at it intelligently will remember that the successive groups pulled together as groups, that the changes of medium acted upon us like changes of registration on an organ or harpsichord, and that the shifts to figure drawing, or to abstract form, seemed in retrospect to have been exactly what we craved at that point in the tour.*[4]

From Bartlett's Big Ideas to Student Artmaking
Bartlett's big idea represents a significant human idea that students could pursue: rules and systems represent human attempts to impose order and meaning. Examples of such attempts range from social order (traffic regulations, income taxes, governing organizations) to individual order (personal habits, arrangements of personal environment).

Both terms—rules and systems—have been utilized in describing Bartlett's approach to artmaking. The basic distinction is that systems are comprised of rules. For instance, with *In the Garden* Bartlett employs several rules such as creating each drawing from the same subject matter, utilizing paper of uniform size, and employing a range of media and artistic styles. Taken together, Bartlett's rules comprise a system for producing the 200 drawings that make up the series. Thus, students might also develop an artmaking project based upon a set of self-imposed rules which compose a system for working.

Teachers might plan such a unit by following a suggestion of curriculum theorist Heidi Hayes Jacobs,

organizing their instruction around essential questions—large questions that are a reflection of conceptual priorities for instruction. Jacobs explains:

Navigators use maps to chart a course. Although unforeseen events and variables affect their journey, they begin by making important choices about their route to avoid a meandering, rudderless voyage… Given the very real limits of time, we must make choices. The essential question forces the teacher to choose the conceptual outcome for the students.[5]

A Unit of Study

Although the essential questions that guide a rules-and-systems unit of study use the work of artist Jennifer Bartlett, they are focused on the big idea, not the artist. Closely related to and derived from the essential questions are specific art questions about the big idea, which help clarify how the big idea and the artworks are related.

Use of the big idea and essential questions to frame the art unit broadens the unit content so as to readily link to learning in other subject areas. Rules and systems, for instance, could apply to student work in science, music, poetry, sports, or writing. Some of the essential questions and the art questions are repeated in different activities, which allows students to engage the questions at deeper levels. Developing a single activity per question is not necessary.

Unit Plan

Designing art instruction around big ideas can occur at several different starting points. One might begin either with a big idea, an artwork, a specific curriculum concern, an existing project, or a special learning opportunity. The important point is to make certain that the big idea is the focus of instruction, regardless of where the planning began.

Big Idea: Rules and Systems
Artist: Jennifer Bartlett
Artworks: *In the Garden* (1979–80), a series of 200 drawings and paintings (Select about twenty for the unit.)[6]

Essential Questions
- What makes a rule?
- How do rules create meaning?
- How do changes to rules affect meaning?

Art Questions
- How does artmaking with rules affect artistic expressions?
- How do changes to rules for artmaking affect artistic expressions?

Activity 1
Essential Question: What makes a rule?
- Give students a set of reproductions from Bartlett's series *In the Garden*, and ask students to construct a set of working rules that Bartlett might have followed in producing the series.

Activity 2
Essential Question: How do changes to rules affect meaning?
Art Question: How do changes to rules for artmaking affect expression?
- Ask students to investigate Bartlett's works in her series to determine how the artist adhered to her rules and how she changed them. Have students write a paragraph explaining how Bartlett's changes to her rules affected the expression and meaning of *In the Garden*.

What's Wrong with This Picture?

An undergraduate art-education student chose *confusion* as a big idea for designing an instructional unit for elementary students. Wassily Kandinsky, the Russian abstractionist, was one of the artists in the unit. How did the undergraduate go wrong?

Many of Kandinsky's abstract paintings are explosive, populated with geometric and free-form shapes that burst and shower over the canvas in a seemingly unorganized profusion that elicits feelings of confusion. However, it is reductive to use this idea as a primary notion for understanding Kandinsky's work. Kandinsky's work is informed by ideas about reality and abstraction, and spirituality.

The student apparently did not know enough about the artist's work. With greater knowledge of Kandinsky, she could have recognized that the artist was not a good choice for her big idea. Artists such as Judy Pfaff, Robert Rauschenberg, and Dada artists have taken the idea of chaos, chance, and disorder as their primary focus. These artists would have been better choices. The problem was not the idea, but the selection of appropriate artists for studying the idea in a meaningful way.

Teaching Tip

Research an artist before making curricular decisions. It is not enough to choose unit artists from visual appearances alone.

Fascinating Facts

Jennifer Bartlett once wrote a thousand-page-plus autobiographical novel called *History of the Universe.*

Activity 3
Essential Questions: What makes a rule? How do rules and systems create meaning?

Art Question: How does artmaking with rules and systems affect expression?

- Ask students to select a specific site as their subject for a series of artworks, as Bartlett selected the garden outside her dining-room window.
- Guide students to formulate and then write a set of three working rules—regarding media, formal qualities, size, and style—for their series.
- Have students produce a series of three works that adhere to their written rules.
- Ask student pairs to exchange series, write a set of rules that they believe informed the making of the series, and write a paragraph explaining how the rules affect the expression of the site they chose as their subject.
- Instruct student pairs to reveal and discuss their working rules and whether the exploration of their chosen subject was helped or hindered by working with imposed limitations.
- Ask students to change or bend one of their rules and create three additional artworks for their series.
- Ask student pairs to exchange their series of six artworks and write a paragraph explaining which rule was changed or bent and how the change affected the expression of the subject matter.

Assessment
This assessment assignment, which derives from the essential questions, requires students to apply the ideas about rules and systems to a new context.

Preparation
- Divide students into small groups, providing each group with reproductions of several different Deborah Butterfield horse sculptures, including

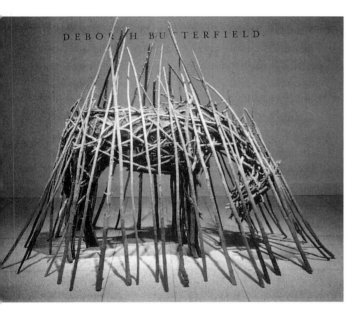

1.3 *Deborah Butterfield*, Horse No. 7 (Bonfire), *1978. Mud, sticks, steel, 108" x 144" x 60" (274 x 366 x 152 cm). Courtesy of the artist. Photograph by Philipp Ritterman.*

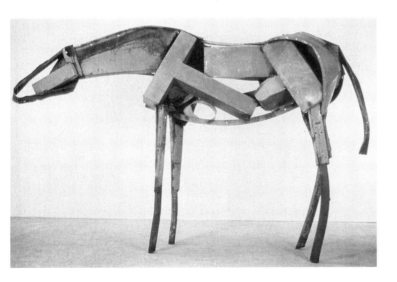

1.4 *Deborah Butterfield*, Riot, *1990. Found steel, 81 1/2" x 120" x 34" (207 x 305 x 86 cm). Courtesy of the artist.*

one cast in bronze.

- Explain to students that the sculptures are of the same subject matter (horses), but each is made from different combinations of found materials such as sticks, wire, mud, steel sheeting, steel tubing, and brick dust.
- Ask students to examine the sculptures and make a list of what they perceive as Butterfield's rules for creating them.
- Instruct students to write an explanation of: 1) how these rules affect the expression of the sculptures; 2) whether Butterfield broke any of her rules, and, if and when she did, how doing so affected the expression of the sculptures.

 Artist Talk

As a child, Deborah Butterfield constantly rode horses. Today she continues this passionate interest on her Montana ranch. She recalls that as a graduate student at the University of California at Davis in the 1970s—in the heyday of Conceptual Art, when recognizable subject matter was definitely taboo—she avoided making horse sculptures "like the plague." She recollects that "it was very uncool to be a girl who liked horses in a serious art department. But I finally faced up to it."[7]

Sculpting horses for over two decades, Butterfield has found that every horse continues to be different for her. "It's like dancing with a new partner. I don't think I'll ever get tired of dancing, you know. I hope I'll be able to dance until I die."[8] The challenge of finding new things to say, and creating a distinct personality for each horse sculpture, gives meaning to her manipulations of discarded materials.

Assessment Criteria

Criteria for evaluating the assessment task is based upon the student's level of understanding of the three essential questions.

Assessment Rubric

Strong Understanding	Average Understanding	Weak Understanding
• The student lists the following rules: Butterfield uses found materials, life-size scale, and the same subject matter in all the sculptures. She limits the different kinds of found materials in each sculpture. • The student explains that Butterfield's use of the same subject matter allows a comparative interpretation of the different identities of each sculpture. • The student reasons that the use of different found materials accounts for different expressions. • The student reasons that limiting the sculptures to only a few kinds of found materials strengthens the power of the horses' identity and expression. • The student observes that Butterfield, by casting one of the sculptures in bronze, changed the rule of using found materials. • The student explains that the casting of the sculpture in bronze changes its expression.	• The student lists the following rules: Butterfield uses found materials, life-size scale, and the same subject matter in all the sculptures. • The student explains that Butterfield's use of the same subject matter allows a comparative interpretation of the different identities of each sculpture. • The student reasons that the use of different found materials accounts for different expressions. • The student observes that Butterfield, by casting one of the sculptures in bronze, changed the rule of using found materials.	• The student lists the following rules: Butterfield uses found materials and the same subject matter in all the sculptures. • The student does not explain how Butterfield's rules affect the expression in the sculptures.

Teaching Tip

Look beyond stylistic characteristics of an artwork when selecting examples for focus. Seurat's *Grande Jatte (Sunday Afternoon in the Park)* is often used merely as an example of pointillism. There's much more to *Grande Jatte* than stylistic invention. This icon in the history of Western art has been interpreted by art historians and art critics with big ideas that refer to social meanings. See Inside the Artist's Head on page 140.

Same Big Idea; Different Subject Matter

Artists frequently transfer big ideas from one subject to another. Bartlett, for instance, investigated the relationship between rules and systems with various subjects: gardens, swimmers, landscapes, bodies of water, and the archetypal house. Having students employ a single big idea with more than one subject encourages them to investigate ideas in greater depth. Although classroom time is always a constraint, it is possible to engage students with a single big idea and several artmaking projects that vary in subject matter.

Minimalist artist Brice Marden, like Bartlett, transferred a big idea from one subject matter to another. Marden produced monochromatic panel paintings for over twenty years, but in the 1980s began to create paintings that bear a strong resemblance to Chinese calligraphy. Marden explains: "I was making a kind of painting I could have gone on making the rest of my life—a kind of signature style. Which was fine, except that I was finding it increasingly boring."[9] Marden's new calligraphic paintings emerged from his enthusiasm for Zen philosophy and Chinese calligraphy and poetry. He altered the form, style, and subject matter of his painting, but his central, or big, idea—the search for transcendence and spirituality—remained intact.

Teacher Talk

Why are big ideas and essential questions important for developing classroom instruction?

Elementary art, music, and classroom teachers who have utilized big ideas and essential questions in their teaching respond with the following comments:

"Knowing the artist's big idea gives the teacher a frame of reference for guiding the lesson. You tend to stay on task."
—Arlene Langford, second-grade teacher

"The artist's big idea is like the foundation of a house. It's what you build on."
—Carolyn Shaffer, first-grade teacher

"The artist's big idea is both generative and unifying. It helps to guide students through a process of inquiry which provides greater meaning."
—Jeffrey Schneider, elementary music teacher

"The big idea and essential questions help me and my students to have a clear vision of what they are going to learn. It gives both of us a goal and also gives me a clear assessment tool."
—Tamara Blair, fourth-grade teacher

"Essential questions are a touchstone for me. I can plan my art lessons around these questions and if students can answer the essential questions by the end of a unit, then understanding has taken place."
—Michelle Cardona, kindergarten teacher

"Essential questions help to narrow my vision. I tend to overdo and want to teach too much."
—Sherri Pittard, elementary art teacher

"When I start to stray from my main idea, essential questions remind me of where I should be."
—Christa Polomsky, fifth-grade teacher

Frequently-Asked Questions

How do you begin designing instruction with big ideas?

The first step is to determine what is significant about the idea. Brainstorming a list of key concepts that inform a big idea is a good starting point.

A Starter List of Key Concepts for Big Ideas

Big Idea: Dreams and fantasy

Key Concepts:

- Dreams are common to the human experience. Everyone dreams.
- Dreams are mixtures of reality and unreality.
- Dreams can be clues to understanding reality.
- Dreams can elicit strong emotions.
- Dreams can help us to imagine new possibilities.
- Dreams twist, distort, skew, warp, and exaggerate reality.
- Dreams that express extreme fears and bizarre experiences are labeled nightmares.
- Dreams are often indirectly related to personal experiences.

For additional starter lists, see page 140.[10]

Instructional Consequences of Misreading an Artist's Big Ideas: Teaching Goldsworthy

Misunderstanding an artist's big ideas and the consequent instructional problems that can occur are presented here in an artmaking lesson about environmental artist Andy Goldsworthy. The lesson was peer-taught by an undergraduate art-education student. Although this highly motivated student showed considerable effort, he encountered instructional problems due to misreading Goldsworthy's big ideas.

From such natural materials as leaves, twigs, dirt, snow, and ice, Goldsworthy constructs ephemeral artworks—those with a limited life span. Fascinated with the subject of nature, he combines art with the natural environment. Through this process, he focuses on two big ideas: the possibilities of a collaborative, personal relationship between humans and nature; and the use of artmaking to learn about nature (see Chapter 2 for more about Goldsworthy).

As the first to peer-teach in the studio methods class, Jack was somewhat nervous about teaching Goldsworthy's environmental sculptures to his twelve peer-students. He began the session with ten Goldsworthy slides that vividly depict the artist's meticulously crafted geometric sculptures of beech leaves; smooth, rounded stones; long, slender grasses; and huge ice blocks. During the slide presentation, Jack told the class about Goldsworthy's extensive travels to sites in Japan, Holland, Great Britain, and the North Pole, where he used on-site natural materials to construct his artworks.

When Jack presented a slide of an image of maple leaves—painstakingly arranged in a circular pattern and shaded with hues of burnt cinnamon to paler shades of orange and yellow—he informed the class that this was the key work for the lesson.

However, instead of engaging the class in interpreting the maple leaves, he moved to the next slide, even though the professor, with the anticipation that the peer-teachers would follow suit, had already modeled a lesson that stressed interpretive discussion.

For the studio activity, Jack directed the class to an outside courtyard, where he had collected piles of leaves, mounds of dirt, and several buckets of water. He instructed the class to use the accumulated leaves, dirt, and water to make personal containers, bowls, cups, and vases. The students could work either individually or in small groups. Although the process was messy, the class enthusiastically began mixing the water with the leaves and dirt. Accompanying a lot of laughter were good-natured comments, such as "Just wait until my lesson, and I'll get you back." After about thirty minutes, the class had produced five rather crudely formed cups, vases, and bowls. The students gathered in a circle around their creations to discuss the project. The following is an edited and annotated excerpt from that discussion:

Professor Why did you choose personal containers as the subject for the artmaking?

Jack It was something I thought would make a personal connection. I needed a form, but I didn't want to choose one of Goldsworthy's geometric forms, like a line or circle. So I thought I would pick a manmade form. Can you guys think of another form I could use?

Jack's use of a human-made form revealed his misunderstanding of Goldsworthy's big idea. Goldsworthy's primary concern is to work as unobtrusively with nature as possible. He specifically avoids human-made forms because he considers them too intrusive. Although Jack had valid concerns about wanting to personalize the studio activity and

Inside the Classroom

Food is a topic that is embedded with cultural meanings and can serve as a big idea for student artmaking. What are some key cultural factors that inform this topic? What questions should students consider when deciding upon a particular food for artmaking—both as content and media? What artists explore food as content and art medium? See page 141, Food As a Big Idea, for some answers to these questions.

1.5 *Maple Patch/difficult/yellow to orange hard to find/wind, sun/Leaves drying out and blowing away. Andy Goldsworthy,* Maple Patch, Ouchiyama-mura, *Japan, 22 November, 1987.*

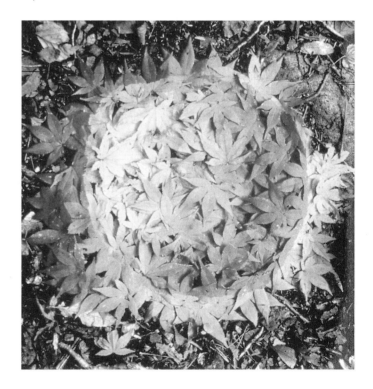

avoid mimicry, he failed to place these concerns into a well-grounded understanding of Goldsworthy's big ideas and intentions.

Tracy I was interested in Goldsworthy's work, so I read up on it and it seems to me that a lot of what he did was with objects which he just found or came upon. I remember that he found rocks along the rivers and covered them with leaves. He seemed to be about something more than just putting leaves and mud together.

Tracy saw that Goldsworthy's artmaking strategies are informed by bigger ideas than just work with natural materials. Importantly, she observed that the artist used materials found on-site, an indication of Goldsworthy's intent to work collaboratively with nature. By bringing materials to the site, Jack had the student artists impose on nature rather than work with what was already there.

Susan Or maybe if you just had us go out to the oval in front of Hopkins [the art-education building] and make something with the materials we found.

Jack As I said in my presentation, I would have had you go out and collect leaves and dirt and water, but the time is too limited.

Although Jack indicated here that he knows Goldsworthy doesn't predetermine his materials and instead uses whatever he finds on-site, he missed the significance of Goldsworthy's strategy in relation to his overall purpose for artmaking.

Susan We could use spit. [Laughter]

Tom We would be out here a long time if we depended upon spit.

It was coincidence that Susan suggested spit. Jack could have discovered this in his research about Goldsworthy, but the class probably was unaware that Goldsworthy sometimes joins leaves

by licking them rather than resorting to glue. This seemingly trivial bit of knowledge carries import when it is related to Goldsworthy's intent to work closely with nature. A firm grasp of the big ideas that inform an artist's work assists in recognizing relevant information.

Carl I'm just thinking, what if you had told us to come out here to the courtyard and choose any natural materials and alter the space. Would that be too open?

Tom It depends upon the age of the students.

Carol It might work for us, but elementary students would probably just wander around asking "What are we out here for?"

Tom What if you referred back to Goldsworthy's work and asked how did he alter the leaves or rocks or ice? That might help them.

Tom demonstrated an understanding of knowledge transfer from the artist's work to student artmaking. He intuited that students can learn from the artist's work and apply similar strategies to their own artmaking.

Susan They could put the leaves in lines or create different shapes with them.

Jack My original idea was for you guys to make lines like Goldsworthy. Remember the slide where he had the leaves in lines? But, I thought, well, I don't want you to just copy what he did. And now I don't know if the personal containers was a really good choice, but I didn't want you to just come out here and do what he did. Although, we are making some reference to what he does by using only natural materials and working outdoors.

Jack couldn't find a satisfactory solution because he only partially understood Goldsworthy's big ideas. He grasped the notion that the artist uses natural

materials in outdoor settings, but he hadn't under-stood that the most personal aspect of Goldsworthy's artmaking is findings ways to work with nature rather than imposing upon it. Students could find a personal approach to this idea without mimicking Goldsworthy.

The most direct approach to student artmaking in this situation would be for them to create an art-work from the materials found in their own environ-ment. This would allow students to emulate Goldsworthy's practice of collaboratively working with the situation at hand. Thus rather than import-ing materials to the artmaking site, students would be challenged to create artworks from available materials. As to the art form itself, instead of having students create specific predetermined subject mat-ter, students might determine their own art form and subject matter in ways that they believe would foster a collaborative venture with the environment in which they are working.

Tom Part of what Goldsworthy is about is that his work looks as though it is part of the landscape. This vase doesn't have that quality about it. It's not nat-ural looking.

Tom, on the right track here, inferred that Goldsworthy's sculptures are strongly tied to nature.

Jerry I think there's some point about Goldsworthy that we missed. I think he is bringing art into the landscape, but it's color, shape, and line instead of manmade objects. We were looking at an art book trying to decide upon our artist and found this artist who makes books from unconventional materials—nails, wire, and stuff—and it seems to me that mak-ing the personal containers from leaves and mud would work just as well with that artist since we made something manmade out of unconventional materials. I'm standing here thinking, what am I

Artist Talk

"I used to say I will make no more holes. Now I know I will always make them. I am drawn to them with the same urge I have to look over a cliff edge. It is possible that the last work I make will be a hole."[11]

—Andy Goldsworthy

Inside the Classroom

Designing art instruction with big ideas can be exciting and challenging. Identity is a natural "big idea" choice for student artmaking, and self-portraits are a logical subject for artwork about identity. What might be a new way to create self-portraits? What knowledge-building activities can you introduce as a background for student self-portrait artmaking? What questions might guide student artmaking? How might you structure a self-assessment checklist? How might you lead a critique? See page 142, Identity As a Big Idea: A New Way to Create Self-Portraits, for some suggestions regarding presentation and assessment of this topic.

learning about Goldsworthy other than his use of natural materials? I'm making a manmade object and that is not what he does.

Jerry targeted the problem with the studio activity. What were the students learning about Goldsworthy other than about his use of natural materials?

Jack But you are making a form that is familiar to you, and that is what Goldsworthy does.

Jerry Okay, I can understand the familiarity, but he has nothing manmade that I can see.

Jack But I didn't want to exactly copy Goldsworthy.

Susan Maybe in your efforts to avoid copying Goldsworthy, you went to the opposite end. You know what I mean? Maybe you could have been just a little more in tune with his work. The project just sort of went from nature to manmade with no connection.

From Goldsworthy to the Artroom

Although it is essential that students create a personal connection for their artmaking, the connection should be consistent with the overall purposes of the artmaking. Lack of consistency—such as occurred in the Goldsworthy lesson, when students made personal containers and contradicted the notion of working collaboratively with nature—is counterproductive to learning.

Big ideas are, perforce, broad enough to allow for numerous interpretations. When an artist mimics another artist's work, what is usually imitated is the artist's style, not his or her big idea. Copying an artist's style reflects a superficial rather than a deep understanding because it is based upon physical forms rather than conceptual ideas. This was the case in the Goldsworthy lesson when the peer-teacher had the students create a human-made object because he felt that creating abstract geometric

forms would result only in an imitation of Goldsworthy. As the instructor, he did not see that conceptual ideas are more significant for Goldsworthy's work than his use of geometric forms.

Use of big ideas provides a conceptual focus—one that extends beyond the study of a particular media, technique, design problem, or subject matter—for artists and for artmaking instruction. And these ideas take on even more significance when connected to other components of the artmaking process—such as personal connections, problem solving, knowledge base, and aesthetic choices.

Notes

1 M. Rothko, B. Newmann, & A. Gottlieb, Letter to the *New York Times*, 1943.
2 "Artist Aloft," *Vogue* (October, 1992), p. 324.
3 Heidi Jacobs, "Redefining the Map Through Essential Questions," *Mapping the Big Picture: Integrating Curriculum and Assessment, K–12* (Alexandria, VA: Association for Supervision of Curriculum, 1997), 3–32.
4 John Russell, *Jennifer Bartlett: In the Garden* (New York: Abrams, 1982), p. 7.
5 Jacobs, p. 25, 30–31.
6 Bartlett's drawings for *In the Garden* can be located in: Marge Goldwater, Roberta Smith, Calvin Tompkins, *Jennifer Bartlett* (Minneapolis: Walker Art Center; New York: Abbeville, 1985).
7 Janet Wilson, "The Mane Event," *Connoisseur*, vol. 222, no. 96, 66–71.
8 Marcia Tucker, "An Interview with Deborah Butterfield," in *Horses: The Art of Deborah Butterfield* (Coral Gables, FL: Lowe Art Museum exhibition catalogue, 1992), p. 34.
9 Bob Spitz, "Different Strokes," *Arts*, p. 94.
10 Concepts generated by ten elementary classroom teachers at Clinton Elementary School, Lincoln, Nebraska.
11 Terry Friedman and Andy Goldsworthy, eds. *Hand to Earth: Andy Goldsworthy Sculpture, 1976–1990* (New York: Abrams, 1990), p. 24.

Chapter

2

Personal Connections

"It's very personal. I tried to bring myself and the feeling I was having to my artwork when I was drawing and painting. This is the first time I have made an artwork that shows my feelings."

—High school student

Artists work from big ideas, but to motivate and sustain their interest and to make their ideas worth pursuing, they find personal connections to them. Student artists also need personal connections to big ideas.

Inside the Classroom

A Title One elementary writing teacher personalized the study of community by having her students search for significant architectural structures in their own neighborhoods. They found that their city of Cleveland, Ohio, was a community densely populated by bridges—suspension, compression, and swing structures. Examining architecture in their own back yard made this study meaningful for the students, who visited some of the bridges and met with an architect who answered their many questions.[1]

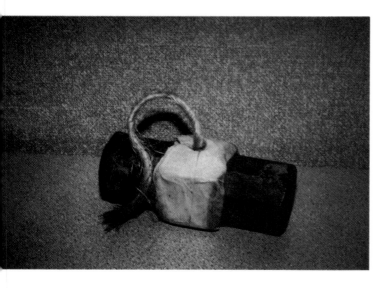

2.1 *Eric Cooper,* The Fuse *(after Lipski), 1996. Sledgehammer head, twine, tape, approx. 7" x 3" x 3" (18 x 7.6 x 7.6 cm). Cardington High School, Cardington, Ohio. Rebecca Hartley-Cardis, art teacher.*

Personalizing Big Ideas

To personalize big ideas for artmaking, student artists may do what professional artists do—link artmaking and big ideas to individual interests, background, and experiences. When we introduce big ideas to student artmaking, we can encourage students to examine them in relation to their own life by answering such questions as: How does this idea relate to my life? Where am I in this idea? What would I want to know about this idea?

Perhaps the most useful link between the personal connection and a big idea is the subject matter chosen for artmaking. Contemporary artists Donald Lipski, Sandy Skoglund, Andy Goldsworthy, and Fred Wilson use everyday events, nature, and social issues as subject matter; and exemplify how the personal can derive from such diverse sources as individual interests, experiences, and social concerns.

Donald Lipski: A Fascination with Objects

Fascination with and love for the manufactured object has served as the focus of sculptor Donald Lipski's artmaking for more than two decades. Lipski explores objects in ways similar to those of early twentieth-century Surrealist artists and writers. Such painters as René Magritte, Salvador Dalí, and Max Ernst; and poet André Breton all examined the nature of meaning through unusual juxtapositions, chance encounters, the subconscious, and the world of dreams; and used these methods as tools for breaking free of the rational and logical bonds of the intellect. Their reverence for chance and the unexpected is illustrated by poet Lautréamont's *Songs of Maldoror:* "Beautiful as the chance encounter, on an operating table, of a sewing machine and an umbrella."[2]

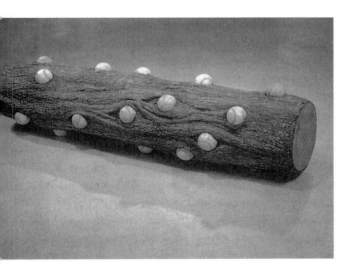

2.2 Donald Lipski, Exquisite Copse No. 13, 2000. *Mixed media, 66" x 18" x 18" (168 x 46 x 46 cm). Courtesy of the artist and Galerie Lelong, New York.*

By juxtaposing seemingly unrelated objects, Lipski continues Surrealist practices. He has combined ordinary objects in bizarre juxtapositions—a pair of open-toe high-heeled shoes stuffed with long-stemmed red-tipped matches; a wax-filled ladle into which a regulation-size baseball is embedded; and a cast-iron boat propeller holding a burning candle—to create meaning. The high-heeled shoes, for instance, denote fashion, but, stuffed with the matches, they connote feminine power and energy.

Lipski began his exploration of objects with small-scale artworks created from a cigar-box collection of plastic stir sticks, matchbooks, toothpicks, rubber bands, pencils, and other marginal artifacts of contemporary culture. He later graduated to larger works—table-size objects and installations.

Because he was not trained as a sculptor, Lipski prefers tying, wrapping, and gluing to more elabrate

Student Writing

Prior to a studio activity based upon Donald Lipski's work, high school students were assigned free writing in which they assumed the perspective of a candle. This encouraged students to develop personal knowledge and empathy for the object before creating their sculptures. One student wrote:

I Go Peacefully in the Night

I am sitting on the fireplace mantel with nothing to do. I was purchased for my new home for no apparent reason. Ah, to be out of the shrink wrap. . .
I am a vibrant red color with a fine textured wick. My only purpose is that of decoration. But beauty is more than skin deep.

Finally, I hear a match strike as a human walks closer toward me. She lights my wick and I grow to a beautiful, bright glow. I am overcome with joy. I begin to cry and the tears drip slowly down my side as I live peacefully into the night.

Another student wrote:

Chillin' in the Birthday Cake

I was just chillin' in the birthday cake and everyone was staring at me. Ha, ha, ha. I am the star of the show even though there are eleven of my friends around me. Hey, wait a minute. Why did the lights go out? Why are those people singing? STOP everything! Why am I getting smaller? I don't like this. Hey, I'm shrinking here. What's going on? What's that light on top of my head? It's getting hotter and hotter. Ahhhh![3]

Teaching Tip

Infusing artmaking with the personal represents a range that can extend from the autobiographical to the social. When planning student artmaking, strive for a balance along this continuum, including experiences with various kinds of personal connections.

Frequently-Asked Questions

How personal is the personal in artmaking?

Autobiographical paintings by van Gogh or Munch have clear connections to the artists' lives, but other artists make their work personal with less direct connection. Consider Haring's subway drawings (see pages 132–134) depicting the power of technology. Haring portrays computers shredding humans and humans mimicking television images; however, Haring was not personally threatened by technology. His drawings were personalized through an expression of his concerns about technology, rather than as a direct reflection of autobiographical issues.

Inside the Artist's Head

Although the physical presence of the artist is not seen in van Gogh's painting of his bedroom at Arles, the painting is a highly personal statement that serves as a self-portrait. Similarly, contemporary artist Jim Dine's paintings, drawings, and prints of bathrobes are personal statements that refer to his identity. What strategy does the work of these two artists suggest for the classroom? Most obviously, students might create self-portraits by substituting material objects for their identity. Yet also, these works connect the personal to material objects. This idea might be the basis for artmaking projects—for instance, the creation of object sculptures (see page 99), or a monumental sculpture project (see page 55).

sculptural methods. He shies away from anything very technical, and feels that fabrication is too time-consuming and doesn't seem necessary, although he will occasionally fabricate a part for a sculpture if he can't find what he needs in a ready-made object. Lipski's method for covering surfaces he dislikes or for cleaning up forms is to wrap them. He sometimes reuses an object from an earlier sculpture. He observes: "I find an object I love, but what I did with it the first time wasn't the right thing to do with it . . ."[4]

Lipski's Brooklyn studio is filled with collected objects whose appearances he found intriguing. In a 1985 interview for *Art in America*, Lipski remarked: "If I'm walking down Canal Street or looking through a hardware store in Sweden, if there's something that appeals to me, if I think something is substantial enough as an object, has enough resonance, I just bring it home, not for the sake of collecting, but to expand my palette." About his love for an object's form and aesthetic qualities, he has said: "It's about what the object looks like way before what the object is."[5] Lipski is particularly attracted to aerospace hardware because of the precision that goes into its fabrication, and, on two separate occasions, Lipski was given access to the salvage yards of aerospace engineering firms.

From Lipski to the Artroom
Lipski has joined his love of objects with artmaking by utilizing manufactured objects as media so as to challenge the meaning of the objects. His artmaking is personally satisfying because he has discovered a way to employ a personal interest in a meaningful manner. Lipski's big idea of changed meanings allows the artist to manipulate manufactured objects into unusual object combinations. These often strange combinations raise possibilities for new meanings, different from those usually associated with the

objects. Although Lipski creates sculptures composed of objects that are not normally seen together, he must join the objects in a visually convincing manner or viewers may be disinclined to interpret the sculptures for new meanings.

Students might tap Lipski's methods and big ideas as resources for artmaking. By encouraging students to develop their personal interests—even in seemingly mundane subjects—we can provide them a stimulating source for artmaking. From our guidance and modeling, students can see ways to approach their interests with inventiveness, to engage in inquiry about them, and to link them to a big idea that provides a conceptual focus for exploring the subject matter. They can develop aesthetic sensitivities as well as conceptual understandings, and then work the aesthetic and the conceptual together to create successful artworks.

2.3 Cameron King, Mobile Phone (after Lipski), 1996. Found objects. Rosemont Elementary School, Virginia Beach. Sharon Clohessy, art teacher.

Frequently-Asked Questions

Why isn't the self-portrait a popular artmaking subject in today's artworld?

Although self-portraits have been a traditional subject among artists at least since the Renaissance, contemporary artists as a whole create very few self-portraits. Why do contemporary artists avoid this art genre?

What Do You Think?

Does personalizing student artmaking impose too many limits on classroom artmaking?

Educator Myra Zarnowski advises that many language arts teachers are beginning to question the practice of almost exclusive emphasis on having students write personal narratives. Zarnowski and others perceive a problem when too much weight is placed on asking students to write as "confessional poets," always describing difficult personal experiences and problems rather than writing from a range of perspectives.[6] The same problem exists with having students make artworks from a single personal perspective. Family background, personal interests, significant relationships, heroes, inner emotions, and beliefs are individual topics that link to the self, but other more social topics such as the environment, popular culture, nature, conflict, and significant social events can also be personalized. It is not the topic that matters as much as showing students how to find personal connections.

Inside the Classroom

An elementary art teacher personalized a study of community for her second and third graders. She led a lesson that focused on their school as an example of community. Students used disposable cameras to photograph various areas that identified the school as a community. Costumed in appropriate attire for photographing and role-playing, the children assumed different school roles. They made lists of the norms and rules that order the school community, considered community problems in the school, examined their own roles in the school community, and discussed how they might change their school community. These experiences became the basis for a large group artwork about their school as a community and several brief performance pieces. Focusing the students on a community that was close at hand and part of their own experience allowed the children to develop deep understandings about community.[7]

Teaching Tip

It is a good teaching strategy to link big ideas to students' personal experiences; however, this linkage does not change the key concepts that inform the big ideas. They are simply taught in a more personal context.

Drawing from Lipski's methods, students might develop their artmaking by looking outside the classroom for materials, ideas, and experiences to bring to their work. Use of some of Lipski's simpler techniques may also prove more fruitful than use of complicated methods: less-involved techniques can allow students to focus on meaning making, whereas skill-intensive techniques can detract from this objective.

**Sandy Skoglund: Exploring
Personal History**

Interest in human behavior has evolved into the primary subject matter of the artmaking of installation artist Sandy Skoglund. Her own suburban upbringing left distinct impressions about people and the ways they organize their lives. In a 1991 interview, Skoglund described her personal experiences of suburbia:

I'm very interested in the idea of the normal, and from that point of view suburbia was a very haunting experience. It's so empty of real content and engagement. People don't have real conversations with one another. It's always the same, a repetition of brand new homes, the smell of Formica, the same sterility.[8]

Skoglund's installation *The Green House* (fig. 2.5) questions suburban homogeneity, alienation, and boredom. In this work, a young couple sits self-absorbed in their suburban living room, unaware of the twenty-five blue and green dogs reclining on the perfectly manicured grassy interior. An undergraduate commented on the installation:

I see this as a play on nature. Man has gone too far, dabbled too much with science. The grass perfectly covers everything in the living room, no bare spots like natural grass as if it were done by ChemLawn®. It's as if man is trying to get close to nature again, but going about it all wrong. [The couple doesn't] want any of the imperfections of nature, so they make their own little perfect world.[9]

Art critic Meg Hamilton interpreted *The Green House* as containing "quiet, but unavoidable refer-ences to vacuity and decay in the grass-filled picture frames, the oversized roaches on the coffee table, and the animal skull beneath it."[10] Both Hamilton and the undergraduate perceived the darker side of suburban life that Skoglund suggests in her unusual installations.

Her interest in the American middle class has led Skoglund to create installations of suburban living rooms, patios, bathrooms, urban restaurants, cocktail

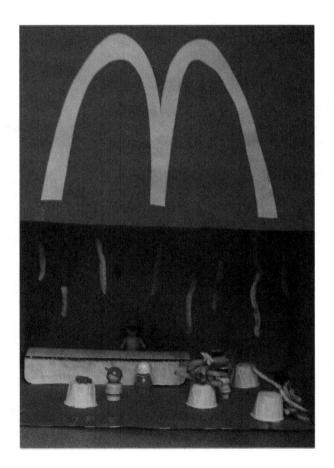

Frequently-Asked Questions

What do artists dream?

His first flag painting came to Jasper Johns in a dream.[11] Sculptor Beverly Pepper says her artworks influence her dreams. She may wake up in the morning exhausted, having worked all night in her dreams. Installation artist Jimmie Durham says most of his dreams are "embarrassingly stupid." He remarks that when he needs a screw or piece of wood for something he is working on, he may dream that it showed up in his studio and the next morning he believes it, but it's never there.

As a student, painter Juan Sanchez was very much influenced by Surrealism and worked with images from his dreams. However, he let go of this practice feeling that it was too esoteric and self-indulgent, "like an amateur Surrealist." Sanchez does have one image from a dream that he has used in several works—a figure whose face is covered by a Puerto Rican flag. He dreamed that someone was being suffocated, not with a pillow, but with a nationalist flag. Pop artist James Rosenquist dreams of amazing colors that don't exist in real life, which he then tries to recreate.[12]

2.4 "The super size fries represent the love of fast food and how society judges the quality of food by its quantity."
—Charles Webb, elementary education student at The Ohio State University.
Robin Booth, Joe Sebastian, Rachel Reeder, Peter Barnes, The Blindfolding of America, *(after Skoglund), 1998. 24" x 12" (61 x 30 cm). Cardboard box, french fries, tempera, paper, thread, plastic figures. The Ohio State University.*

parties, and weddings. To produce these, she consistently draws upon her own experience. Her attention to the details that typify each setting gives her works a convincing quality, one that strikes the needed contrast with the fantasy elements. In *The Green House*, the fantasy elements (twenty-five blue and green dogs lounging on furniture and carpeting that resemble the perfectly manicured lawns of suburbia) seem authentic because the setting is highly convincing as a typical suburban living room.

As a former resident of this milieu, Skoglund assumes a critical distance. Her purpose, her big idea—which she achieves through a carefully balanced combination of fantasy and reality—is not merely to illustrate her recollections of suburbia, but to question its values, norms, and practices.

From Skoglund to the Artroom

As another way to get students to use personal experiences for artmaking, we can provide prompts and strategies to help them reconstruct the past. Such methods might include questioning so as to identify significant elements, recall specific sensory details, articulate associated emotions, and consider such fac-

2.5 Sandy Skoglund, The Green House, *1990. Installation. Photo courtesy of the artist.*

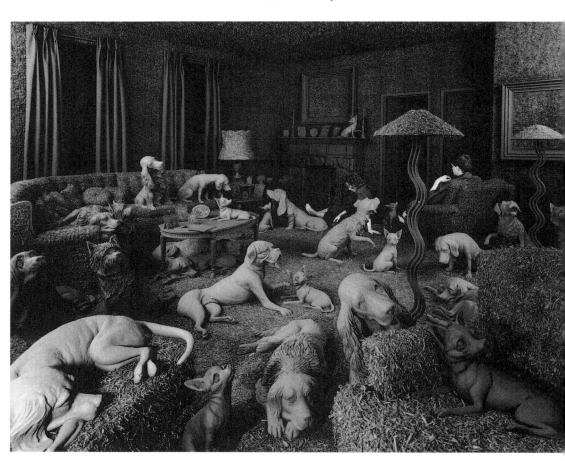

2.6 Untitled, (after Skoglund), 1995, Installation. Braided rug, plastic tableware, chairs, artificial plants, balloons, buckets, paper streamers. Sixth-grade students at Harrison Elementary, Sunbury, Ohio. Lori Groendyke, art teacher.

tors as what was visually important; what smells, textures, and sounds were present; and what emotions were experienced. Without our active intervention, students' remembrance of past events, even recent ones, may be vague; and their representations of the events will likely reflect a superficial treatment.

Skoglund's articulation of her memory of suburbia represents the type of rich description that students can engage in to develop the past as a fertile source for their artmaking. The students who produced *The Blindfolding of America* (fig. 2.4) first examined their own knowledge—their personal experiences with fast-food restaurants. Articulating this knowledge prior to artmaking enabled them to produce a convincing installation with attention to such details as physical arrangements, furnishings, signage, color, and human activities and behaviors.

 Frequently-Asked Questions

Why are students' artworks so frequently lacking in rich content?

Student artmaking can be superficial and shallow because the subject matter or big idea is too far removed from students' personal lives. This does not mean we should limit art instruction to a narrow range of topics, but instead find ways to link to students' lives. Sometimes this involves raising awareness of what students have experienced. It can also mean providing students with new experiences to utilize as a knowledge base for artistic expression.

Teaching Tip

Students often do not have the skills to access what they already know and have experienced. When instructing students to reach into past experiences for artmaking, it is important to provide them with strategies for accessing this knowledge. For example, students might be asked to identify which were the significant parts of a particular experience, or to recall specific sensory details, or to articulate particular emotions associated with the experience. Ask:

• What was visually important?

• What smells, textures, and sounds were present?

• What emotions did you experience?

2.7 Andy Goldsworthy, working. Courtesy of the artist.

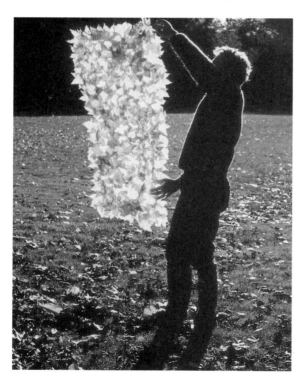

Andy Goldsworthy: Connecting with Nature

Environmental artist Andy Goldsworthy has linked his personal interest in nature with his artmaking. In the mid-1970s at Preston Polytechnic College (now the University of Central Lancashire), Goldsworthy chose to work outdoors in the wet and wintry cold along Morecambe Bay, rather than in the warmth of the studio. He explored and photographed the rock structures of the cliff along the bay, learned about the marine life, and discovered how to harness the weather, by using the sun and freezing temperatures, to melt and fuse ice. At this time, Goldsworthy began to develop methods of working, and also the big ideas that have informed his artmaking for more than two decades.

Initially, Goldsworthy experimented by treating the sand on the beach as a canvas, superimposing geometric patterns on the natural background; however, he soon viewed this as an imposition on nature. Thus, in these early art experiences, Goldsworthy realized that his intention was not to improve on nature, but to learn more about it. As he continued to develop a personal approach to artmaking, he recognized that, in addition to his appetite for understanding the materials of nature, he was also absorbed by nature's processes—growth, light, seasons, and weather. He has commented, "When I'm working with materials it's not just the leaf or the stone, it's the processes that are behind them that are important. That's what I'm trying to understand, not a single isolated object but nature as a whole."[13]

Goldsworthy now lives in Scotland, but he has received commissions to make art all across the globe. In the winter of 1987, he worked on the beach in Kiinagashima-cho, Japan. When he arrived at the location, his initial sense was that the area was a terrible site for working, and he wondered

what he could create in this desolate place. All he could see were small gray pebbles on the beach—nothing more. However, he believed that if he set himself to work, he would open his eyes to the potential in the place. He found some dead bamboo lengths and began to push them into the ground.

He noticed the mountains across the sea, moved the bamboo close to the water's edge, and created a screen to look through to view the mountain. The screen, the view, and the dark purple clouds and rain that suddenly appeared, all became a part of Woven Bamboo/Hole. Goldsworthy remarked that at the end of the day, he felt that he understood the essence of the place. He explained that some places are about what he can hold in his hand, but on the beach in Kiinagashima-cho, it was the expansiveness of nature that defined the place for him.

Also in 1987, Goldsworthy received a commission from The Collins Gallery, at Glasgow's University of Strathclyde, for the exhibition "Perspectives: Glasgow." Because he had never been to Glasgow, he approached the city as he would any new place: "a map in one hand, looking for places to work."

Goldsworthy had no specific intentions other than to develop his work from day to day in response to the place, season, weather, and materials. He described the weather during his visit as "the most intense autumn weather I have experienced and the most extraordinary range of colours in the leaves scattered everywhere—sycamore, elm, chestnut . . ."[14] Working in the Glasgow parks, Goldsworthy experimented with the leaves and a light that changed dramatically each day, altering from a dark, overcast sky to an intense autumn brightness. One of his most successful experiments was a hanging sheet of yellow sycamore leaves stitched together with stalks.

On another occasion, Goldsworthy began working under an overcast sky and in an open field of tall, light, dry grass stalks in Loughborough, Scotland. He wove some stalks together and twisted them at the tops so as to work the reflected light; but, as the wind grew stronger, Goldsworthy decided to abandon the project until another day.

He moved to a pond in the area. He struggled for about an hour, trying ways to work the surface of the pond. He floated horse-chestnut leaves over the pond, but, not wanting to hide the pond, he tore holes into the leaves so that the water showed through. Goldsworthy created a system for working, tearing a hole in every other leaf. He described the resulting arrangement of leaves as "leaf, water, leaf; dark, light, dark, light... arrows—work taking on form and direction, determined by the positive and negative lines of the leaves."[15] The resulting leaf work emerged from a dark corner of the pond and extended about 8' across the pond.

Goldsworthy assessed the day as a good one, and considered his mistakes as important as his successes. He felt that the failed grass experiments in the open field were necessary to bring him to an awareness of the dark, enclosed space of the pond. He described stretching the leaves out across the pond as his way of exploring the pond, the place, and the season.

From Goldsworthy to the Artroom
The primary objective of a site-specific artwork is the use of a particular site as an essential component of the piece. Goldsworthy, whose work is a strong example of this contemporary method of artmaking, not only uses the specific site, but also the materials found on-site. Although Goldsworthy works spontaneously, he does not work in an entirely impromptu fashion. His primary objectives—to learn from nature and to work collaboratively with it—guide and direct his actions.

When students work in response to a specific site, they too need objectives; otherwise, the experience is likely to be too open-ended, engendering confusion rather than productivity. We can challenge students to use Goldsworthy's objectives, having them address such questions as: How did you work with the site? What did you learn from the site? Such objectives give direction to the artmaking and also provide criteria for assessing student learning.

Goldsworthy's practices evidence two essential components of the artmaking experience: reflection and experimentation. Reflection provides the needed perspective for assessing the consequences of artistic decisions. Students, however, need planned reflection, perhaps by large- or small-group discussions, individual writing exercises, and checklists. Experimentation also must be overtly addressed: our job is to let students know that they should experiment and that they have our permission to fail and try again. Over time, such guidance will encourage students to become risk takers who push ideas. Goldsworthy's artmaking methods offer exemplary practices of inquiry, reflection, and experimentation; and emphasize the process over the product, accentuated by his ephemeral artworks.

Goldsworthy's methods, procedures, objectives, and type of artmaking are obtainable in the classroom. A condensed list of these illustrates the artist's tenets that we might include in the curriculum:

- Personal interests can be incorporated into artmaking in substantive, meaningful ways.
- The artmaking process is as important as the art product.
- The site for artmaking can become an essential component of the artwork.
- Experimentation and risk taking are essential to artmaking, but students must have permission to fail, as well as to succeed.

2.8 Andrea Evans creating outdoor sculpture (after Goldsworthy), 1997. Art-education graduate student at The Ohio State University.

- Even when artmaking is spontaneous, specific objectives are necessary. Too much freedom can be as inhibiting as too many restrictions.
- Planned reflection of their own artmaking is a significant component of students' artmaking process.

Fred Wilson: Questioning Museum Practices

Many contemporary artists center their artmaking around social concerns, most often informed by personal beliefs, values, and experiences. For example, contemporary artist Fred Wilson, who is of African and Native American descent, is best known for his mixed-media installations that disrupt and question racial exclusions from museum display.

Not only Wilson's heritage but also his employment in the education departments of the Metropolitan Museum of Art, the American Museum of Natural History, and the American Crafts Museum has prompted him to consider how the display of artworks and artifacts affects viewers' understanding of them. Wilson has taken up larger social concerns to extend his personal experiences beyond himself.

For *Mining the Museum*, Fred Wilson's 1993 installation at the Maryland Historical Society in Baltimore, the artist was given unlimited access to the museum's entire collection, including stored items that had never been exhibited. In a short video shown in the museum lobby, Wilson defined the museum as a place "where anything can happen," a space designed to "make you think, to make you question."[16]

Wilson's experiences in museum education departments had sensitized him to consider the museum's role in society, its practices, and its possibilities. Without these experiences, Wilson's artmaking likely would have moved in another direction.

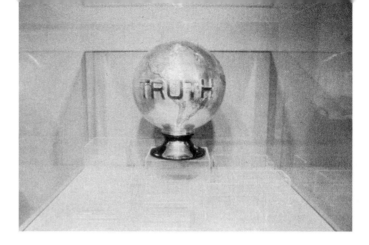

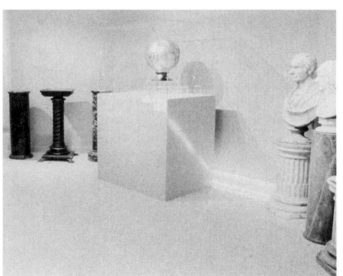

2.9 Fred Wilson, Truth Trophy and Pedestals, *from* Mining the Museum, *1992. Baltimore Museum of Art. Courtesy of the artist and Metro Pictures. Objects from the Maryland Historical Society: Globe, by Mr. Thoman, c. 1913, Baltimore. Silver plated copper. Designed and crafted by Mr. Thoman, produced by Stieff Company. Word "truth" attached in brass letters. Plaque on base reads: "Awarded to/The Advertising Men's League of New York/1913/The Minneapolis Advertising Forum/1914/The Advertising Club of Indianapolis/1915/The Advertising Club of Milwaukee/1916/The Kansas City Advertising Club/1917/The Advertising Club of Indianapolis/1918/The Cleveland Advertising Club/1919 and 1920." Pedestals, Harriet Tubman, Frederick Douglass, Benjamin Banneker, Henry Clay, Napoleon Bonaparte, Andrew Jackson (not shown).*

Inside the Classroom

A university professor photographed a campus park directly adjacent to the art building and gave each of her art-education undergraduates one of the photographs. She instructed the students to photocopy their park photographs as many times as desired, and to use the photocopies and other media for an artwork about how humans interact with nature.[17]

The extra step taken to provide students with photographs of a familiar public space made a great difference in the quality of the students' artmaking experiences. This teacher could have had her students use photocopies of images taken from magazines and other print media; however, familiarity with the park gave the students' artmaking greater authenticity. Further, a follow-up project in which students worked in small groups to propose an environmental artwork for the park yielded rich results.

Truth Trophy and *Pedestals*, one of the displays in the installation, presented visitors with a sizable silver-and-gold "truth trophy" that won the 1922 Truth in Advertising Award. Wilson flanked the left side of the trophy with three white pedestals bearing white marble busts of Napoleon Bonaparte, Henry Clay, and Andrew Jackson (all significant in Maryland history), and the right side with three black pedestals but no busts; the pedestals were labeled Harriet Tubman, Benjamin Banneker, and Frederick Douglass (all Marylanders).

Through suggestive display and juxtaposition, Wilson raised questions about the absence of these prominent figures. Wilson's display prods viewers to consider whose truth is on exhibit and to see history as a constructed "truth," narrated from particular perspectives. Wilson's other displays in the installation also utilized the subject matter of museum display and curatorial practice, and the big idea of constructed historical truth.

In *Metalwork 1793–1880* and *Cabinetmaking 1820–1860*, Wilson's sardonic juxtapositions demonstrated how museum classifications can separate history into categories that frequently deny and hide historical truth: in *Metalwork*, Wilson paired a silver repoussé tea set with iron slave shackles; in *Cabinetmaking*, he combined two finely wrought armchairs, two handsome side chairs, and a single rough-hewn whipping post and platform.

An eight-year-old visitor to the installation said of Wilson: "I like Fred Wilson, he asks more questions than he answers."[18] The goal of artwork about social commentary is inquiry, the prodding and provoking of viewers to ask questions about social issues. If such artworks fail to incite viewers to question, they become mere social propaganda.

From Wilson to the Artroom

Although students might readily find artmaking ideas in social concerns, they need a personal connection to the issues. For instance, if the artmaking subject is the environment, making artworks about acid rain in Australia may not be as relevant for students as producing artworks about rampant commercialization in their own neighborhood. Too often, students' artmaking is superficial because the subject matter or big idea is too removed from their life. Personal concerns should link to big ideas; but conversely, significant ideas and issues should connect to the personal. Meaningful artmaking requires both.

The notion of constructed truth is a sophisticated concept, but it is not beyond the grasp of older students. To study this idea, students might, like Wilson, visit a museum to analyze curatorial choices—the types of artworks, the display strategies, the information provided for viewers—so as to understand how a particular view is constructed by curatorial choices and to consider views that may be absent. As a follow-up, students could curate their own displays of art or nonart objects for a schoolwide exhibition.

As Wilson discovered, artmaking about social concerns may derive from personal experiences, sometimes those that offer alternative perspectives and do not conform to mainstream views. The linkage of the personal and the social is a strong combination for artmaking. However, artmaking about social concerns requires subtlety and the use of a strategy in which the artist raises questions about social issues, but does not tell viewers what to think.

Students too can expand the personal into the social. They must consider the questions stated at the beginning of the chapter (see page 20), and they must understand that ideas have social meanings as well: big ideas have private and public facets. Students usually relate easily to the personal, but

Teaching Tip

Personalizing artmaking for students often requires expansive thinking. Teachers often already have promising artmaking projects that lack a personal dimension. The strategy is not to change the conceptual focus or big idea, but to consider how it might be enlarged to include the students' world.

Inside the Artist's Head

Contemporary photographer Cindy Sherman has photographed herself numerous times, but each time she portrays someone other than herself. Where is the personal in Sherman's work?

Sherman's photographs of herself are not self-portraits. The artist photographs herself in costumes, make-up, poses taken from female roles in 1950s films, horror movies, fairy tales, old master Baroque paintings, and the fashion world. As she disguises herself in numerous roles and types, Sherman explores identity as a social phenomenon and construction. She questions how society constructs identity through images in film, advertising, fashion, and art; she prompts us to examine the overwhelming influence of images in our media-driven culture.

Theater and performance are the subtext of Sherman's questioning strategies. The artist makes no pretense about the fact that she is role-playing as an actress, but not for entertainment purposes. Through the fiction of multiple selves, Sherman poses serious questions about the fictions of our own lives and our constructed identities.

Artist Talk

Modernist painter Stuart Davis who worked during the same time period as the Abstract Expressionist was unequivocally against the expression of the personal through artmaking. He remarked, ". . .Painting is not an exhibition of Feelings. . . The artist's feelings are his own affair."[19]

The high school student who created an object sculpture of a large pair of scissors and a battery charger tied with a red ribbon expressed her personal feelings about being attached to her parents, and also those about wanting to cut loose from them. Without knowledge of the student's intent, a viewer might interpret the sculpture as the expression of a need to cut loose from an external source or support. This interpretation parallels the student's own interpretation, but reflects a wider human experience. Although the student began from a personal experience, our job is to help her to understand the broader implications of her work, as it relates to the human experiences of dependence and rebellion. If the student had not been personally invested in the idea for the artmaking, she likely would have produced a mimicked, unimaginative response, one that exhibited an overall lack of passion.

2.10 "I feel like I'm tied to my parents. They are the ones in charge and I don't have freedom. I would like to be cut away sometimes, but I am unable to." *Cari Paulenich, Untitled (after Lipski), 1997. Battery charger, ribbon, scissors, approx. 12" x 6" (30 x 15 cm). Ocean Lakes High School, Virginia Beach. Cynthia Monetta-Copperthite, art teacher.*

they do need overt instruction as to how to place personal experiences and interests within a social context. We might ask: What other perspectives inform your idea? How are they similar to or different from your own perspective? What larger social meanings are connected to your idea? Expanding students' private interpretations to more public meanings can help expand the audience for their artworks beyond themselves.

Students may begin artmaking from the personal or from a big idea. Either way, the combination of the personal and the larger idea is what gives artmaking—by the student or by the professional artist—its greatest depth. Big ideas without personal investment lack passion and depth of understanding. Personal experiences disconnected from larger ideas lack the dimension they have when perceived as common human experience.

Notes

1 Virginia Wiseman, teacher at Newton D. Baker Elementary School, Cleveland, Ohio.

2 Alexis Lykiard, trans. *Chants de Maldoror: English, Maldoror & The Complete Works of the Comte de Lautréamont* (Cambridge, MA: Exact Change, 1994).

3 Art students of Ms. Cindy Monetta-Copper at Ocean Lakes High School, Virginia Beach.

4 Donald Lipski, "Sculptor's Interview," *Art in America* (November 1985), p. 124.

5 Ibid.

6 Myra Zarnowski, "Constructing Historical Interpretations in Elementary School: A Look at Process and Product," *Advances in Research on Teaching*, Vol. 6 (1996) 183–205.

7 Art teacher Ms. Christine Linn at Newton D. Baker Elementary School, Cleveland, OH.

8 Nan Richardson, "Wild at Heart," *ArtNews* (April 1991), p. 118.

9 The undergraduate was a participant in a criticism course taught by Birgit Lennertz at The Ohio State University in 1995.

10 Meg Hamilton, "The Premier of the Green House: Sandy Skoglund," *The New Art Examiner* (Summer 1990).

11 Barbaralee Diamondstein, "Jasper Johns," *Inside the Art World: Conversations with Barbaralee Diamondstein* (New York: Rizzoli, 1994), 114–120.

12 M. Mifflin, "What Do Artists Dream?" *ArtNews* (October 1993), 144–149.

13 N. Sinden, "Art in Nature: Andy Goldsworthy," *Resurgence*, no. 129, (July-August, 1988), p. 28.

14 Terry Friedman and Andy Goldsworthy, eds. *Hand to Earth: Andy Goldsworthy Sculpture, 1976–1990* (New York: Abrams, 1990), p. 65.

15 Friedman & Goldsworthy, p. 162.

16 L. G. Corrin, ed., *Mining the Museum: An Installation by Fred Wilson* (New York: The New Press, 1994), p. 13.

17 Part of the studio methods course taught by the author at The Ohio State University.

18 Corrin, p. 18.

19 John Lane and Stuart Davis, *Art and Art Theory* (New York: The Brooklyn Museum, 1978), p. 68.

Chapter

3

Building a Knowledge Base
for Artmaking

"[The practice of installation artist Ann Hamilton is] informed by her undergraduate studies in geology and textiles, graduate work in sculpture, [and] readings that range broadly among literary, anthropological and sociological texts."[1]

—art critic Joan Simon

One reason that artists are able to explore big ideas over long periods is the time that they invest in building a solid knowledge base. Similarly, students need an adequate knowledge for artmaking if their exploration and expression of ideas is to be substantive and complex. Although an undeveloped knowledge base for artmaking often accounts for shallow results and loss of student interest in classroom art projects, we often overlook the importance of stimulating this component of the artmaking process; instead, we maintain a constant influx of new media, techniques, and gimmicks to sustain interest.

Frequently-Asked Questions

What types of knowledge do artists need for art-making?

Picasso was fifty-six years old in 1937 when the exiled Spanish government commissioned him to paint a mural for their pavilion at the Paris World's Fair. Picasso decided to convey the drama and complexity of his country ravished by fascist bombings. In researching the genesis of *Guernica*, psychologist Rudolf Arnheim lists the following as the make-up of Picasso's knowledge base for the execution of this work: knowledge of the destruction of Spain through photographs and eyewitness descriptions of warfare—destroyed cities, death, heroism; a Spaniard's knowledge of Spain in general—its history, landscape, portrayal in literature and painting; personal memories until the age of nineteen when Picasso left for Paris; and, a range of artistic styles used to portray public events.[2]

Teaching Tip

Becoming familiar with how artists build a knowledge base will assist you in helping your students with this important artmaking phase. See page 143, Frequently-Asked Questions, for artist examples.

Artists and Research

Many artists, such as Chuck Close, Brice Marden, and Ann Hamilton, usually conduct research for artmaking. Close, a photorealist painter, prefers to execute portraits of artists whom he has come to know both personally and through their artworks; this is his artmaking research that contributes to his knowledge base for his portraits.

Contemporary painter Brice Marden's knowledge of Chinese calligraphy and poetry, and Zen philosophy motivated a major change in his painting. Marden's earlier paintings were influenced by Western philosophy and artistic theories, but his new interest instituted a breakthrough direction in his work.

Installation artist Ann Hamilton conducts elaborate research before constructing her on-site installations, making a point to choose materials and conceptual ideas that have connections to the history of and associations to the installation site. To build this knowledge base, Hamilton makes an initial site visit to let the feel of the place seep into her; she then reads widely, based upon what she encountered. In an interview with art critic Barbaralee Diamondstein, Hamilton described the post-visit phase:
There is a period of time when I do a lot of reading… This means that I might be reading as many as ten books, dipping in and out of material… Then there is a long process of describing the physical aspects of the space to myself—thinking about the context. All this information sits, and then I wait, I wait for an image.[3]

Building a Knowledge Base in the Artroom

Compiling information about the physical and informational aspects of a site as practiced by Hamilton can be applied to art instruction. For instance, if students are instructed to create a proposal for a public space they should be provided with information about the site such as its location, purpose, and history along with significant physical attributes. All of these aspects have relevance in creating an artwork that relates to a specific site.

Students often fail to make the necessary connections between what they know and the artmaking task at hand because their knowledge is dormant, or inert.[4] By use of some simple classroom activities, we can stimulate students' prior knowledge and build their knowledge base for artmaking. Such activities include:

- Having small groups of students compile all that they know about a subject.
- Holding a class discussion by having each student, in turn, tell one thing he or she knows about a subject, continuing as long as someone can add something new.
- Having students fill out worksheets to answer such questions as: What are the most important visual clues for identifying this subject? What ten descriptive terms best describe this subject? What context do you usually associate with this subject? What is your personal experience with this subject?
- Encouraging students to create a detailed list of the physical traits of the subject.
- Asking students to write a paragraph that describes a personal experience with this subject matter.

 Artist History

Robert Motherwell

- His move to New York in the early 1940s opened the doors for Motherwell to begin a career as a painter. He came into contact with other artists, particularly the Surrealists.

- Motherwell found the Surrealists' free association process, doodling on paper as Motherwell practiced it, to be artistically liberating. For him, it was a way of finding himself.

- The series *Elegies to the Spanish Republic* represents only five percent of Motherwell's work, but it is considered central to the artist's body of work.

- Motherwell thinks his use of black, white, and ochre in the *Elegies* series can be traced to his growing up mainly in California where the landscape was not dissimilar to the central plateau of Spain. The crisp, intense, clarifying light is the reverse of northern atmospheric light.

- In the 1940s Motherwell made his first collages in Jackson Pollock's studio as the two young artists both tried the new artmaking technique together.

- Motherwell was born in 1915 in the state of Washington, and grew up in California.

- Motivated by parental expectations, Motherwell became a Harvard University philosophy major rather than an art student.

- In 1950, Motherwell invented the term "New York School" to describe the group of artists, particularly Abstract Expressionists, working in New York City at that time. The term stuck, becoming the official art-historical label for this artist group.[5]

Inside the Artist's Head

Text-based artist Jenny Holzer, known for her cryptic LED signs, derived her knowledge base for her first series of works, *Truisms*, by compiling the essence of Eastern and Western philosophic writings. She explains:

"The *Truisms* series was partially a response to a wonderful reading list in the Whitney program. It included numerous books, all of which were heavies, so just the prospect of wading through them was enough to make me do Jenny Holzer's *Reader's Digest* version of Western and Eastern thought. I loved all these great thoughts on Western culture, but I figured I was reasonably bright and reasonably well educated, and if I couldn't plow through it certainly a lot of other people couldn't either. I realized the stuff was important and profound, so I thought maybe I could translate these things into a language that was accessible. The result was the *Truisms*."[6]

A Storehouse of Memories

In Chapter 7, artists Oldenburg and Skoglund both refer to ideas that have been mentally stored for a number of years. Psychologist Rudolf Arnheim discusses Picasso's storehouse of memories used for creating *Guernica*. He refers to Picasso's personal memories of Spain—its history, landscape, and portrayal in literature and painting.

Artists and students possess a fund of personal memories which can be drawn upon for artmaking. Students often require overt prompts to tap into these resources. Further, this concept of a "memory bank" helps to explain why adult artmaking is often more complex than student work; adult artists have had a longer time to make deposits into their mental storehouse.

Robert Motherwell: An Extensive Knowledge Base

Robert Motherwell, who executed *Elegies to the Spanish Republic* (1948–78), a series of more than 100 paintings, brought personal and contextual knowledge to his work to express the idea of human tragedy. Although he worked with severely limited formal means—primarily black and white hues and variations of a single ovoid form—his contextual knowledge that informed *Elegies* was extensive. In the case of *Elegies*, minimal formal qualities do not indicate a lack of complex meaning.

Motherwell dedicated the series to the Spanish republic that lost the Spanish Civil War to Francisco Franco in 1939. On a personal level, the artist developed his interest in and passion for Spain from his frequent trips to Mexico and from a childhood spent in California's Napa Valley, a landscape not dissimilar to the central plateau of Spain.

Motherwell derived *Elegies* from his own work, a small canvas titled *At Five in the Afternoon*, which, in turn, refers to a refrain in Federico García Lorca's "Lament for Ignacio Sanchez Mejias," a narrative poem about the death of a well-known Spanish bullfighter. Both Lorca's poem and Motherwell's *Elegies* are informed by notions of death in Spanish culture. Motherwell commented:

All my life, I've been obsessed with death and was profoundly moved by the continual presence of sudden death in Mexico (I've never seen a people so heedless of life)! The presence everywhere of death iconography: coffins, black glass-enclosed horse-drawn hearses, sigao skulls, figures of death, corpses of priests in glass cases, lurid popular wood-cuts . . . and many other things, women in black, cyprus [sic] trees in their cemeteries, burning candles, black-edged death notices and death announcements...[7]

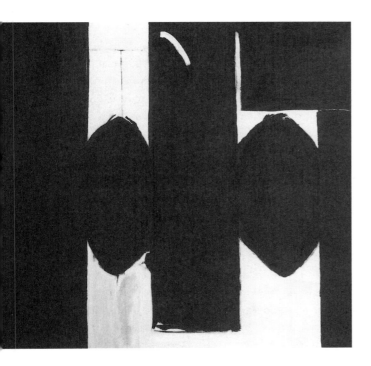

3.1 *Robert Motherwell,* Elegy to the Spanish Republic No. 55, *1955–60. Oil on canvas, 70" x 76 1/4" (178.1 x 193.7 cm). The Cleveland Museum of Art, 2001, Contemporary Collection of The Cleveland Museum of Art, 1963.583.© Daedalus Foundation, Inc./Licensed by VAGA, New York, NY.*

The overpowering black of Motherwell's *Elegies* speaks of Spanish death, but also echoes a more universal theme, that of human tragedy.

An Application of Motherwell's Knowledge Base
A graduate-level course used Motherwell's *Elegies* as the focus of an art unit that engaged students with artmaking based upon extensive personal and contextual knowledge.[8] The development of this knowledge base included 1) learning about Motherwell's personal experiences with Spanish history, literature, and culture that informed the creation of *Elegies*;

Critic Talk

"Motherwell's work is abstract in the sense of being nonrealistic but not in the sense of being nonobjective. Each painting is about some definite thing that could have been shown realistically... Each of the works is a response to some visual reality."[9]

—Arthur Danto, art critic

Fascinating Facts

Robert Motherwell originally planned to title his *Elegies* series with a refrain from a poem by Garcia Lorca, "At Five in the Afternoon." Motherwell changed his mind when he realized that this title might suggest that the paintings had something to do with cocktails.

Art Historian Talk

"In the *Elegies* it [white] is the empty arena where death [black] solemnly dances a slow ponderous dirge."[10]

—Robert Hobbs, art historian

Fascinating Facts

In the 1950s, Abstract Expressionists worked from a knowledge base that included movies, literature, philosophy, and modernist and traditional art.

Artist Talk

In a 1979 conversation with art students Motherwell remarked:

"The painting has as much to say as you have. . . Most bad painting—outside of boredom or indifference on the part of the maker—is when the maker is trying to impose too much of his will on the object in the same way as a very authoritarian personality imposes his will on another human being."[11]

Frequently-Asked Questions

What counts as a knowledge base for artmaking?

It is not possible to list all of the various ways artists build a knowledge base for artmaking, but the following is a starter list.

Knowledge Used in Artmaking

- Observations from everyday life
- Historical knowledge of past events
- Self-knowledge
- Art-historical knowledge
- Artistic knowledge about media, techniques
- General knowledge about a particular subject
- Knowledge from personal experience such as travel
- Knowledge of:

 contemporary artists' work

 music such as classical, folk, avant garde, jazz, rock, or heavy metal

 popular culture such as film, television, or sporting events

 contemporary events, issues

and discovering his artistic techniques for executing the paintings; and 2) conducting research for a painting series based upon a personal theme (which included writing a description of personal connections to the theme, identifying problems and issues inherent to the theme, listing expressive terms associated with the theme, presenting a theme-related poem to the class, researching an artist who explored this theme, and finding six media theme-related photographs).

To build this knowledge base, the instructor introduced *Elegies* with a slide presentation, and held a class reading of Lorca's "Lament for Ignacio Sanchez Mejias," after which students compared the poem's insistent refrain—"at five in the afternoon"—to Motherwell's rhythmic repetitions, and also noted a somber emotional tone present in both. Students read encyclopedia accounts of bullfighting and Spanish political history; discussed vignettes about matadors from Hemingway's *In Our Time*; and were read statements about *Elegies* written by the artist, art critics, and art historians. Additionally, students examined photographs of Spanish bullfighting and interpreted Picasso's *Guernica* and Käthe Kollwitz's drawings on the theme of death.

The art-education students spent several weeks with this contextual material, linking it to *Elegies* through writing and class discussions; and attempting to understand not only Motherwell's paintings, but also how an artist constructs a knowledge base for artmaking. One student who had attended a bullfight in Spain described the importance and status of the bullfighters as comparable to that of rock stars. The class read a graphic description from *In Our Time*:
Maera [the matador] lay still, his head on his arms, his face in the sand. He felt warm and sticky from the bleeding. Each time he felt the horn coming.

Sometimes the bull only bumped him with his head. Once the horn went all the way through him and he felt it go into the sand.[12]

From their immersion in contextual knowledge about Spain; bullfights; Motherwell; *Elegies*; and themes of death in art, poetry, and literature, the students substantially increased their appreciation for and understanding of Motherwell's series. Those who had had little enthusiasm for abstract painting gained a different perspective. Their understanding of the breadth of contextual knowledge that Motherwell brought to the creation of more than 100 paintings made them appreciate that such knowledge can inform artmaking and can increase its quality. This experience set the stage for the students' creation of their own painting series.

The students used what they had learned not to create works about bullfights or death in the Spanish culture, but to produce a series of paintings based upon their own themes and subject matter.

3.2 Emily Aldredge creating a painting series, 1997. Art-education graduate student at The Ohio State University.

Frequently-Asked Questions

Does the subject matter for artmaking need to be deep and serious or can everyday topics produce rich artmaking experiences?

Subject matter for artmaking does not need to be arcane or exotic; student interests can be tapped as an important resource for artmaking. The strategic factor is linking the interest to a big idea which can serve as a conceptual focus. For example, students may have an interest in sports. In this case, the big idea might be exploring the range of emotions that accompany being a sports participant. Competition as a characteristic of American society might be another way to engage this idea with artmaking.

Personal interests, even seemingly mundane subjects, can become a stimulating source for artmaking if they are approached with an attitude of inquiry. Donald Lipski, Sandy Skoglund, and Andy Goldsworthy have taken the most ordinary of subject matter, everyday objects and environments, and transformed them into subjects of sustained interest for themselves and viewers. The artist's personal vision and perspective make the difference.

Teaching Tip

Design art instruction with strategies that motivate students to think more deeply and inventively about a subject.

Inside the Classroom

Fifth-grade students in Ohio learned about the Civil War with a story quilt artmaking project. The students first studied the war in their regular classroom. They assumed different perspectives such as a soldier, farmer, plantation owner, slave, and Glory Roader, and wrote letters "from the front lines" based on these perspectives.

The art teacher then had students work in small groups to create a narrative based upon their imagined war experiences, and design a quilt that incorporated their stories. To expand their knowledge base for quilts, the art teacher introduced students to coded quilts of the Underground Railroad, and contemporary story quilts by Faith Ringgold.[13]

Motherwell's processes of knowledge building and his approaches to artmaking—not his themes or subject matter—became pivotal to their artmaking.

Like Motherwell, the students built an extensive knowledge base around a theme that each selected —from conflict, relationships, innocence, war, insiders and outsiders, and communities. Using this knowledge, they produced a series of ten abstract paintings with only a single form and two hues, noting that Motherwell had been able to sustain his interest throughout his series, with variations of only a single form and a palette of primarily black and white.

3.3 Anonymous, Violence, *1994. Acrylic, tempera on paper. Art-education graduate course at The Ohio State University.*

Knowledge of Motherwell's methods also motivated the students to give considerable thought when making formal choices for their own series, as they recognized that connotative meanings are embedded in formal choices.

The students approached their series with the kind of directness that Motherwell had applied to *Elegies:* painting directly on the canvas, without sketches or preconceived plans, responding to the work as it progressed. They worked in a manner similar to that of Motherwell, who, as an Abstract Expressionist, was sensitive to the canvas as an arena of action where even slight differences such as drips, splatters, blobs, rectilinear forms, smears, and irregular, idiosyncratic edges assumed significance. Working on a series allowed the students to compare paintings, to leave them, and then to return to them for further work, thereby making the experience quite different from executing a single painting.

Use of a Knowledge Base in Artmaking Instruction
The significance of the students' producing a series with repetition of the same formal elements, rather than a single artwork, pushed them to probe more deeply with each additional painting. Students were confronted with such questions as: What more can I say? Am I saying it better, more complexly, or just differently? What common threads am I finding? Are my ideas changing?

A well-developed knowledge base is necessary for all student artmaking. However, art instruction too often provides students with only a technical knowledge base. Research into subject matter, context, ideas, and artists' works is essential. Professional artists work from research and well-articulated knowledge; classroom artmaking requires no less.

The points that we can cull from the students' experience in painting a series dependent on a

Inside the Classroom

To build students' knowledge base for creating a self-portrait, they might complete a workbook entitled *You*. Tasks to include in the booklet are:

- Draw the significant objects in your life. Tell why they are significant.

- What opposites describe you?

- Name an object that you are most like. Why?

- Name an animal you are most like. Why?

- Name a piece of furniture you are most like. Why?

- Draw a symbol for yourself.

- How many different people are you? Draw a web for all the roles you play.

- Who would you like to be? Why?

- Who would you not like to be? Why?

- Draw your earliest memory (strangest memory, funniest memory).

- What have you bought in the last three days? What do your purchases tell about you?

- I was_____, I am_____, I will be_____.

Inside the Artist's Head

How does Skoglund determine what fantasy elements to include in her installations?

Frequently, it has to do with the cultural connotations of an object or animal. She brings a cultural knowledge base to her decision making. With her installation *Walking on Eggshells* (1998), Skoglund consciously juxtaposed snakes and rabbits to investigate the different cultural readings which have evolved for each of these creatures. Rabbits generally are portrayed as cute and winsome while snakes are depicted as evil and sinister. For this installation, set in a bathroom, Skoglund created a series of forty-five cast-paper, relief-printed tiles with images of rabbits and snakes drawn from the history of art and popular culture. In researching the various snake and rabbit icons through time, Skoglund made selections from Minoan, Egyptian, Mesoamerican, western European, African, Asian, Near Eastern, American, and Native American sources.[14]

knowledge base, and that we can incorporate into the curriculum are:

- The development of a knowledge base for artmaking that includes research about ideas, subject matter, artmaking techniques, and related artists' works results in richer artmaking experiences for students than those resulting from instruction that eliminates these steps.
- Studying an artist's processes is a significant aspect of learning about his or her work. Knowing how an artist works (which can include the artist's research for building a knowledge base, as well as the actual artmaking processes) is as important as knowing about his or her artworks.
- Creating a series of works can motivate deeper engagement and thinking than the execution of a single work.

Although a well-developed knowledge base is an essential component of the artmaking process, we would be unreasonable to expect students to develop knowledge to the extent that professional artists do, or, for instance, to expect a third-grade student to acquire the same level of knowledge as a middle school student could. Classroom artmaking at every level needs attention to what students already know and to what they need to know.

Art instruction consistently overlooks the building of students' knowledge beyond the technical aspects of media and style. We assume too often that if students are somewhat familiar with a subject for artmaking, there is no need to call attention to what they already know about the subject or to add to their knowledge. Knowledge figures prominently in the depth and quality of exploration and expression in artmaking: the results of student artmaking

around a big idea informed only by surface knowledge are likely to be disappointing.

Although we, as art teachers, may yield to student pressure to move quickly to the artmaking process itself, students will soon lose interest because they have brought little in the way of knowledge to inform their artmaking. Under these conditions, artmaking instruction becomes a constant search for new media, techniques, and gimmicks to sustain student interest. As demonstrated in this chapter, artists can sustain their interest in a single big idea because they probe the idea at deeper levels, asking new questions and acquiring more knowledge.

Notes

1 J. Simon, "Temporal crossroads: An Interview with Ann Hamilton," *Kunst & Museumjournaal* 6, 1995, 51–60.

2 R. Arnheim, *The Genesis of a Painting: Picasso's Guernica* (Berkeley: University of California Press, 1962).

3 Barbaralee Diamondstein, *Inside the Art World: Conversations with Barbaralee Diamondstein* (New York: Rizzoli, 1994), p. 105.

4 J. Bransford, R. Sherwood, N. Vye, & J. Rieser, "Teaching Thinking and Problem Solving: Research Foundations," *American Psychologist*, 41, (10), 1986, 1078–1089.

5 Stephanie Terenzio, *Robert Motherwell and Black* (Storrs, CT: William Benton Museum of Art, University of Connecticut, 1980).

6 Diamondstein, p. 107–113.

7 Bryan Robertson, *Addenda to personal interview with the artist, 1965* (transcript in Motherwell Papers, Greenwich, CT).

8 Graduate course taught by the author at The Ohio State University.

9 Arthur Danto, *The State of the Art* (New York: Prentice Hall, 1987).

10 Terenzio, p. 144.

11 Ibid., 140.

12 Ernest Hemingway, Chapter XIV, *In Our Time*.

13 Windermere Elementary School, Columbus, OH. Fifth-grade teachers Pam Bachman, Christina Balderaz, Mindy Fullenkamp, Judy Miller; visual arts teacher Susan Myers; other instructors involved were Jodi Palmer, Jean Warnick, Karia Edwards, Deb Foley, and Mary Beth Dixon.

14 R. Rosenblum, S. Skoglund, L. Muehig, A. H. Sievers, *Sandy Skoglund: Reality Under Siege, a Retrospective* (New York: Harry N. Abrams, 1998), 56–79.

4

Problem Solving

"The real question is not HOW TO PAINT but WHAT TO PAINT."[1]

—modernist painter Stuart Davis, 1923

Artmaking involves problems—technical, aesthetic, stylistic, conceptual, and expressive. How to paint is a technical problem, but what to paint is a conceptual problem when it extends beyond subject matter. For example, in his painting *Woman with a Green Stripe* (1905), Matisse chose to render the subject with broad brushstrokes, highly simplified forms, and unnatural coloring—a wide green stripe traverses the woman's face from her forehead to the tip of her nose. Depicting the woman with a green stripe is a conceptual problem relating to Matisse's intention. This action—rendering the subject with unnatural coloring—conceptually moves the painting into the realm of expressionism rather than mimeticism. Matisse dealt with both technical and conceptual problems: How is the paint to be applied? How are the woman's form and her feathered hat to be portrayed?

Frequently-Asked Questions

What if the technical problems in an artmaking project are extremely difficult? What effect will this have on other aspects of the project?

If technical challenges are extremely difficult, it will be hard to focus on other concerns. The technical aspects of the project will be all-consuming. Prioritizing the conceptual aspects of problem solving can only be accomplished if the artist or art teacher creates the necessary conditions.

What Do You Think?

In 1913, Marcel Duchamp created art in a new way. He mounted a bicycle wheel onto a wooden stool. At the time, Duchamp didn't recognize this as a revolutionary artistic act, but he later purchased a metal snow shovel and signed it "Marcel Duchamp, 1915" giving it the title *In Advance of a Broken Arm*.

Duchamp's chosen objects, later called "readymades," sent shock waves through the artworld. His actions were seen as an assault on the unquestioned assumption that artists make artworks. Traditionally, at least part of an artwork's value derived from the artist's skill in making the work. Duchamp changed the rules by insisting that any object, if it was chosen and signed by an artist, could become an artwork.

In the 1950s Robert Rauschenberg conceived of "combines," paintings that incorporate readymade objects. Numerous installation artists since the 1970s have included readymade objects in their works. Usually these artists, unlike Duchamp, work with the objects rather than simply selecting and signing them.

What student artmaking problem can you design, based upon the readymade?

These represent conceptual problems because they contribute to how the image is read and what it communicates. For instance, the loose handling of paint and the rendering of subject matter in very general, non-detailed forms signal an intent to communicate expressive feelings and emotions rather than an articulated description of the subject. However, they are also technical problems in that the artist must use technical knowledge in applying paint and rendering forms.

Although big ideas provide the conceptual structure for artmaking, it is not enough for artists to focus on big ideas: artists also require strategies for exploring the content of the big ideas. One such strategy is to create, or construct—and then solve—conceptual problems that address the big idea.

Transformation, disruption, and concealment are examples of artist-generated problems. The purpose in examining a problem is to recognize the link between it and the big idea. If problem solving were merely an end in itself, artworks could easily become forms of novelty or gimmickry. For instance, sculptor Claes Oldenburg uses transformation as a problem-solving strategy so as to change everyday objects into monumental sculptures. Without pursuing the meanings of objects and sculpture, Oldenburg's transformations might be seen as huge jokes, with no deeper meanings.

Artmaking Problems

In the classroom, artmaking problems are often disconnected from meaning making. By explicitly addressing an artist's conceptual problem-solving strategies as meaning-making tools, we can create another powerful instructional tool for students— one that directs them toward insightful and inventive use of a well-developed knowledge base.

Presented Problems and Constructed Problems

Problems such as technical challenges or artistic decisions about media, style, and formal qualities more or less present themselves to artists. However, other types of problems must be constructed—artists must generate these problems for themselves[2] so as to pursue ideas more deeply and to discover new perspectives.

For instance, Andy Goldsworthy creates artworks almost exclusively in natural environments: he has created an artmaking problem for investigating the interaction between humans and nature (see Chapters 1 and 2 for further discussions of Goldsworthy). This problem did not present itself to Goldsworthy; he had to construct it. Some of Goldsworthy's technical problems evolved from his conceptual problem. His decision to use only natural materials and his technique of licking the backs of leaves to attach them, rather than using manufactured glues, relates to his conceptual—constructed—problem of working as closely as possible with nature.

Artmaking Problems as Tools for Probing Big Ideas

Artmaking problems can create perspectives that push ideas beyond their more obvious aspects. For instance, in striving to create artworks as a collaborative venture with nature, Goldsworthy deepened his insights into human interaction with nature.

Sculptor Donald Lipski constructed an artmaking problem that engages him in producing sculptures of bizarre combinations of manufactured objects (see Chapter 2). Lipski's interest in creating these combinations of objects extends beyond the unusual. In pursuing his artmaking problem, he has investigated the nature of meaning—how it may be influenced and how it may be changed.

Artmaking Problems in the Artroom

Artmaking involves both presented and constructed problems, and art teachers must plan instruction for both. The design of artmaking problems begins with big ideas. Once big ideas are established, the artmaking problem becomes a strategy for examining and exploring the big idea. Possible artmaking problems are:

- transformation—Visual strategies that alter an object, person, or situation from its usual or normal representation. Examples: Surrealist artworks such as Magritte paintings; or, Skoglund installations that alter physical characteristics such as color, scale, or texture.
- concealment—Visual and conceptual strategies that partially hide or conceal information. Examples: Lucas Samaras's closed boxes that conceal information from viewers; or, Howardena Pindell's paintings containing fragmented photographs presenting viewers with only partial information.
- disruption—Conceptual strategies that alter a viewer's usual manner of perceiving and understanding specific subject matter. Such strategies might include unexpected juxtapositions of objects, persons, and situations, or new twists on social conventions and commonly accepted ideas. Examples: Cindy Sherman's photographs that present the artist as literally hundreds of different personages disrupt our understanding of an individual as a single entity; or, Barbara Bloom's "Collections" series disrupts our understandings of the items usually collected.
- illogical combination—A conceptual strategy that is a subcategory of disruption. Objects, persons, and situations are juxtaposed in unusual combinations. Example: Donald Lipski's object sculptures composed of manufactured objects not

Teaching Tip

Artist-defined artmaking problems are often a good place to begin when designing student artmaking problems. When adapting to the classroom, however, it is important to ensure that the artmaking problem retains its purpose. For instance, if the media or subject matter is changed, how does that affect the problem? See page 145, Frequently-Asked Questions, for examples.

What Do You Think?

Western artists have traditionally made artworks within the confines of the studio. Contemporary artists have challenged this tradition and created artworks outside of the studio. The Impressionists moved their canvases out-of-doors, but more recent artists have created artworks in collaboration with outdoor spaces.

Christo is an example of an artist who has engaged this problem. He has physically wrapped entire buildings, an Australian coastline, and a Parisian walkway; surrounded small islands in Miami's Biscayne Bay with rings of bright pink fabric; and stretched an orange nylon curtain across a canyon in Rifle, Colorado. By physically moving the artwork into the world, incorporating real objects as part of the artwork, and endowing it with impermanence, he changes our understandings about the nature of art, the objects involved, and the environment.

What student artmaking problem can you design, based upon creating an artwork in a specific public space?

normally found together, such as women's high-heeled shoes stuffed with bundles of long-stem matches.

- opposition—A conceptual strategy that utilizes polarities. Examples: Jennifer Bartlett's *In the Garden* which depicts the same garden as highly representational and nonrepresentational in the same series; or, Magritte's paintings that portray night and day in the same scene.

These artmaking problems are generic enough to use with most big ideas. Opposition, for instance, could be used with big ideas such as identity, humans and nature, and conflict. However, in and of themselves, artmaking problems do not necessarily motivate students to explore meaning. Unless we link such problems to big ideas, they function more as novelties. For example, if we do not link transformation in an artmaking project to larger ideas about the meanings of fantasy and reality, students are likely to gain little meaning from the project beyond their ability to create strangeness.

Who Should Construct Students' Artmaking Problems?

A study of fourteen practicing artists found that problem construction, which occurs throughout the artmaking process, is nonlinear and varies in the nature of problem development and solution during the process.[3] However, artistic maturity is necessary for constructing artmaking problems, so most students require direction for doing so.

Creativity studies have found that individuals with more sophisticated problem-construction abilities produce more creative solutions.[4] Thus, our job is not only to present students with an artmaking problem, but also to encourage them to reshape, redefine,

restate, and reconsider artmaking problems from a personal perspective throughout the artmaking process.

Divergent Thinking

Creativity research also contends that problems with diverse and inconsistent elements produce a wider range of responses than those with more consistent elements. Artists often construct artmaking problems with contradictory or diverse elements because doing so permits them to think differently about, and to think beyond, big ideas.

Goldsworthy, for instance, approaches artmaking as a collaborative venture with nature. He welcomes the resistance from this opposition because it enables him to create meaning by continually negotiating a satisfactory resolution between himself and nature. Multimedia artist Lucas Samaras makes artworks that both reveal and conceal his identity, an opposition that serves as a useful structure for creating meaning. Although the usual artmaking problem for self-portraiture is expression of one's identity, Samaras gives this problem a twist, and works not only to disclose his identity but also to withdraw or hide it simultaneously.

If, as creativity research demonstrates, thinking innovatively is easier in the presence of resistance and divergence, we, as art teachers, need to construct student artmaking problems that contain disparate elements.

Artmaking Problems from Professional Artists

In-depth study of conceptual artmaking problems can be derived from several contemporary artists' work and from subsequent artroom work that employs similar problems.

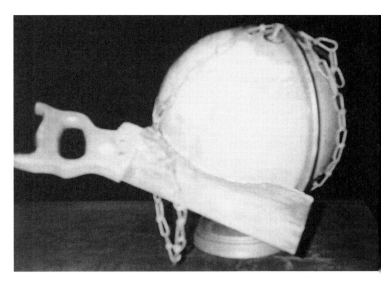

4.1 "The saw represents the destruction of the earth by disease, war, man's technology or any other ill while the chain is the force that is still holding the world together."
John Lukeman, Habitat by Humanity *(after Lipski), 1996. Saw, globe, chain. Canal Winchester High School, Canal Winchester, OH. Sandra Packer, art teacher.*

Transformation

Physical transformation often produces bizarre and sometimes shocking images; however, an artist's purpose in using it most often extends to more substantive issues. Transformation alters reality, endowing it with new perspectives that can motivate artists and viewers to question what is normally taken for granted. Too often in classroom artmaking, physical transformation lacks this edge, and student efforts produce creations of strangeness as ends in themselves. If we use physical transformation as the focus of student artmaking, we must accompany it with an artmaking problem that evokes such questions about reality as: What is normal? What is abnormal? Why?

What's Wrong with This Picture?

After studying the paintings of Surrealist René Magritte, fourth-grade students were instructed to create a drawing of an impossible world using cartoonlike figures.

What is wrong with this artmaking problem?

An important aspect of Magritte's work is that he presents an "impossible world" in a highly naturalistic style. Rendering objects in highly convincing terms serves to create the surprise in his works when things are discovered to be not quite right. Changing this aspect of Magritte's artmaking problem, creating forms in a cartoon style, alters the problem significantly.

Where is the line between fantasy and reality? Who decides? In addition, we must clarify to students that the problem is as much about reality as it is about fantasy.

Examples of physical transformation are found in the work of sixteenth-century Italian painter Giuseppe Arcimboldo, who transformed human portraits into bizarre arrangements of fruit, vegetables, and other objects; and also in works of 1920s Surrealist artists who transformed the everyday with altered sizes, textures, forms, and hues. René Magritte, for example, depicted soft human flesh, businessmen's heads, and human torsos by converting them, respectively, into granite, apples, and giant birdcages. Contemporary installation artist Sandy Skoglund transforms reality by using raisins, cheese twists, raw hamburger, and bacon slabs to create human forms and physical spaces.

Claes Oldenburg: Transformation at Work

For more than thirty years, the work of Claes Oldenburg (and, beginning in 1976, his collaborations with his wife, Coosje van Bruggen) has elicited questions about both sculpture and everyday objects. His sculptures are colossal enlargements of everyday objects: transformations of the usual subject matter of monumental sculptures. His works include a 42' clothespin; a 48' rubber stamp, a 68' match cover, a 41' trowel, and a 38' flashlight.

Batcolumn, a 100' sculpture of a baseball bat made by Claes Oldenburg and Coosje van Bruggen, stands in front of the Social Security Administration Building in Chicago. The work prompts such questions as: Why is a baseball bat considered a proper subject for a monument? Is the sculpture a baseball bat, an art object, or both? Has the meaning of the baseball bat been altered? Further, in the context of the government building, *Batcolumn* raises questions

4.2 Claes Oldenburg, Clothespin, 1976. Cor-Ten and stainless steel,
45' x 12' 3 1/4" x 4' 6" (13.72 x 3.74 x 1.37 m). Centre Square
Plaza, Fifteenth and Market Streets, Philadelphia. Photograph by
Attilio Maranzano.

that extend beyond the bat as a sports object, such
as: Are baseball bats about power?

The following classroom example demonstrates
how two art-education students utilized Oldenburg's
artmaking problem, transforming everyday objects
into monuments, for a classroom artmaking project.

From Oldenburg to a University Classroom
Following a study of Oldenburg's monumental sculp-
tures (a baked potato, clothespin, drum set, tennis

Frequently-Asked Questions

*Often, students are given the artmaking assignment
to create an artwork in a particular style. Are tech-
nical and stylistic problems sufficient for student
artmaking?*

High school students may be instructed to create a
self-portrait using a Cubist style. In order for the
artmaking problem to be meaningful, these ques-
tions must be addressed: What is the conceptual
idea that informs the use of this style? Would the
students understand why they are using this style
other than as part of a classroom assignment?
Would they think about or discuss how fragmenting
the subject matter and presenting it from multiple
perspectives changes or informs the meaning of the
self-portrait?

During the early 1900s Picasso and Braque invented
Cubism. They began to fragment forms and present
them from multiple perspectives. Was this only a
formal invention? Why did these artists eventually
begin to collage real fragments of the real world
into their Cubist works? Was it because they felt
that their artworks were losing their connections
with the real world? The issues of reality: how we
perceive reality, how artworks represent reality, and
why artworks represent reality, are at the core of
Cubism. But frequently, these issues are not part of
student learning. Too often, in the classroom,
Cubism is treated solely as a formalist artmaking
problem disconnected from meaning.

Teaching Tip

Artmaking problems that focus on artistic style should include its meaning-making effects as well as its aesthetic properties. Style is often treated only in a formalist manner that is associated with producing particular visual effects. However, every artistic style has broader implications that extend beyond its aesthetic effects. As art historian Mieke Bal comments, style is not only an aesthetic concept, but a way of thinking about culture and the intellectual life of a society. A geometric style, a Baroque style, an expressionist style—all work in ways that create meaning.

What Do You Think?

Can conventional artmaking problems be utilized for student artmaking without being tiresome and worn?

How might still life be reinvented to challenge and excite students? What if the still-life problem was linked to exploring a social issue? Would this energize the problem? How would you structure it? Would students set up individual arrangements? Group arrangements? What if the problem of still life was linked to creating a self-portrait? Would this involve students? What if the problem was linked to expressing particular emotions? The paintings of Janet Fish could serve as examples of thinking about this traditional subject in a contemporary way.

How might the traditional subject of landscape be reinvented to challenge and involve students? Would creating a landscape from only words revitalize this traditional artistic problem? Would creating a landscape as a metaphor for a particular time period energize this problem for students?

What other traditional artmaking problems can you rethink?

sneaker, and hand saw), two undergraduate students, peer-teaching an artmaking lesson about the role that context can play in producing meaning, led their fellow students to the campus oval. The class transported a giant bagel sculpture, constructed from a discarded bean bag chair, across the campus; placed the bagel sculpture in three different sites (the students later characterized the activity as a "bagel drag"); and considered how the different contexts altered its meaning.

4.3 Lee Scott, Kristy Moore, Untitled *(bagel sculpture), 1997; Main Library. Synthetic fabric. Art-education undergraduate students at The Ohio State University.*

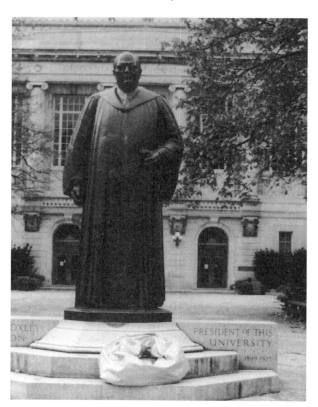

4.4 *Lee Scott, Kristy Moore,* Untitled *(bagel sculpture), 1997; The Wexner Center for the Arts, The Ohio State University.*

The students placed the sculpture at the base of a monument honoring a former president of the university, at the entrance to a contemporary-arts center, and on a table in a local bagel shop. The class agreed that the art center was the least provocative context, whereas, surprisingly, the bagel shop provided the greatest tension. The slick, commercial posters of bagels hanging on the walls of the store were a sharp contrast to the large, lumpy bagel sculpture resting on the table.

Incorporating an experiential component into instruction—transporting and placing the giant bagel sculpture in various contexts—significantly increased the students' understanding of the influence that context can exert on the meaning of an artwork; actually viewing the bagel sculpture in three different locations provided a more powerful impact than

a classroom discussion of the possibilities. Of course, creating experiences of this nature is not always practical, but is certainly worth the effort when possible.

After the bagel drag, the artmaking problem for each student was to create a proposal for a monumental sculpture for Columbus, Ohio. The sculpture was to be based on an everyday object with connections to the city, and the students were to consider the social meaning of their chosen object, as well as the visual appearance.

4.5 *Lee Scott, Kristy Moore,* Untitled *(bagel sculpture), 1997; Ed Rendle with sculpture in Bruegger's Bagels, Columbus, Ohio.*

What Do You Think?

Example of artworks based upon clothing include Beverly Semmes' *Four Purple Velvet Bathrobes*, 1991; *Red Dress*, 1992; and *Pink Feather Coat*, 1998/90; Edgar Degas' bronze ballerina dressed in a tulle tutu and silk hair ribbon; Ann Hamilton's performance piece in which the artist wore a toothpick coat; and Duane Hanson's super-realistic sculptures attired in used clothing.

Can you design a meaningful artmaking problem around articles of clothing as the artmaking medium?

Teaching Tip

In each of the artist examples, the use of real clothing is an essential part of the meaning of the work. The design of a student artmaking problem with clothing as the medium should be built upon this same premise.

Engaging the students in creating proposals for the city of their university home placed Oldenburg's artmaking problem within a personal context. However, an in-depth discussion of the city and its meaning for the students was missing from the lesson. This was a lost opportunity for deepening the students' personal investment in the artmaking problem.

The students began working on the artmaking problem by selecting from color photographs, provided by the instructors, of prominent downtown sites—parks, bridges, riverbanks, and the city skyline. Next, they selected everyday objects for their colossal sculptures and rendered the proposed monuments onto acetate sheets layered over the color photographs. To conclude, the students wrote mock letters to the Columbus City Council, requesting the commissioning of their proposal. Among the pro-

4.6 Andrea Evans, Milk Carton Floating on Scioto River *(after Oldenburg), proposal for monumental sculpture at River Front Park, downtown Columbus, Ohio. Art-education graduate student at The Ohio State University.*

Chapter 4

posed colossal sculptures were a milk carton, handgun, lipstick, sailboat, and pizza slice.

As the class interpreted the meanings of the proposed monuments, they determined that the milk carton was the most successful. Their reasoning was that the mundane subject matter reflected wholesome midwestern values and also infused the urban skyline with irony and humor: the milk carton contradicted the seriousness and power of the surrounding corporate structures while simultaneously mirroring their structural qualities (an architectural resonance of Oldenburg's view of *Batcolumn*).

Writing a proposal to the city council was an essential component of the art lesson. This task is often required of artists who seek commissions, and the activity directed the students toward deeper thinking about why their chosen object was an appropriate choice for a particular site. (See Chapter 7 for information about Oldenburg's practice of keeping extensive notes explicating his choices for monuments.)

Questioning the Problem: A Monumental Sculpture
The following questions may be used to assess the quality of an artmaking problem. The answers, which address the monumental sculpture, indicate that an effective artmaking problem does not have to be complex or complicated to raise substantive issues.

- Does the artmaking problem originate in big ideas?

 The artmaking problem is based on big ideas about sculpture, everyday objects, and context.
- Does the artmaking problem include divergent elements that provoke meaning beyond its apparent and obvious aspects?

 The artmaking problem includes a divergent element in its use of transformation. This element

necessitates thinking about both sculpture and objects in new ways.
- Does the artmaking problem extend beyond cleverness and novelty?

 The requirement to create a proposal for a specific site aids in preventing the artmaking problem from becoming trivialized. The meaning of the sculpture—not the novelty of enlarging an everyday object to colossal proportions—is the important issue.
- Is the artmaking problem directed toward meaning?

 The selection of a particular object for a specific urban location and the written argument justifying and persuading this choice focus the artmaking problem on meaning.
- Is the artmaking problem flexible enough to incorporate individual responses and shaping of the problem?

 The range of responses in the present lesson—milk carton, handgun, lipstick, sailboat, pizza slice—evidence the expansiveness of the problem. Students interpreted the problem with individuality while remaining within the confines of the original problem.

Concealment
Why would an artist make artworks that deliberately conceal information? Artists such as Lucas Samaras and Jasper Johns engage this artmaking problem in very different ways.

Lucas Samaras: Concealment of Identity
For three decades, Samaras's personal identity has been the sole subject matter of his prolific artmaking endeavors. In a quest to explore his own psyche through artmaking, Samaras has tantalized viewers with partial revelations. In 1964, Samaras literally

Teaching Tip

A good teaching strategy is to present students with several artists who engage a similar big idea but employ different artmaking problems for exploring the idea. See page 146, Inside the Classroom, for a starter list.

Inside the Classroom

Many contemporary artists use food as an art medium, not simply to produce bizarre artworks, but to explore the cultural meanings of food. *Scenario:* You are planning an artmaking project to engage high school students with examining the cultural meanings of food. You have four suggestions for an artmaking project. Which will you choose? Why?

1. Make a landscape from bread.

2. Make a life-size article of clothing from several kinds of junk food or from food packaging.

3. Plan, cook, and serve a meal.

4. Create an installation with food.

Consider these questions when deciding upon the artmaking problem which seems best:

1. Which of these artmaking problems seems like it misses the point?

2. Which problem seems most likely to engage the students in an exploration of the cultural meanings of food?

revealed his private life to the public in a tableau installation comprised of the contents of his own bedroom. But, as art critic Thomas McEvilley observed: "Here is the artist's room; where is the artist?"[5]

Evidenced by Samaras's bedroom installation, concealment can be accomplished through excess, as well as by deficit. Samaras's tableau of the contents from his bedroom presents excessive information that appears to reveal, but actually conceals as much as it discloses.

The occasion of Samaras's bedroom installation was his move from his parents' home to his own apartment. Rather than transport the furnishings and objects he had accumulated—as a teenager, a college student at Rutgers, and early years as an artist—he installed them at the Green Gallery, in New York City. The artist had persuaded dealer Richard Bellemy to construct a room for the installation's contents: a single metal-frame bed with a blanket on a sheetless mattress, glass-front bookcase, cluttered desk, partly finished artworks, piles of small objects that Samaras had collected for use as art materials (yards of tangled, colored yarn; bags of beads), pins, little plaster sculptures, aluminum-foil sculptures, paintings, pastels, a handful of books, and, over the bed, a long string hanging from the dome light, within reach from the bed.

McEvilley associates the absence of the artist with Samaras's move out of the family home: "It signified a kind of death, an end to one identity and the beginning of another."[6] However, McEvilley questions if even the intimate history revealed in the accumulated objects from Samaras's growing up can reveal the artist, the self who collected this treasure trove. The critic found traces of the self, as well as its absence.

Even though many of Samaras's works—decorated boxes and large sewn-fabric wall hangings—are abstract, nonrepresentational pieces, they contain

autobiographical references. Pins, needles, ribbons, sequins, fabrics, and other domestic items refer to a childhood with his mother but not his father. The found items—colored yarns, beads, nails, forks, and mirrors—reference Samaras's collection of cast-off items for making toys in wartime Greece.

Samaras has often explored his identity through the format of boxes, references to both the reliquary boxes from the Greek churches near his home in Kastoria, Greece and to the boxed gifts mailed from his father who worked in the United States during World War II and the Greek Civil War. At age eleven, in 1948, Samaras and his mother joined his father in West New York, New Jersey. The box serves as a metaphor for the exploration of the visible and invis-

ible parts of the artist's identity. The outside of a box is visible, exposed and available for viewing; whereas the inside is secret, private, dark, and intimate.

As a visual ploy, Samaras often displays his boxes slightly open so as to tantalize and frustrate viewers with only partial information about the contents. The artist covered his early boxes with straight pins or razor blades, visual repellents against touching or handling the sculptures. Although threatening on the outside, many of these boxes contained soft, cuddly materials, suggesting the contradictions of the human personality. *Box #105* is covered with protruding, twisted forks that McEvilley described as "an instrument for feeding oneself and attacking another."

4.7 Lucas Samaras, Box #105, 1977, Mixed media, 11" x 26" x 17 1/2" open, 12 1/2" x 16" x 11" closed. (28 x 66 x 44.5 cm open; 32 x 41 x 28 cm closed). Photograph courtesy of Pace Wildenstein. ©1977 Lucas Samaras.

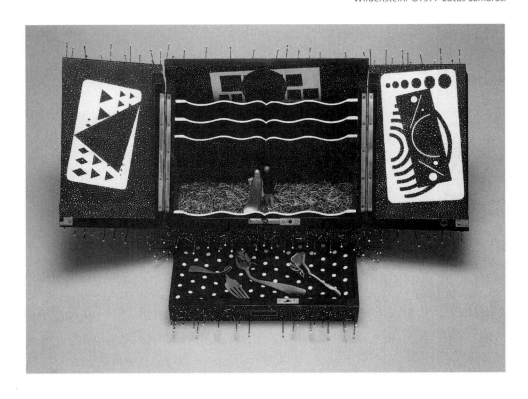

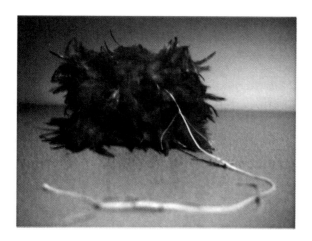

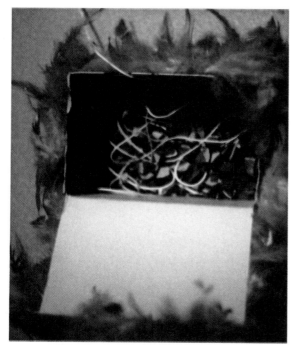

4.8 Valerie Zabek, Untitled (after Samaras), 1997. Self-portrait box, open and closed versions. Feathers, string, glue. Art-education undergraduate student at The Ohio State University.

McEvilley recognized Samaras's simultaneous withdrawal and disclosure as an investigation of the human paradox of how one is ever to know another.[7] The critic wrote: "the thoughts, feelings, intentions, ambitions that no one outside ever fully and surely knows of—and the outside, that aspect that faces the world, that is there to keep away the world from that hidden interior, to protect the secret life."[8]

From Samaras to a University Classroom

After studying Samaras's autobiographical boxes, art-education students were challenged to make self-portrait boxes that both revealed and concealed their identity.[9] The art students first wrote a short narrative about the way they believe others perceive them. They then selected an appropriate prefabricated box such as a shoe box or tissue box, located found materials, and created the exterior and interior of the box as a representation of their identity.

One student, Valerie Zabek, created a study in contrasts: the small, square box was completely covered with fluffy hot-pink feathers; it had one short string protruding from the front, and a mass of tangled rubber bands and string on the inside. She had used Samaras's strategy, disclosing her inner, hidden qualities in a somewhat secretive way while openly displaying her more obvious, outer characteristics. The artmaking problem gave Valerie and the other art students a structure that encouraged deeper thinking about their identity. Valerie reflected after completing her self-portrait box:

I was thinking about the role that I play being a female lead singer in an all-male band. I am often treated much differently than the men in the group, because I am just the cute little "female" singer. I also have noticed that several people seem to tell me that I always seem so happy and bubbly on the outside, and never really bothered or stressed, or depressed.

Of course, this couldn't be further from truth. I was trying to show these aspects in my box. The string hanging out with the broken rubber bands was a symbol of my dysfunctional insides. By letting it hang out, if you get close enough and look past the outside of me, I will let you in and let you know what is really going on inside.

Presenting the same artmaking problem in the work of several artists is instructionally effective: doing so allows students to realize that a single artmaking problem can generate a variety of possible resolutions. Subsequent artmaking might engage students with this same artmaking problem, but with greater subtlety and different solutions. Because students often have only a single opportunity to explore a subject, idea, or strategy, artmaking instruction designed with repetitions of these is particularly useful in broadening students' range.

Questioning the Problem: A Self-portrait Box
These questions may be used to assess the quality of an artmaking problem. The answers address the self-portrait box that both reveals and conceals identity.

- Does the artmaking problem originate with a big idea?

 The artmaking problem is premised upon a big idea about personal identity.
- Does the artmaking problem include divergent elements that provoke meaning beyond its apparent and obvious aspects?

 The divergent elements of revelation and concealment of identity infuse the artmaking with the problem of understanding identity, thereby encouraging deeper thinking.
- Does the artmaking problem extend beyond cleverness and novelty?

What's Wrong with This Picture?

Sandy Skoglund creates room-size fantasy installations depicting scenes such as suburban living rooms, backyard patios, cocktail parties, and urban bistros. Skoglund's portrayals are both ordinary and extraordinary. *Fox Games*, for example, portrays an elegant bistro with more than twenty bright crimson foxes jumping over tables and chairs, and cavorting throughout the dining area.

Following a study of Skoglund's installations, students were instructed to use multiple photocopies of an everyday object such as a toothbrush, paper clip, scissors, knife, or plastic toy to make a collage.[10]

How could this artmaking problem be improved? The problem is too loose, and lacks structure. Students are left on their own to identify the important aspects of Skoglund's installations; there is no stated direction for the collages; and the function of the repeated object is not explained. How might the teacher provide direction and purpose?

A better way to construct this problem would be to instruct students to depict an ordinary scene and disrupt its "reality" by repeating an everyday object. It is important to inform students that Skoglund repeats objects in order to disrupt reality rather than as simply a visual pattern. An even better way would be to have students think in a more considered manner about their selection of an object to repeat and its relationship to the scene. A more challenging problem would be to abandon the criterion of a repeated object, letting students decide how to disrupt the reality of their scene.

Frequently-Asked Questions

What makes some artmaking problems better than others?

Students studied the work of Surrealist painter René Magritte, and were then asked, "how would you rate four artmaking problems, based upon the five key questions?"

The five key questions:

1. Does the artmaking problem originate with a big idea?

2. Does the artmaking problem include divergent elements that provoke meaning beyond its apparent and obvious aspects?

3. Does the artmaking problem extend beyond cleverness and novelty?

4. Is the artmaking problem directed toward meaning?

5. Is the artmaking problem flexible enough to incorporate individual responses and shaping of the problem?

The four artmaking problems rated by students:

1. Choose a Magritte object (apple, key, clouds, bird) and create a drawing of the object in an unusual situation.

2. Create a drawing of an everyday scene with everything transformed into stone.

3. Create a drawing of a dream world.

4. Create a drawing that includes both reality and unreality.

(See page 146, Frequently-Asked Questions, for student comments.)

The artmaking problem is not about cleverly creating an identity box, but it is about revealing and concealing one's identity.

- Is the artmaking problem directed toward meaning?

 The requirement that students make distinct choices about revealing and concealing their identity directs the artmaking toward meaning making.

- Is the artmaking problem flexible enough to incorporate individual responses and shaping of the problem?

 Although the problem is tightly structured with four specific requirements (create a self-portrait; use a box form; incorporate found media; reveal and conceal identity), it allows, perforce, for individualistic responses.

Jasper Johns: Concealment through Coded Images
Artists, of course, may use other strategies to engage concealment as an artmaking problem. For example, in *The Seasons: Fall, Winter, Spring, Summer* (1985–86), four large autobiographical paintings by Jasper Johns, the artist concealed information by embedding coded autobiographical references. For the pivotal figure in each painting, Johns used his own shadow, which he produced by tracing his body onto each canvas; he replicated the various flooring from his four studios for the background of each painting; and encoded the four-part work with numerous other motifs that are references (the American flag, an open hand, a skull, a crosshatched pattern) to his previous artworks. In addition, Johns included double-coded images from popular culture: *Spring* contains a duck–rabbit decoy image and an ugly hag–beautiful woman image.

Concealment in the Artroom

The artmaking problem developed by Johns (using coded images to create an autobiographical work) provides a useful structure for student artmaking. Students might grapple with such questions as: What do I reveal? What do I hide? How? Why? How do I simultaneously hide and reveal information? How do I create coded images? Will they be decipherable? By undertaking such inquiry, students work to understand the nature of interpretation, and see that artists choose from an array of image possibilities, ranging from the widely understood to the less comprehensible, usually personal, images.

Further, by examining the work of Johns, students can recognize that artists not only conceptually encode images, but also visually manipulate the reading of them. Johns fragments, reverses, layers, and turns images upside down so as to obstruct viewers' reading of them.

Samaras, on the other hand, creates an excess of information that challenges the reading of his work. If we encourage students to experiment with coding or hiding information, they will work toward the realization that artmaking can be about not only concealment but also disclosure.

Disruption

A number of contemporary artists use disruption as an artmaking problem. Artists Barbara Bloom, Barbara Kruger, and William Wegman, for example, employ disruption to question society: Bloom disrupts traditional social ideas about collecting by substituting new, unusual subjects as objects to collect; Wegman exposes social stereotypes by substituting animals for humans. Photomontage artist Barbara Kruger disrupts contemporary views of women and social power through disjunctive combinations of text and images.

4.9 Jasper Johns, Spring, 1986, Encaustic on canvas, 75" x 50" (190.5 x 127 cm), signed UR: J. J. 1986. (stenciled). Jasper Johns/Licensed by VAGA, New York, NY.

What Do You Think?

Middle school students were asked to create the directions for producing an artwork. The students were to give these directions to another student who would create the work. *Would this be a meaningful artmaking problem? For both students? What would the students learn from this problem?* Consider the work of conceptual artist Sol LeWitt before you answer.

LeWitt produces enormous wall drawings without using any type of marking tool—or even being physically present when the drawings are executed. He creates his drawings by writing instructions for others to produce them. For example, he sent instructions to his assistants and a group of Phillips Academy students at the Addison Gallery of American Art to create a trio of wall drawings. One approximately 32' white wall was to receive 10,000 1' lines, none of which were to touch one another. Another 65' black wall was to be scribbled to maximum density with lead pencil. A third wall was to receive 10,000 1' lines, each of which was to cross and touch other lines.[11] LeWitt has taken a traditional problem—execution of artwork—and used it to explore the nature of art itself.

Students at Doherty Middle School near the Addison Gallery actually created a LeWitt drawing on a wall in their building. They received permission from LeWitt, and the Addison Gallery lent the school *Wall Drawing #716* from its permanent collection. Under the guidance of Andrea Myers, the Addison's education fellow, the Doherty student team spent three weeks working after school each day to create the LeWitt drawing.[12]

What do you think now? Would this be a good artmaking problem for the classroom?

Barbara Bloom: Disruption of Categories

To explore an inquiry into what comprises a collection, artist Barbara Bloom created a set of postcards with photographic images. She named her collections *Curtains, Sitting, Reading, Roads, Vessels, Crowds, Broken, Corners, Twos, Muses and Models, Ball/Pearls/Globes, Light & Shadow, Stand-Ins, Boudoirs, Water, Arenas,* and *Metaphors.* Bloom formatted these collections into grids of either twelve or sixteen photographs per postcard, thereby producing twelve roads, twelve crowds, sixteen corners, and so forth. The idea that such things as roads and corners can constitute a collection disrupts common beliefs about collections. Bloom's new categories raise questions about real collections: Why are certain items collectible, whereas others are not? Can images of "sitting" become a collection? Why or why not?

For students, Bloom's strategy offers an intriguing idea for creating an artmaking problem built around the big idea of categories. The idea of disrupting categories with unusual inclusions is quite playful, but it can lead to serious inquiry, with such questions as: What are the possibilities for inclusion in a category? What are the criteria for inclusion and exclusion in a category? What constitutes a good category? What are the qualifying factors of a category?

Bloom's new collections offer a strong example of how a social category might be disrupted and changed. Bloom did not exhaust the possibilities, but she did provide a framework in which students could explore this idea by, for instance, investigating kinds of collections—scientific, art, personal, sports—and creating photographic images of unusual components; then justifying and debating the new inclusions with other students.

William Wegman: Disruption with Humor

In *Mother and Child* (1990), photographer William Wegman posed a weimaraner—holding a rubber baby doll—in a dark, curly, unkempt wig and a long, floral nightgown. Wegman's purpose was not to entertain viewers with clever substitutions of dogs for humans, but to raise questions about human behavior—in particular, social stereotypes: Why does a dressed-up dog so convincingly depict a mother

4.10 William Wegman, Mother and Child, *1990. ©William Wegman. Courtesy Pace/MacGill, New York.*

figure? Are there universal meanings and visual clues associated with mothers? Is this image a stereotype? Are all mothers the same?

If they are linked to big ideas, dress-up, make-believe, pretend, and disguise are useful techniques for constructing classroom artmaking problems that can extend beyond mere entertainment. Having students dress up to assume new roles could be a meaningful activity if it is about exploring identity. Or dressing up stuffed animals, in the manner of Wegman's posed weimaraners, could become meaningful as a unit that investigates everyday human behavior.

Barbara Kruger: Disruption of Social Power through Images and Text

Photomontage artist Barbara Kruger rephotographs black-and-white images from print media such as newspapers and magazines, and combines them with short, often clichéd, statements to unmask contemporary beliefs and practices about male and female roles. For the uninitiated viewer, the image-text combinations are often baffling. For example, a 1982 photomontage superimposed the text "We have received orders not to move" over the silhouette of a seated woman who is bent at the waist and looking downward. What is the meaning of Kruger's conundrum?

Art critic Jeanne Siegel interprets Kruger's photomontages as unveiling "the role of power in patriarchal societies."[13] In this context, "We have received orders not to move" acquires meaning as social commentary directed toward male power and authority. In a 1983 photomontage, Kruger overlaid the text "You are not yourself" on a cropped photograph of a woman's face reflected—and "fractured"—in a shattered mirror. A puzzling image, until we interpret it in light of Kruger's questioning of women's roles in contemporary society.

Artist History

Barbara Kruger:

- was born in 1945 in Newark, New Jersey. She was always "one of the kids in the class who could draw."

- attended the Parson's School of Design for two years, working with photographer Diane Arbus and graphic designer Marvin Israel.

- worked for ten years as a graphic designer at *Mademoiselle* and *Seventeen*. She attributes her career in fashion to being a woman growing up in the 1950s when career tracks for women were highly limited.

- began her art career in 1969, working first with fibers and related craft techniques, then painting.

- also writes film and television criticism for *Artforum*.

- discontinued painting in 1976 and two years later began to make montage artworks using words and photographs.

- began in 1985 to make text and image artworks in billboard scale including outdoor billboards in Minneapolis, Berkeley, Chicago, Las Vegas, England, Scotland, and Northern Ireland.

- collaborated with novelist Stephen King on *My Pretty Pony*.

- works in a studio that resembles more of an office space than a conventional studio.

Disruption in the Artroom

Kruger's artmaking problem of disruption offers a good example of the importance of thoroughly understanding what an artist is about when transferring his or her artmaking problem to the middle and high school artroom. Students who are challenged to demonstrate Kruger's artmaking problem by creating their own advertisement-based photomontages might initially find images that portray, for instance, the social problem of environmental pollution—unauthorized trash dumps, beachfronts awash with dead birds, skies darkened by industrial smog, business areas overwhelmed by commercial signage.

4.11 Barbara Kruger, Untitled (We have received orders not to move), 1982. Photograph, 72" x 48" (183 x 122 cm). Courtesy Mary Boone Gallery, New York.

However, Kruger's work is not about presenting recognized social problems; rather, she exposes hidden issues: she selects seemingly innocuous images and then constructs the problem with disruptive text.

Kruger does not randomly select text and images; rather, her actions are quite deliberate. The image of the woman's face reflected in the broken mirror and the text "You are not yourself" have an obvious relationship, even though its precise meaning may be unclear. Because the surface-level meaning of the text and image is so obvious, viewers are generally motivated to seek a deeper meaning by asking why the woman is not herself. Similarly, the text "We have orders not to move" has an obvious relationship to the image of the submissive woman, but it raises questions about the woman: Why is she threatened? To whom does "we" refer? Who is giving the orders?

To construct their own artmaking problem based upon Kruger's work, students must work with images depicting social situations that appear unproblematic, but contain hidden issues. Such images as ads that target teenagers—especially ads for clothing, body-building equipment, perfumes and colognes, deodorants, hair products, electronic items, and sports equipment—are good examples. Although they may not be perceived, at least initially, as problematic, advertisements contain many embedded messages promoting social values that appeal to physical appearance, conformity, instant gratification, fun, sexuality, and fame. Therefore, class discussion of both the explicit and implicit messages of advertising images can form a basis from which students construct their photomontages.

After students each have selected an image, they generate possibilities for new text that alludes to possible hidden meanings in the image and that disrupts the ad's intended meaning. Throughout this challenging studio assignment, we must encourage

 Artist Talk

". . . I'm interested in working with pictures and words, because I think that they have the power to tell us who we are and who we aren't."[14]

—Barbara Kruger

students to return to and use Kruger's work as a model, so as to grasp the interplay of meaning between text and image. Students will also need to exercise their understanding of language so as to create text that is both literal and figurative—language that disrupts the meaning of the image, such as irony and double entendres.

For students to create disruptive text-image photomontages, we might design artmaking instruction that follows these guidelines:

- Conduct a class discussion about student and professional artworks that disrupt the meaning of images with text, and have students identify reasons why some examples are stronger than others.
- Remind students that the artmaking problem is not about disruption for its own sake, but should be used to change, alter, and question meanings that ordinarily would remain unexamined.
- Explain that, although the notion of disruption connotes negativity, it can be used playfully as a strategy that allows artists to think differently.
- Ask students to consider several possibilities before committing to a final selection.
- Guide students to avoid overly obvious connections between text and image.

In summary, meaningful classroom artmaking is dependent upon a well-constructed artmaking problem related to ideas—not only upon technical, formal, or stylistic concerns. To assess the quality of a problem, we might address these questions:

- Does the artmaking problem originate in big ideas?
- Does the artmaking problem include divergent elements that provoke meaning beyond its apparent and obvious aspects?

- Does the artmaking problem extend beyond cleverness and novelty?
- Is the artmaking problem directed toward meaning?
- Is the artmaking problem flexible enough to incorporate individual responses and shaping of the problem?

The solving of the artmaking problem, often dissociated from meaning making, must involve exploration of ideas, not simply the production of dazzling or clever results.

Notes

1 Diane Kelder and Jane Myers, *Stuart Davis: Graphic Work and Related Paintings With a Catalogue Raisonne of the Prints*. 1971.

2 J.W. Getzels & M. Csikszentmihalyi, *The Creative Vision: A Longitudinal Study of Problem Finding in Art* (New York: John Wiley, 1976).

3 M.A. Mace, "Toward an Understanding of Creativity Through a Qualitative Appraisal of Contemporary Art Making," *Creativity Research Journal*, 10, 2 & 3, (1997), 265–278.

4 Getzels & Csikszentmihalyi.

5 Thomas McEvilley, "Intimate but Lethal Things: The Art of Lucas Samaras," *Lucas Samaras: Objects and Subjects, 1969–1986*, catalogue, Denver Art Museum (New York: Abbeville, 1988), 11–30.

6 Ibid., p.14.

7 Ibid., p. 20.

8 Ibid., p. 19.

9 The studio project was conducted in a studio methods art-education course taught by the author at The Ohio State University. A similar elementary school project, *Inside-Outside Boxes*, is described in Terry Barrett's *Talking about Student Art* (Worcester, MA: Davis, 1997).

10 The collage project was conducted in a studio methods art-education course taught by the author at The Ohio State University.

11 Sol LeWitt Retrospective, April 16–June 13, 1993, Addison Gallery of American Art, Phillips Academy, Andover, Massachusetts.

12 J. Reynolds, *Sol LeWitt: Twenty-Five Years of Wall Drawings, 1968–1993* (Andover, MA: Addison Gallery of American Art, 1993), 7–17.

13 Jeanne Siegel, *Arts Magazine* (Summer 1987), p. 17.

14 Barbaralee Diamondstein, "Barbara Kruger," in *Inside the Art World: Conversations with Barbaralee Diamondstein* (New York: Rizzoli, 1994), p. 154.

Setting Boundaries

"Descriptive drawing is extremely valuable if part of your ultimate expression is description. It is not all that valuable if that kind of describing is irrelevant to your ends."[1]

—Robert Motherwell

To express and explore ideas, artists must work with another type of problem: setting boundaries for artmaking. That is, artists create structures for artmaking with artistic choices about media, formal qualities, subject matter, style, and technique. Choices of this nature reflect presented problems, as opposed to constructed problems (those more directly linked to meaning making).

An understanding of boundary setting is critical for designing art instruction that engages students with meaning, rather than simply the production of products. Two or three purposeful requirements for a project are more effective than a lengthy list of them; unlimited options fail to offer the resistance needed for creation. Boundaries set necessary limits that enable artists to work productively.

Frequently-Asked Questions

Do titles count as part of an artist's work?

Titles are part of an artist's repertoire of meaning-making strategies. Even an artist's decision to use "untitled" as a title creates meaning. However, knowing when to introduce the title requires sensitivity. If a title is too descriptive, it may prevent students from interpreting the artwork from other perspectives. Titles should also be considered part of students' artmaking. See page 147, Frequently-Asked Questions, for a teacher discussion about titles.

Frequently-Asked Questions

Why is it that teachers rather than students usually set the boundaries for classroom artmaking?

Partially, it stems from practical reasons. Individual students might not be aware of space, material, or technical constraints. There are conceptual reasons as well. As stressed in this chapter, artmaking boundaries have meaning-making implications that act as structures to help the artist pursue meaning. Students are not always artistically mature enough to create these structures for themselves. However, it is worthwhile to engage mature students in learning how to set meaningful boundaries for artmaking.

Setting Boundaries for Classroom Artmaking

Setting boundaries for student artmaking requires more than selection from available media, more than choice of a style for the sake of exposure to a variety of ways of working, and more than a focus on design elements and principles for the sake of familiarizing students with the formal language of art. Although budget, time, physical space, and range of art knowledge are certainly valid instructional concerns, these should be secondary when structuring classroom artmaking. Conceptual concerns should be foremost. We must ask: What ideas are students to explore? How can media, style, and formal boundaries serve the expression and exploration of these ideas? By setting aesthetic boundaries, we do not predetermine all the decisions for students; rather, we provide a framework for their own decisions.

Thus, the boundaries that we set must have specific links to the ideas that are to engage students. For instance, if the big idea for student artmaking is identity, an art teacher sets aesthetic boundaries that will serve students in the exploration and expression of identity. Limitations in colors, scale, and style might be the boundaries for creating an expression about identity. By setting these boundaries and making their connections to expression explicit for students, the teacher enables students to make more purposeful aesthetic decisions, thereby directing students toward conceptual concerns for expression.

Researchers recognize that creativity is motivated more by constraints than by a lack of them.[2] In a conversation with art students, painter Robert Motherwell remarked: "If the elements [for a collage] are very disparate, it's a very precarious enterprise to organize them . . ."[3] And recently, architect Richard Meier observed that his almost unlimited budget for the Getty Center, in Los Angeles, made

the task fairly daunting. Certain limitations are actually welcome enablers rather than restrictive barriers.

Toward Student Understanding of Artmaking Requirements

Students are accustomed to art teachers' specifying certain requirements for artmaking projects; however, they may lack understanding of why these boundaries have been set. They may wonder: Why does the art project permit only three colors? Why must I use deep space? If students are to use artmaking requirements in meaningful ways, art teachers must make their purposes explicit, most obviously through the study of professional artists' boundaries, and then use this knowledge to inform subsequent discussions about the motives for project requirements.

We might ask such questions as: Why, for example, did painter Robert Motherwell limit his palette for *Elegies* to hues of primarily black and white? Why did sculptor Claes Oldenburg enlarge everyday objects, but not human figures, for monumental sculptures? Why did Lucas Samaras create in multiple kinds of media? By answering such questions, students will come to recognize that artists' choices are not mere whims, but are boundaries intentionally set for expressive purposes. Such recognition, in turn, will help students understand why requirements for their own artmaking should have a similar function.

Toward Student Understanding of Artmaking Relationships

All of an artist's artistic choices function in a relationship to his or her other artistic choices. Motherwell commented that meaning in artworks is about structure, and "structure by definition is a relation among elements…"[4] Aesthetic choices are always relational: every aspect of an artwork participates with all other

Frequently-Asked Questions

How important is media as an artmaking boundary?

In the late 1960s, Marshall McLuhan's slogan "the medium is the message" popularized his notion that television communicates differently than other media. McLuhan called attention to the fact that television conveys its own message as a subtext of the program content. Similarly, the meanings associated with different art media are often subliminally intuited. Certain traditional art media—oil paint, bronze, and marble—have acquired the status of major media. Other traditional media—clay, wood, charcoal, wood block, metal etching and engraving—connote less importance. These views reflect a hierarchy derived from Western art history. Students thus need to learn not only about the physical properties of media, but also about cultural and artistic connotations.

Inside the Classroom

Challenging artmaking problems can be created by altering the artmaking media to materials that are not usually thought of as art media (food, natural materials, clothing, office supplies, household objects). However, changing art media to unusual materials should be purposeful, not a gimmick.

Students might be instructed to choose a material directly related to a big idea, theme, or social issue that is to be the focus of their artmaking. The following artists have merged big ideas with their choice of artmaking media:

Faith Ringgold utilizes the quilt form to create narrative paintings. Her media choices merge form and idea, since storytelling has traditionally been associated with quilts.

Andy Goldsworthy strives to only use natural materials to explore artmaking in the natural environment. He has used his own saliva to join leaves rather than resort to manmade adhesives.[5]

Lynn Aldrich's use of bread slices (white, dark, pumpernickel) creates an artwork that speaks of stockpiling food for an emergency, as an emotional crutch, and as implicit waste.[6]

parts of the artwork. But do students understand the relational aspects of boundaries? Unfortunately, such relationships usually escape their understanding: in creating artworks, students make aesthetic choices in isolation.

Physicist David Bohm, from his exploration of creativity and creative acts, acknowledged the importance of discerning relational differences and similarities. He remarked: "[Q]uite generally, in a creative act of perception, one first becomes aware (generally non-verbally) of a new set of relevant differences, and one begins to feel out or otherwise to note a new set of similarities…"[7] Bohm also noted that the perception of relevant differences and similarities "leads to a new order, which then gives rise to a hierarchy of new order, that constitutes a set of new kinds of structures."[8] The key term in Bohm's premise that creative acts involve the discernment of relevant similarities and differences is *relevant*.

Students must not only comprehend the relational aspects of artworks, but also must be able to judge which are the more significant relations. Artist Elaine Reichek said that "everything in an artwork counts."[9] Reichek is indeed correct, but we must encourage students to understand that everything in an artwork does not usually receive equal emphasis or possess equal expressive power; and to recognize that, even though the manner in which, for instance, they apply paint to a surface, or tear rather than cut an edge, impacts how the artwork communicates the import of their actions relative to the totality of the artwork. Therefore, in some artworks, surface treatment is a primary tool for expression; in others, color choices carry more expressive weight.

All aesthetic choices carry importance, but some carry more weight than others in a piece!

Sean Scully: Difficult Relationships

Studying Scully's abstract, striped paintings can inform students about making aesthetic choices that express human emotions, that are disturbing rather than pleasing, and that deliberately employ imperfection. Such a study may be challenging for students who expect artworks to be harmonious expressions.

Scully builds a knowledge base through acute observation of his surroundings. Art critic Armin Zweite tells of Scully encountering a crudely painted black-and-yellow striped warning sign on New York's Canal Street. Struck by the sign's immediacy and energy, Scully promptly went into a nearby paint store, bought the same colors, and then incorporated them into a painting he was working on, *Heart of Darkness*.[10]

Scully often observes such areas as New York's Lower East Side, and has commented that "I like to see doorways missing and pieces of wood banged up over the top and old buildings that have been boarded up."[11] He knows the hues and smells of the dry earth in North Africa, the look of the shanty towns and

5.1 Andrea Dickens, Deanna Fox, Jordan Sebastian, City Center (after Scully), *1997. Tempera, cardboard, 5' x 3' (152 x 91 cm). Bailey Elementary School, Dublin, OH. Janice Kuchinka, art teacher.*

Frequently-Asked Questions

How do artists select media for artmaking?

Certain practical considerations play a role in artists' decisions about media. Is a two- or three-dimensional work desired? What is the scale of the work? How available/expensive is the chosen medium? What are the visual characteristics of the medium? Does the artist possess the necessary technical skills to work with this medium?

Other considerations count, as well. For instance, artists select media for associative connotations as well as physical properties. Maya Lin designed the *Vietnam Veterans Memorial Wall* in Washington, DC with shiny granite, etched with thousands of names. Frederick Hart executed a more traditional memorial—also in Washington—using bronze to depict four young soldiers. Lin and Hart each selected a medium based upon its properties. Granite is durable, capable of sustaining a large-scale form, possesses a highly reflective surface (when polished) that incorporates viewers into the memorial, and carries strong connotations to contemporary architecture. Bronze is durable, capable of rendering highly realistic, life-size representations, and carries strong artistic traditions of honoring military valor.

Inside the Artist's Head

Deborah Butterfield creates her horse sculptures from scrap steel, sticks, mud, barbed wire, corrugated tin, burlap, plaster, and bailing wire. She is acutely aware that the horse has been traditionally executed in bronze either as a military or Wild West figure, and that her nonconformist media express something entirely different. See page 148, Inside the Artist's Head, for more about Butterfield and her sculptures.

Artist History

Sean Scully:

- is a successful painter who lives in New York City, but was born in Dublin, Ireland, in 1945. When he was four, his family moved to England to escape poverty, but were unable to do so.

- knew he wanted to be an artist by nine years of age.

- had trouble with the police while growing up.

- worked as a printer's apprentice, a laborer, and a discotheque manager.

- shares a loft in Manhattan with his wife, Catherine Lee, who is also a painter.

- paints using housepainters' brushes.

- may meditate on a painting for a long time before actually making the painting. He says, "I have a little TV screen in the front of my mind that is full up with paintings."[12]

- is tall, strong, and has a brown belt in karate, but speaks quite softly.

- has been profoundly influenced by the novelist Samuel Beckett. Scully has titled four paintings after Beckett's works—*How It Is, Molloy, Murphy,* and *Come In.*

- says that if he was not a painter, he would be a filmmaker. His painting *Four Days* is based on film frames, edits, and cinematic time.

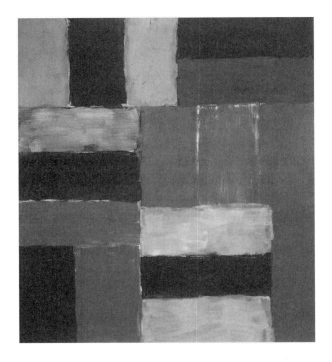

5.2 Sean Scully, Wall of Light Orange Red, *2000. Oil on canvas, 84" x 96" (213 x 244 cm). Galerie Lelong, New York. Courtesy of the artist and Galerie Lelong, New York.*

adobes in Mexico, and the way that stones in the Yucatan are set into temple walls and the ground. These and other perceptions have formed a storehouse of sensory information that Scully draws upon for his huge, striped abstractions.

Scully's Artistic Boundaries

Scully attains a considerable richness from exploring a single subject matter, the stripe. He says that he sees stripes everywhere. Camping on a Moroccan beach one summer, he awoke to the sight of giant-size family tents whose wide, colorful stripes changed directions with each panel. He remembers:

"I almost cried, it was too beautiful."[13] He has also said of the stripe: "[It] is neutral and boring—you see it all over the place—and that makes the stripe receptive to interpretation."[14] Art critic Carter Ratcliff has argued that the stripe is so integral to Scully's paintings that nothing in his entire body of work should be explained without referencing stripes.

Scully deliberately creates paintings with disturbing and uncomfortable visual relationships. The painter has commented: "I like to put things together that shouldn't really be together. Difficult relationships are what I'm interested in."[15]

Scully's pursuit of difficult relationships permits him to express disturbing, uncomfortable feelings and emotions. He purposefully mismatches colors and patterns that create deliberately awkward compositions. For example, US (1988), a Scully painting of four striped rectilinear forms that float against a dull ochre and muted gray-green striped background, intrigues and irritates because the square in the upper right quadrant of the painting doesn't quite seem to fit. Scully striped this form in orange and black; the three other forms he striped in white and black. The difference in the striping of the forms is off just enough to disturb, but the difference is not enough for viewers to dismiss the composition as totally ineffective. The painting resides uneasily in an unresolved state of tension. Zweite has observed that Scully merely hints at deviation rather than exploiting it to the full, but that if such a contrast were absent, the pictures would likely be "a banal enumeration of shapes and colors."[16]

The Big Idea in Scully's Artmaking

Postmodern painters today reject spiritual and expressionist notions of abstraction, believing that the abstractionist's geometric forms and expressive mark-making are empty signifiers of nonexistent

What Do You Think?

What are formal choices about?

In his analysis of the creation of Picasso's monumental painting, psychologist Rudolf Arnheim remarks, "I have taken pains to show that formal considerations lead to solutions that are always more than formal. When an object had to be moved, the formal change entailed a change of meaning."[17] How would you instruct students that formal changes affect the meaning of an artwork?

Artist Talk

Misalignments, gauche placements, and imbalances proliferate in Sean Scully's abstract paintings. In a 1994 interview conducted in his New York studio, he observed:

"My paintings are very much about power relationships, or they're about things having to survive within the composition. . .the composition becomes a competition for survival. It's interesting that something small can stand up and be in a composition dynamically, and have to deal with something much bigger."[18]

However, Scully concedes that he is not opposed to viewers finding their own references in his paintings. He remarks that if his paintings remind you of buildings, weather, or a new political order at the end of the millennium, he is not disturbed.[19]

What Do You Think?

Is there more to creating abstractions than producing compelling designs?

An art-historical perspective is helpful in thinking about this question. In the early 1900s, pioneers of abstraction such as Kandinsky, Malevich, and Mondrian viewed art as transcendent and spiritually based. Mondrian's formal choices sprang from a spiritual basis and a desire to convey the deep rhythms of life, its essential and eternal qualities. To the charge that his art (Neo-Plastic painting) was merely decorative geometric painting, Mondrian responded, "Neo-Plastic painting is neither decorative nor geometric painting. It only has that appearance." He further added, "One must become thoroughly familiar with Neo-Plastic work to know that, like all other painting, it expresses the *rhythm of life,* but in its *most intense* and *eternal aspect.*[20]

Abstract Expressionists of the 1940s and 1950s such as painter Mark Rothko contended that abstraction was philosophically based. However, Minimalist painters and sculptors in the 1970s objected to reading visual forms as anything beyond themselves.

Students should be encouraged to create artworks from a world view, not simply make pleasing visual arrangements. This means that abstraction—as other art forms—should be taught as a meaning-making endeavor to express ideas about the world. How would you plan for students to create abstract artworks that are about more than design?

truths. However, some contemporary painters, exemplified in this text by Scully and Motherwell, carry on the tradition of abstraction as a conveyor of spiritual and philosophical truths and human emotions. Scully observed: "Abstraction's the art of our age. . . It's a nondenominational religious art. I think it's the spiritual art of our time."[21] Although students may not be receptive to expressing spiritual or philosophical truths, they will likely be able to express emotions readily.

The spirituality of Scully's paintings is always balanced by a strong physical presence. That is, the material qualities of Scully's paintings—large scale, deep stretchers, coarse surfaces—create a polarity between the spiritual content and the actual material presence of the works. For instance, Scully often paints on separate canvases that he joins by bolting three or four panels together. In many cases, he slightly extends one canvas beyond another. Additionally, he wraps his bands of color around the sides of the canvases and applies highly noticeable brushwork that follows the direction of the stripes. Scully has declared that he has intended each of his large paintings to be "a physical event, a physical personality, just like people."[22]

We might engage students with the physical aspects of painting by having them attach several large cardboard boxes and then paint around the sides of the boxes. Most often, art teachers do not address the physicality of painting as a significant element, but instruction that examines scale and the physical construction in the manner of Scully can add new dimensions to students' understanding about what can contribute meaning to a painting.

Scully employs a rough, unfinished technique with uneven edges that are never ruled, streaked colors that appear poorly blended, harsh color combinations that are never ingratiating, and dirtied whites that

are never pure. Scully considers these qualities as assets that humanize his abstractions. Zweite gives his interpretation of Scully's unorthodox approach: *Scully's aim of humanizing abstract painting has a quite elementary anthropological dimension. This is apparent in the deliberate roughness of execution: looking at the stripes of color, one could almost begin to think that the artist has tried to apply the color evenly in clearly demarcated sections, but lacks the necessary technical skill to do so. This failure to achieve flawless perfection creates the kind of tension which always arises when amateur artists get things slightly wrong, and this is evidently just the effect Scully is aiming for... The perfect lack of perfection is, of course, a deliberate tactic, allowing Scully to preserve a remnant of spontaneity which can serve as a symbol of authentic, non-alienated experience in a coldly rational urban world.*[23]

As a professional critic, Zweite accepted Scully's imperfections as deliberate and necessary qualities that express a humanness that opposes the coldness of the modern world. However, students may resist these flaws, as happened in a high school art class in Canal Winchester, Ohio.

From Scully to a High School Artroom

Canal Winchester High School art teacher Sandra Packer began her Design II art class with numerous slides of Scully's paintings. Flashing *Angel* (1983) onto the screen, she asked, "Does it bother you that the lines in Scully's painting *Angel* are not perfect?"

One student remarked, "I don't mind it. Because it looks manmade and if it is cleaner, it looks mass-produced." Another student reasoned that the light color in the painting could "represent purity, and the uneven lines might represent human error." He continued, "If Scully wanted to use straight lines, he could have easily gotten hold of a straightedge, but

Inside the Artist's Head: Boundary Changes

In the 1960s, after forty years as an Abstract Expressionist, artist Philip Guston charted a radical new course. Relinquishing abstraction, Guston adopted a cartoon style of painting, populating his canvases with iconic autobiographical images of hooded figures, old shoes, cigar-smoking heads, and the painter's tools—brushes, easels, and canvases. Not only did Guston transform his imagery, but his big ideas no longer focused on the existential angst that informed his poetic abstractions—they now focused on his identity as an artist. Such shifts are rare in the work of mature artists, but occasionally they do occur.

5.3 Sean Scully, Wall of Light Blue White, *2000. Oil on canvas, 84" x 96" (213 x 244 cm). Galerie Lelong, New York. Courtesy of the artist and Galerie Lelong, New York.*

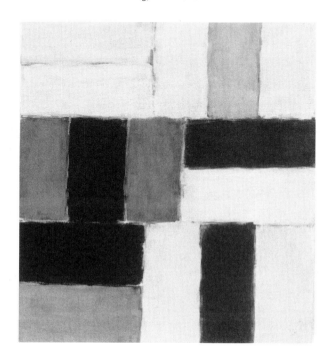

Can an artist set her or his boundaries too narrowly?

What if the artist eliminated all visual imagery? Would that be setting the boundaries too narrowly? What if the artist used only words? What can you do with only words to make a visual statement? Native American artist Edgar Heap of Birds makes powerful visual artworks within the confines of language. His public artworks in the guise of posters, billboards, and the Spectacolor Light billboard in Times Square are produced entirely from language. He writes words backwards and upside down to disrupt our normal reading patterns. For example, he reverses the term "natural" to act as visual metaphor to challenge the dominant cultural reading of his own identity and other Native Americans. These disrupted terms immediately command our attention, pronouncing stark commentaries on the status of Native Americans. Other contemporary artists such as Jenny Holzer and Christopher Wool have created visual artworks entirely from language. Although such artworks appear to have little to do with the visual, in fact, the artist's visual presentation of language has much to do with the meaning of the work.

Would it be possible to plan meaningful student artmaking which was limited to the use of language? How would you develop student awareness of the visual qualities of language?

if he did that, it would be hard and have taken away from the painting." A third student, however, reacted quite differently to Scully's imperfections. She characterized the streaked paint as "like a marker running out. It's ugly and boring and looks like something a three-year-old could do. The lines are not even straight. It's all messed up." This student's honest reaction is a frequent response to Scully's work.

The art teacher acknowledged the legitimacy of both the negative and positive reactions: "This is a good discussion because we have two different reactions and interpretations of Scully's painting. Both are valid responses."

She then directed a strategic question to the student who could not accept Scully's imperfections. She asked, "Are you saying that every artwork has to

5.4 Sharon Donahue, Jail Bird (after Scully), *1996. Watercolor on mat board, 12" x 18" (30.5 x 46 cm). Canal Winchester High School, Canal Winchester, Ohio. Sandra Packer, art teacher.*

have perfect lines?" Undaunted, the student responded, "Not every artwork, but I'm saying, what's the purpose of having those lines like that in this painting? It's stupid." This student obviously was not convinced of Scully's artistic worth, but the interaction was worthwhile because the class considered whether technical perfection is always desirable.

Students' sense of aesthetics usually typify Scully's work as messy and childlike. Although a single art lesson will not necessarily transform such judgments, exposure to a range of contemporary artwork accompanied by discussions about the role of technique offers possibilities for greater tolerance and increased art understanding.

An instructional strategy useful for students to learn to accept aesthetic choices that are different from their own is to display Scully's earlier paintings, which he created with ruled lines, razor-sharp edges, and smoothly blended hues. Such a presentation demonstrates Scully's technical capabilities and raises questions about why an artist would deliberately alter his or her technique. Some students may never prefer a rough, unrefined aesthetic, but recognizing that some artists deliberately choose to work in this manner is another important step in understanding art.

Following the study of Scully's paintings, Ms. Packer engaged the art students in creating their own abstractions in tempera and acrylic paints on mat board. For some students, this artmaking experience was their first with abstraction. The teacher instructed the students to derive their paintings from a significant emotional event in their life, incorporate ideas that they learned from studying Scully's work, and limit their formal choices to variations of two colors and a single abstract shape. The students took the assignment seriously; many based their painting on such intensely personal situations as a

drug overdose, a parents' divorce, a car wreck, and a break-up with a girlfriend.

On a worksheet provided by the art teacher, each student wrote about the results of his or her painting. Answering "What personal experience motivated this painting?" one student wrote:
I don't really want to say. It's very personal. I tried to bring myself and the feelings I was having to my artwork when I was drawing and painting. At the start, I tried to use a variety of colors to represent different feelings. Then I tried to create a pattern that wasn't perfect, to show that things in life happen in an indefinite cycle. I used a lot of the same color to show the feeling that overshadows the rest and fades out to a darker pattern and then black. I don't want to say the real feelings, but they are mostly frustration and anger. This is the first time I have made artwork that shows feelings.

This student's response reflects an understanding of the use of abstract forms for expressive purposes. His reference to creating an imperfect pattern to express the imprecision of life demonstrates an understanding of the symbolic consequences of aesthetic decisions with visual form. As an initial experience in using abstract forms to express emotions, the student was insightful and on the right track. In approaching the painting experience as a search for meaning, he utilized the abstract forms, colors, and patterns to give his feelings a physical reality.

Opportunities for art learning frequently occur after students have completed their artwork. Deciphering a student's understanding solely from the visual evidence offered by the artwork can be very difficult. With no art instruction to engage students in verbal or written reflections about their artwork, the artmaking process for students terminates, and teachers are left with a less-than-complete assessment of student learning.[24]

Can a formal element such as repetition become an inquiry tool?

Repetition can become an inquiry strategy if the artist uses it to probe more deeply into a subject. For example, Robert Motherwell used the same formal choices throughout his *Elegies,* a series of over one hundred paintings, to push himself to search more deeply. Deborah Butterfield also utilizes repetition for inquiry. Repeating the same subject matter compels Butterfield to investigate her subject further and further. These artists use formal repetition as a strategy for searching further.

In what way might you employ repetition as a meaning-making strategy for student artmaking?

Inside the Classroom

Why is it important for students to consider their artworks even after they are complete?

Student reflections about their artmaking are an essential part of art instruction. The actual artmaking process can be very intuitive; understanding often comes only after the artmaking is finished. Deborah Butterfield explains the need for reflection after a sculpture is finished:

"When I'm actually working, I go in and out of emotional involvement with the piece. While I'm making it, I'm quite brutal. To make the sculpture is a physically brutal process, you're sledgehammering and cutting with a torch and knocking things around. . . I'm totally ruthless and have no kind of emotional contact with it until I'm done."[25]

By extending art projects, we can provide another opportunity for student learning. An extension of the Scully project, for instance, in which students focus upon Scully's concept of difficult relationships, offers students the chance to see that this is not only a formal problem, but also one that translates into expression. Scully does more than simply include aberrant elements; as art critic Zweite noted, he creates difficult relationships with subtlety and complexity. We can require similar difficult relationships for student artmaking; otherwise, their work may become meaningless.

From Scully to a Middle-School Artroom
Middle school art teacher Rebecca Hartley-Cardis found that what students wrote about the Scully-inspired abstract paintings that they created, revealed a wide range of understandings about abstraction.[26] In the initial lesson, as Hartley-Cardis presented Scully's work in a slide presentation, students interpreted several of the paintings. She then instructed the students to select a single color and one geometric shape, and to produce an abstract tempera painting on 24" x 36" paper. She encouraged the students to push the formal requirements by mixing the singular hue into ranges of value and intensity and to create their geometric shape in varied sizes. She also instructed the students to base their painting on a personal experience, either an everyday event or a particularly memorable one. Some students chose thematic ideas, such as pressure, confusion, and trust; whereas others focused on specific events, such as a sister's wedding, homework, traveling to the beach, and exploring a cave.

The students' completed paintings were visually impressive and showed a great deal of effort and technical skill. Unlike Scully's work, their paintings displayed well-blended colors; clean, sharp edges;

and well-organized, harmonious composition. The students had created rich monochromatic studies in greens, purples, reds, or blues in an array of value and intensity; and many had organized their squares, circles, rectangles, or triangles into complex arrangements. After completing their painting over several class periods, each middle school student wrote a brief description and reflection about its meaning.

About his painting of multiple orange circles organized in a radial design and titled *Basketball*, one student wrote, "This artwork reminds me of last season playing basketball. All of the circles resemble the ball going through the hoop." Another student, about her dark painting with overlapping monochromatic violet squares and titled *Homework*, wrote, "This picture represents homework. The purple is my school and the squares are books." These comments indicate a lack of understanding that their abstract forms could express more than a literal interpretation of events.

Why did the students fail to understand that abstraction is about more than literal representations? Without having witnessed the students' study of Scully nor having heard their discussions, we might speculate that the art teacher may have been unclear about the meaning of Scully's abstractions. Scully is interested in art with spiritual resonance and emotional impact; he is not interested in literally replicating specific sites, events, or objects, even in an abstracted form. Perhaps the students understood the symbolic meanings present in Scully's work but did not transfer his approach to their own artmaking. We often assume understandings that students may not possess; these students might have benefited from a more explicit explanation of the role of the symbolic in abstraction.

An explanation and/or discussion of Scully's emotional engagement with his physical surroundings—

Inside the Artist's Head

Howardena Pindell's autobiographical paintings contain photographic snippets —eyes, hands, heads, various pieces of landscape—as well as bits of text, heavily embedded in thick layers of paint. The fragmented forms that characterize Pindell's work parallel a disarrayed puzzle which must be fitted together in order to become a meaningful object. Metaphorically, Pindell's visual processes stand for queries about her big idea: personal identity. *How is one's identity formed? Is it pieced together from multiple sources? Is it layered, always waiting for further excavation?*

Inside the Classroom:
Emotional Maturity

Students often have limited resources for expressing or interpreting emotions through artmaking and artworks. The following imagined classroom scenario demonstrates how strategic questions can expand the complexity of student responses to emotional qualities.

A group of high school students might interpret Scully's painting, *US* (1988), as an expression of loneliness. The teacher's next step would be to guide the students in developing a concept of loneliness, asking questions that would motivate students to elaborate upon the feelings, words, and associations connected with loneliness. She might ask: "Is 'trapped' a term you would associate with loneliness? What does loneliness feel like? What color is loneliness? How do you recognize loneliness?" and "What does loneliness sound like?"

To push the students' thinking further, the teacher might inquire if the students can recall personal experiences with loneliness. If so, she might pursue such questions as: "Is loneliness always the same? What are some different experiences of loneliness?" and "What is your worst experience of loneliness?" The next step would be to have the students apply this knowledge to Scully's painting with such questions as "How would you describe the loneliness in *US*? Is this a specific kind of loneliness?" and "What types of loneliness are not part of *US*?"

The questioning sequence in this imagined classroom scenario demonstrates the type of instructional strategy needed to develop student understanding of emotions at deeper and more complex levels than is ordinarily found among high school students.

such as his response to the striped tents on the Moroccan beach—and of the ways he symbolically represents such responses in his abstractions is an instructional strategy that could develop students' understandings about abstraction. Complementing this understanding is having students describe the sensory qualities of a physical place that has an emotional resonance for them. For instance, the student who created *Basketball* might have considered the sensory qualities of the basketball court—the rhythm of the ball's bouncing down-up, down-up, down-up; the blur of players rushing down the court; the sound of sneakers pounding the court. Students are often blind to the sensory qualities in their environment, and therefore lack a sensory knowledge bank to draw upon for translating an experience, event, or feeling into visual terms.

Some of the middle school students were able to infuse their abstraction with symbolic meaning. A student who titled her red monochromatic composition *Trust*, wrote, "The squares represent people in my life. Some of them are stacked sturdy, and some are on the edge, about to fall. The bases are people in my life who I am confident will be with me forever and who I can trust. Boxes that are almost falling are people who I am unsure of."

What we can compile from the students' experiences and also incorporate into the curriculum are:

- Sensitivity to the sensory aspects of one's surroundings can provide a richly funded resource for artmaking.
- Difficult relationships, as well as more harmonious relationships, present a possibility for artmaking.
- Technical imperfections do not always represent failures of skill, but can function as deliberate strategies for expression.
- Physicality can contribute to meaning in painting.

- In artworks, emotional qualities can be expressed with complexity rather than oversimplified responses.

George Segal: Boundaries in Representational Artworks

As important for students as the study of boundaries and aesthetic choices in abstract works is the study of such choices in representational artworks. Sculptor George Segal exemplified this study in his life-size tableau installations of one or more plaster figures situated in various urban environments.

Segal's first effort at body casting, in 1961, was an excruciating experience. A student of Segal's, whose husband was a chemist with Johnson & Johnson laboratories, brought Segal some recently perfected medical bandages that had been developed to help set broken arms. Segal told a *Newsweek* reporter that the incident was an epiphany: "Immediately, I knew what I wanted to do. I was my own first model. I wrapped myself in the bandages and my wife put on the plaster. I had [quite] a time getting the pieces off and reassembled."[27]

Segal's introduction to the medical bandages was a major turning point in his artistic career. Until then, Segal had been a painter of large expressionistic figures and a sometime sculptor of life-size figures that he made from wire-mesh armatures that he layered with burlap and dipped into plaster. Segal developed this method after studying how department-store mannequins were fabricated. To his surprise, Segal discovered that in the years before plastic molds became commonplace, mannequins were constructed of plaster and chicken wire, materials readily available to him on his chicken farm. (In the early years of his career, Segal unsuccessfully struggled to support his family on his father's chicken farm in South Brunswick, New Jersey.) Segal was

Artist Talk

George Segal described Edward Hopper's art as "some kind of marriage between what he can see outside with his eyes, touch with his hands, and the feelings that were going on inside. Now, I think that's as simply as I can say what I think art is about."[28]

Artist History

George Segal:

- was born in 1924 in the Bronx, New York City, and lived most of his life forty-five minutes from the Museum of Modern Art.

- realized when he was still in grammar school that he wanted to become an artist.

- began his art career as an expressionist painter, not a sculptor.

- memorialized his father with an installation, *The Butcher Shop*. Segal's father operated a kosher butcher store.

- was running a chicken farm when he first began trying to make it as an artist.

- tried sculpture because he was dissatisfied with the representation of space on a two-dimensional surface.

- felt it was important to personally supervise every major presentation of his art.

- was interested in the everyday, but also contemporary political events.

5.5 George Segal, The Diner, 1964–66. Plaster, glass, paper, wood, chrome, laminated plastic, masonite, fluorescent lamp, 93 3/4" x 144 1/4" x 96" (238 x 366 x 244 cm). Collection Walker Art Center, Minneapolis. Gift of the T. B. Walker Foundation, 1966. © The George and Helen Segal Foundation/Licensed by VAGA, New York, NY.

dissatisfied with the results of his plaster figures made from wire mesh and burlap. They needed, in his words, "more definition."

If not for his fortuitous "meeting" with the medical bandages, Segal would have foregone sculpture; instead, he began wrapping bandages around live models and casting them in plaster in a time when such casting was not an accepted artistic practice. Segal's complicated process, after removing and reconstructing the casts, was to refine the reconstructed plaster figures and then create a three-dimensional physical environment for the figures.

A single artwork such as Segal's, one that is worked on over an extended period, requires a dif-ferent cognitive process than that for creating artworks directly and spontaneously: the longer process emphasizes reflection and deliberation, whereas direct artmaking accentuates instinctive and intuitive behaviors. Certainly, one goal of art instruction is to provide students experience with both approaches.

Segal was not interested in a direct translation of reality, but in a more generalized, expressionistic depiction of the human figure. In his tableaux, he produced the semblance of reality that he desired, although he elected to leave the plaster figures in their raw, unpainted state. He described his all-white, roughly finished sculptures as portraits, but not in the manner that we usually think of portrai-

ture. He explained: "They're portraits in the same way you recognize a friend walking down the street a block away."[29]

Segal placed his ghostly white figures in ordinary, everyday situations. His ideas for these situations were informed by where he lived, never more than forty-five miles from New York City. For instance, Segal replicated a diner like the one he would frequent on his way back to New Jersey after an evening in Manhattan, a kosher butcher shop like the one his father had operated, and urban New York City street scenes—the front of a movie theater, a hot dog stand, a photo booth, the interior of a subway car.

Segal reproduced portions of these urban sites from real and constructed props; but even in these recreated, tangible environments, he excluded extraneous details, changed colors, and manipulated space. Commenting on his *Gas Station* (1964), Segal said: "Originally the whole thing was plastered with these brilliant fluorescent posters you find in these places, then I stripped it down to achieve the effect of desolation I wanted."[30] In this instance, Segal sacrificed—excluded—realism for psychological expression. Although he invented realities that corresponded to his aesthetic sensibilities and had psychological resonance, he admitted that he had to include certain truths about reality: "I can't violate truths about the person, his body build, his characteristic attitudes. I can't violate the proportions of a door."[31]

Segal's decision not to violate certain expectations about reality is significant. Because his intent was to create a believable reality—but one without exact replication—he had to decide what essential elements to use for conveying the veracity of a situation. Such purposeful decision making serves as a strong model for student artmaking. For instance, we might encourage students to ask: Why am I

Fascinating Facts

Sculptor George Segal usually made his plaster figures in three stages. He would cast the torso first, then the lower body, and finally the head. Exposed flesh and hair were coated with cosmetic cream so the plaster could be removed painlessly. Segal wrapped his models with medical bandages, dipped in warm water and shaped to the body. He cast figures quickly but often spent weeks reassembling them, taking extreme care to reconstruct the figure's gesture. For example, the angle at which a head is set on a neck can be crucial as an indication of the mental life of that person. This attention to detail provides Segal's plaster figures with their individuality and power to convey human emotions.

Critic Talk

"Warhol shows us our idols, Segal shows us ourselves."[32]

—Phyllis Tuchman

making this artwork? What is my purpose? How does this affect what I include and exclude?

Not only was Segal concerned about creating a believable reality, but he also wished to express a particular content about that reality. To do so, he would decide which colors, poses, objects, and spatial arrangements would evoke a convincing statement. According to art critic Phyllis Tuchman: "Early on Segal seems to have meticulously studied how he could incorporate a host of formal devices with thought-provoking content. (When she was seven, Segal's daughter would occasionally inform a telephone caller that her father was busy 'thinking')."[33] For example, Segal created the tableau for *Cinema* (1963) from four primary elements: 1) a single white

5.6 George Segal, Cinema, *1963. Plaster, illuminated Plexiglas and metal, 118" x 96" x 30" (300 x 244 x 76 cm). Albright-Knox Art Gallery, Buffalo, NY. Gift of Seymour H. Knox, 1964. © The George and Helen Segal Foundation/ Licensed by VAGA, New York, NY.*

plaster figure removing the final letter from a movie marquee, 2) a large, backlit rectangular marquee gridded into eight equal sections by narrow metal strips, 3) bold red letters proclaiming CINEMA above the marquee, and 4) a small black letter R in the upper-right corner of the marquee.

About Segal's *Cinema*, we, as viewers and as art instructors, might ask: Why did the sculptor limit his palette to three hues: red, white, and black? What is the significance of the placement of these three colors? Why is the man positioned at the extreme right of the tableau? Why did Segal pose this figure with his back to us? What is the significance of the backlighting? What did Segal exclude? Why did he not include more letters on the marquee, other plaster figures, and more details of the theater? For students, such inquiries will lead to deeper understanding of Segal's aesthetic choices and the role of such choices in their own artmaking.

From Segal to Artroom Installations

The challenge for students, in constructing a tableau installation in the manner of Segal, is to create a convincing representation of a particular site that also conveys a particular psychological state or emotional tone. Even though the focus of this artmaking project is the making of purposeful aesthetic choices of inclusion and exclusion within stated boundaries (selecting a specific location, replicating the site with veracity, and creating a particular mood or psychological tone), students do have leeway in their interpretation of the assignment. For instance, instead of casting plaster figures, students might achieve a similar effect by dressing human subjects in monochromatic attire; they might construct props from cardboard or use found objects; they might dramatize their installation with lighting, a significant feature in Segal's tableaux (for this aspect, students

What Do You Think?

Could an artist use excess as a boundary for artmaking?

Installation artist Judy Pfaff has used the concept of excess as a primary strategy in creating her room-size installations, composed of copious amounts of salvaged humanmade objects, natural materials, and parts fashioned by the artist herself. *Cicelo*, a typical Pfaff piece displayed on the roof of the Denver Art Museum, was made from stretched fiberglass filaments, plastic netting, lead weights, translucent plastic forms reminiscent of ocean kelp, giant seed pods, and several pine trees heavily textured by burning, tarring, and wire wrapping.

There is no single viewpoint in Pfaff's works. As viewers physically move through the installations, they are immersed in cacophonous environments. Pfaff remarks, "Peripheral vision is and always has been crucial to my work. If you can look and see it all at once—then there is a false sense that you know it. I think if half the work is in back of you, you'll never be able to know or see it all."[34] The artist's expansive approach allows her to express a feeling of the flow and complexity of a continuously changing world.

About her approach Pfaff relates, "I'm always working towards an ever increasing vocabulary."[35] How can Pfaff avoid losing control? And how can artmaking experiences be planned so students learn to deal with excess as a formal boundary to be corralled and controlled?

Inside the Classroom: Creating an Installation

Installation can seem prohibitive for the classroom. How could you organize students to create an installation? See page 148, Inside the Classroom, for some ideas.

might first do a study of Segal's *Aerial View; The Moviehouse; Walk, Don't Walk; Cinema;* and *The Hot Dog Stand)*. Mirrors, windows, and other reflective surfaces are important in Segal's work, and students might also consider their use.

Students do not necessarily have to emulate Segal's sparse aesthetic nor his somber moods; they may take a completely different approach. The important instructional point is that students are deliberate in their aesthetic choices, guided by the intent of the installation.

Artists' aesthetic choices are deliberate and directed toward expressive ends. Although some artists, like installation artist George Segal, make formal decisions quite analytically; others, like painter Sean Scully, are more intuitive about aesthetic choices. In either approach, the artist seeks to understand the expressive consequences of his or her aesthetic choices. For mature artmaking, students too must understand the expressive consequences of artistic decisions about media, style, and formal qualities.

As art teachers, we must carefully attend to the conditions that we specify for student artmaking, and set two or three purposeful requirements for a project. By setting boundaries for students—beyond the use of available media or focus on particular elements and principles—we make conceptual concerns foremost in their artmaking. The primary focus for students must be their exploration of ideas and their solutions about how media, style, and formal boundaries can serve the expression and exploration of the ideas. In setting aesthetic boundaries, we do not make aesthetic decisions for students, but we do provide a framework to enable them to make such decisions.

5.7 Michelle Lipp and Amy Pavolino constructing an installation, 1996. Art-education undergraduate students at The Ohio State University.

Notes

1. Robert Motherwell in a conversation with students, April 6, 1979; in Stephanie Terenzio, *Robert Motherwell and Black* (Storrs, CT: William Benton Museum of Art, University of Connecticut, 1980), p. 128.

2. Ronald A. Finke, Thomas B. Ward, and Steven M. Smith, *Creative Cognition: Theory, Research, and Applications* (Cambridge, MA: MIT Press, 1992), p. 62.

3. Terezio, p. 142.

4. Ibid., p. 125.

5. Terry Friedman and Andy Goldsworthy, eds. *Hand to Earth: Andy Goldsworthy Sculpture, 1976–1990* (New York: Abrams, 1990). 52–55.

6. Jules Schwendenwien, "Cravings: Food into Sculpture," *Sculpture* (Nov/Dec 1992), p. 45.

7. David Bohm, Lee Nichol, ed. *On Creativity* (New York: Routledge, 1998), p. 16.

8. Ibid., p. 16.

9. Elaine Reichek, personal communication, July 21, 1998, Virginia Beach Contemporary Art Center.

10. Armin Zweite, "To Humanize Abstract Painting: Reflections on Sean Scully's 'Stone Light,' catalogue essay, in Ned Rifkin, *Sean Scully: Twenty Years, 1976–1995* (Atlanta: The High Museum of Art, 1994), p. 21–30.

11. Judith Higgins, "Sean Scully and The Metamorphosis of the Stripe," *ArtNews* (November, 1985), p. 104.

12. Ned Rifkin, *Sean Scully: Twenty Years, 1976–1995* (Atlanta: The High Museum of Art, 1994), p. 65.

13. Ibid., p. 107.

14. Carter Ratcliff, "Sean Scully: The Constitutive Stripe," *Sean Scully: The Catherine Paintings* (Fort Worth: Modern Art Museum, 1993), p. 9.

15. S. Muchnic, "Rocking and Striping," *ArtNews* (September 1992), p. 13.

16. Zweite, p. 25.

17. Rudolf Arnheim, *The Genesis of a Painting: Picasso's Guernica* (Berkley: University of California Press, 1962), p. 133.

18. Rifkin, p. 66.

19. Ratcliff, p. 11.

20. Piet Mondrian, *The New Art—The New Life: The Collected Writings of Piet Mondrian*, H. Holtzman and M. S. James, eds. & trans. (Boston: G.K. Hall, 1986), 237–238.

21. Higgins, p. 106.

22. Ibid., p. 108.

23. Zweite, p. 27.

24. In this *Art Education in Practice* series, Terry Barrett has authored *Talking about Student Art*, (Worcester, MA: Davis Publications, 1997), which is extremely useful for art teachers who want to engage students in discussions about classroom artmaking.

25. Marcia Tucker, "An Interview with Deborah Butterfield," *Horses: The Art of Deborah Butterfield* (Coral Gables, FL: Lowe Art Museum exhibition catalogue, 1992), p. 53.

26. Ms. Hartley-Cardis teaches in Cardington, Ohio.

27. Phyllis Tuchman, *George Segal* (New York: Abbeville, 1983), p. 23

28. Gail Levin, ed. "Artist's Panel," *Art Journal*, 41 (Summer 1981), 150–54; Symposium held October 27, 1980, at the Whitney Museum of American Art.

29. Tuchman, p. 110.

30. Ibid., p. 42.

31. Ibid., p. 110.

32. Phyllis Tuchman, *George Segal* (New York: Abbeville, 1983), p. 5.

33. Tuchman, p. 28.

34. Judy Pfaff, "Sculptor's Interviews," *Art in America* (November 1986).

35. Ibid.

Chapter

6

Designing Studio Instruction

Designing studio instruction that engages students with meaning making is a complex task. All the various components of the artmaking process—big ideas, personal investment, problem solving, a knowledge base, formal choices, media choices, subject matter, technical skills—must be integrated into a holistic learning experience for students.

The components of the artmaking process can be broken into two categories: those factors directly linked with artmaking; and those that support artmaking. Factors that require a direct engagement with the artmaking process include problem solving and decision making with predetermined boundaries such as media, subject matter, and formal choices. Indirect, supporting factors include big ideas, personal investment, and the development of a knowledge base for the artmaking.

Unit Plan

I Conceptual Framework

Develop a conceptual structure that includes:

- A big idea. State the big idea that will drive the artmaking unit.

- Key concepts. List the important concepts about the big idea.

- Essential questions. Ask three or four questions that encapsulate the most important concepts about the big idea.

- Key artistic concepts. State the primary concepts that will inform the unit from an art perspective.

II Supportive Instructional Activities

Develop the instructional activities that will permit students to:

- Explore key concepts about the big idea.

- Address the big idea through the unit artists and artworks.

- Learn about relevant artistic ideas.

- Develop a body of knowledge specifically for artmaking—about subject matter, media, and techniques.

III Artmaking Activities

Develop one or more artmaking activities that will permit students to:

- Explore and express the big idea.

IV Assessment

Create assessment criteria that evaluate student understanding of:

- The big idea, essential questions, and key artistic concepts.

A Unit Format

A straightforward instructional unit may be organized into four essential sections: 1) conceptual framework, 2) supportive instructional activities, 3) artmaking instructional activities, and 4) assessment. Each section is planned to engage students with exploring and expressing the big idea. See "Unit Plan" (at left) for an explanation of the four components of an instructional unit, and Chapters 1–5 for amplification of the components of the artmaking process: big ideas, personal connections, knowledge base, boundaries, and artmaking problem solving.

Guidelines for Teachers: Conducting Unit Research

To design artmaking instruction for in-depth learning, teachers must first build their own knowledge base about the unit's big idea, biographical information for relevant artists, unit-related artworks and the social context of their creation and presentation, and associated artistic ideas. With such a knowledge base at their disposal, teachers are better able to design instruction that engages students with rich learning experiences. Meaningful content is given to artmaking, artists' biographies inform students about professional practices, presentations of artists' artworks provide students with a range of possibilities for their own artmaking, delving into artistic ideas contextualizes art and artmaking with larger ideas, and social context locates art as part of the fabric of life.

Why Research Big Ideas?

Big ideas—and their accompanying key concepts and essential questions—form the primary conceptual framework for designing artmaking instruction (see Chapter 1). Research about big ideas may be as simple as creating a list of key concepts about the idea, or it may be as involved as exploring multiple per-

spectives of the idea in a variety of resources. Armed with a well-developed understanding of the big idea, teachers can avoid designing instruction that presents a big idea in a shallow manner or that misrepresents the big idea. Instead, they can help develop students' understanding of the idea in a supportive structure that carries their artmaking beyond the manipulation of media to the exploration and expression of meaning.

Research about big ideas can extend to many other fields. For instance, the big idea of heroes might involve historical research to learn the criteria that determines what makes a hero in various societies at different times; or it might entail research into literary works or popular culture to develop a richer context for understanding how and why societies create heroes.

Why Research the Artist's Personal History?
By providing students information gleaned from research into an artist's background, teachers can make the artist come alive for students and enlarge their understanding of the realities that confront artists. Application of the research can inform students about the artist's working routines, artistic influences, training, financial support for his or her artmaking, and so on.

Why Research the Artistic Context?
By placing an artist within a tradition of artmaking, teachers help students realize that "art comes from art"—that all artists depend upon models and prior artmaking. Students, for instance, may recognize how an artist extends the work of previous artists or challenges prior artistic ideas. Although student artmaking is dependent upon models for artistic ideas, its goal is not to mimic the models but to be stimulated by them to understand the possibilities for

Teaching Tip

Designing classroom art instruction around big ideas can originate with:

- a big idea
- an artist's work
- a specific curriculum concern
- an existing project
- a special learning opportunity.

The big idea should remain the focus of instruction, regardless of where planning begins.

Frequently-Asked Questions

Should an instructional unit include more than a single artist?

For the sake of clarity, the unit in this chapter focuses upon a single artist. However, including several artists who work from a similar big idea appears to be a better instructional strategy. Students receive a more comprehensive understanding of the idea and how it may be interpreted in different ways. Yet, a single-artist focus is preferable to a shallow treatment of too many artists. A variety of artists may be presented in a unit, but it is important to include in-depth study of at least one.

Frequently-Asked Questions

What should you know about the artist for instruction?

A Starter List of Research Questions

Why did this person decide to become an artist?

What is a typical day for the artist?

What is the artist's family background?

How does the artist support him/herself?

Who are other artists known by the artist?

What is the artist's working routine?

Where does the artist work?

How was the artist trained?

Where does the artist find ideas for artmaking?

How does the artist conduct research?

How many works does the artist make at one time?

How long does it take for the artist to complete a work?

Does the artist have assistants?

How does the artist know when a work is finished?

Does the artist rework artworks after a period of time?

artistic expression. If we expose students to artists other than their peers, their artmaking will have much to nourish its growth.

Why Research the Social Context?

Even if the context of an artist's work does not have an overt connection to social issues, consideration of such issues is important. Art derives its meaning not just from personal perspectives; all artworks must be viewed within a social context, related to the time and place of creation, as well as to the viewer's time and place.

For example, sculptor Claes Oldenburg (see Chapter 4) creates monumental sculptures from commonplace objects found in the contemporary world—baseball bats, clothespins, fast food, hand tools, and sneakers. Oldenburg's sculptures do not directly speak about social matters, but if viewers wish to interpret and understand the artworks, they must consider the context—that of an industrialized, consumer society. Big ideas about materialism and the role of manufactured objects in contemporary society inform the understanding of Oldenburg's sculptures.

As another example, contemporary artist Sean Scully (see Chapter 5) creates large expressionistic paintings that speak to the emotional and spiritual side of life. Although not directly linked to contemporary society, Scully's paintings achieve increased meaning when placed in the context of a secular society, one that favors the material aspects of life over the spiritual. Neglecting their social context would diminish our understanding of Oldenburg's and Scully's works.

Social values and beliefs are directly or indirectly embedded in all artworks. Artists express personal views and beliefs, but these perspectives have a

social dimension that enlarges the meaning of an artwork beyond the individual artmaker.

A Model Artmaking Unit on Changed Meanings

The following model unit, which demonstrates how to design artmaking instruction for in-depth learning, describes the required research about the big idea, artist, and artworks; the conceptual framework; instructional activities that support the artmaking activities; and the actual artmaking activities.

Research Results: The Big Idea

Changed meanings, the unit's big idea, is highly abstract and best understood in specific works. Contemporary sculptor Donald Lipski, the unit's

6.1 *Donald Lipski,* Untitled #289, *1989. Axe with glass and wood block, 48" x 96" x 96" (122 x 244 x 244 cm). Courtesy of the artist and Galerie Lelong, New York.

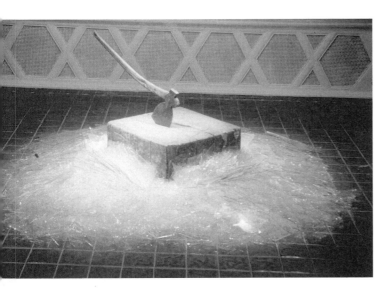

Frequently-Asked Questions

How should you present information about the artist?

Even high school students are not inclined toward a lecture format for learning about artists and artworks. It is more effective to feed students artist information at strategic points in the unit. Integrate information into the learning purposes of the unit, rather than presenting as a separate body of knowledge.

Teaching Tip

Be aware of students' readiness to learn more about an artist. Once students have seen an artist's works, they often become curious about the artist's background, and how and why the works are produced.

What's Wrong with This Picture?

Gardens are the subject matter of Jennifer Bartlett's *In The Garden* series, but gardening is not the big idea that informs Bartlett's creation of the series (see page 4). In a professional development meeting for art teachers at Ocean Lakes High School in Virginia Beach, Bartlett was one of several artists chosen for an instructional unit on gardens. As the teachers began to consider Bartlett's series and learn more about Bartlett, it became apparent that the artist's primary interest concerned experimenting with the rules and systems that inform artmaking. It was not wrong to interpret Bartlett's drawings from the perspective of gardens, but without knowledge of her larger concern with rules and systems, the lesson, as well as any understanding of Bartlett's work, was incomplete.

Frequently-Asked Questions

Does it take more time to teach with big ideas?

Teaching with big ideas does usually require more instructional time. The learning purposes are complex. Students are involved with content that extends beyond art production to include understanding from the world of ideas. Fewer art projects may be completed by students, but the learning goes deeper and wider. Students learn how artmaking and artworks are a source of understanding ideas.

Frequently-Asked Questions

How important is sequence in a unit of instruction?

Cognitive learning theory emphasizes the importance of knowledge organization for learning. If knowledge is not meaningfully connected, it has little value. The implications of this for instructional planning are that the sequence in which knowledge is presented to students must be meaningful. Knowledge must be thought of in terms of building blocks, scaffolding, and connections. As teachers, we must ask ourselves "What do students need to know first so they can understand what follows?"

artist, creates sculptures from everyday objects, and this subject is an obvious choice for considering how meaning changes. Questions to guide understanding the concept of meaning and how it changes are: How might everyday objects acquire meaning? Can everyday objects have multiple meanings? How might the meanings of everyday objects change?

Additionally, a list of key concepts about the big idea, such as the following, will aid in understanding the implications of the idea, and can thereby give purpose and direction to instructional activities:

- Objects can have personal and social meanings.
- Objects can have multiple meanings that relate to function, economic value, social status, and aesthetic qualities.
- Objects can have hidden meanings.

Research Results: The Artist's Background

Since 1974 Lipski has had over thirty solo exhibits; participated in numerous group exhibitions; held the first exhibition of the Southeast Contemporary Art Center's pilot project, The Artist and the Community (1994); and created on-site installations for the Capp Street Project in San Francisco (1993); The Contemporary Arts Center in Cincinnati, Ohio (1991); The New York Experimental Glass Workshop in Brooklyn (1991); and The Fabric Workshop at the Philadelphia College of Art (1990). This lengthy career evidences the seriousness with which Lipski's work has been received, even though his work breaks sculptural norms about media and artmaking, and often has distinctly whimsical or perplexing effects.

Research Results: The Artistic Context

As a contemporary sculptor, Lipski continues an artistic tradition begun around 1918, when Marcel Duchamp signed and exhibited a snow shovel, porcelain urinal, and bottle rack as legitimate artworks.

Duchamp reasoned that, as an artist, he could dispense with artmaking and, instead, merely select objects from the world of interesting things. He termed these artworks "readymades," and proclaimed that the creative act could be reduced to a choice of the mind rather than that of the hand. This act resonates in contemporary art.

Lipski, for example, has constructed sculptures from such ordinary objects as an axe, razor blades, a

6.2 "Our sculpture represents fear and death."
Group project, Fear and Death *(after Lipski), 1997. Vases, wooden beads, paintbrush, string, Grade 6 students at An Achievable Dream Academy, Newport News, VA. Carlton Emblidge, art teacher.*

Frequently-Asked Questions

What should you know about the social context to interpret an artist's work?

What relationship do these artworks have to society?

Do the artworks express overt political content?

Do the artworks raise gender issues?

What spiritual or religious beliefs, or traditions, are referred to by these artworks?

What ethnic or racial issues are raised by these artworks?

What social values or beliefs are referred to by these artworks?

Who is generally the audience for these artworks?

Who decides the value of these artworks?

How are these artworks used by society?

Teaching Tip

Art instruction must be developed from an informed perspective. To avoid unintentionally misrepresenting an artist, first identify the artist's big idea and then plan for teaching about the artist and his or her work.

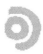

Inside the Classroom

The interaction of humans and nature is ideal as a big idea for student inquiry. What are environmental artworks and earthworks all about? How do some artists (such as Walter DeMaria, Mel Chin, and Maya Lin) explore the ways humans and nature connect? What are some ways students can learn about the process of planning such an artwork? See page 149, Creating Proposals for Environmental Artworks, for some answers to these questions.

tea kettle, and high-heeled shoes (see page 20). Unlike Duchamp, however, Lipski is highly concerned with aesthetic appearances. He actively pursues object combinations that are visually alluring, in spite of their irrationality. The aesthetic appeal of Lipski's sculptures is a significant factor in persuading viewers to find meaning in his bizarre combinations.

Lipski's sculptures also have strong Surrealist ties, although, as art critic Nancy Princethal recognized: "The Surrealist label doesn't quite fit… Surrealism exalted the time-encrusted found object, redolent of personal and collective meanings. Lipski, on the other hand, prefers the new objects that are unencumbered by nostalgia."[1]

Nevertheless, Lipski's sculptures exhibit a weird logic, and art critic Eleanor Heartney characterized Lipski's work with the familiar Surrealist tenet of "making the familiar strange."[2] She has described Lipski's sculptures as "[w]renched from their usual context and recombined in unexpected ways, such ordinary items as rusty tongs, weathered books, pickaxes, buckets and plastic shoes become objects of contemplation."[3] Lipski himself has commented: "More than anything you just try to keep busy, try to keep reassembling the world."[4]

Research Results: The Social Context
Lipski's works do not appear to have strong social content or connections, other than his use of manufactured products of contemporary society. However, there are exceptions: the *Flag Ball* series, in which Lipski created a number of sculptures from the American flag; and his *Oral History* series, sculptures created from cigarettes. *Oral History* (1994), created in Winston-Salem, North Carolina, is quite controversial, since tobacco products have been linked to health problems.

Because Lipski has mostly chosen less controversial objects for his other sculptures, they are not so laden with social connotations. However, even the choice of everyday objects does carry social connotations. For instance, Lipski's sculpture of high-heeled shoes stuffed with long-stemmed red-tipped matches cannot be disassociated from gender issues (see page 21).

Changed Meanings: An Artmaking Unit for Elementary, Middle, and High School

1. The Conceptual Framework

Changed meanings are a key idea in Lipski's sculptures and serve as the primary concept for this artmaking unit. As an example, Lipski's axe and glass sculpture (fig. 6.1)—a wooden butcher block embedded with an axe—denotes the act of chopping wood; but the surrounding shards of broken glass divulge the axe's more violent potential. His sculpture *Untitled* (high-heeled shoes, long-stem matches) connotes female power, energy, and sexuality, and thereby demonstrates how his unusual object combinations often alter the usual meanings of the everyday objects. The changed meanings here are not extreme: the new, or changed, meanings remain within the range of possible meanings for these objects.

Other Lipski sculptures show greater differences in changing the meaning of an object. For instance, his sculpture *Untitled* (candle, trumpet, wax) of a single lighted candle inserted into the mouthpiece of a trumpet that has been encased in a layer of wax, greatly alters the meaning of the trumpet as a musical instrument. Silenced and no longer able to produce sound, the trumpet now serves another function: its meaning has changed from an active to a passive function, and its secular meaning has been transformed to a spiritual connotation. Rather than conceiving of the trumpet as an instrument associated with the secular world of jazz, by serving as a support and holder for the lighted candle, the trumpet can acquire spiritual connotations often linked with sacred occasions and lighted candles such as weddings, funerals, and other religious observances.

Once a big idea has been identified, the next step is to unpack the idea with key concepts and essential questions (see page 6). Key concepts are often better understood and more useful for students when they are stated as questions. Curriculum theorist Heidi Hayes Jacobs suggests identifying essential questions as a strategy for organizing instruction, and contends that choosing essential questions forces teachers to make important choices about the conceptual outcomes for instruction.[5]

Key Concepts for the Unit
- Objects can have personal and social meanings.
- Objects can have multiple meanings that relate to function, economic value, social status, and aesthetic qualities.
- Objects can have hidden meanings.

Essential Questions for the Unit
- How might objects acquire meaning?
- How might objects have multiple meanings?
- How can the meanings of objects be changed?
- What are hidden meanings in objects?

The key concepts and essential questions derive from the big idea that drives the unit—not from the specific artist and artworks. Although artistic content is significant for instruction, it becomes more meaningful for students if placed within the framework of big ideas that extend beyond the area of art.

2. Supportive Instructional Activities

Supportive activities develop students' knowledge base and understanding needed for the artmaking activity. The activities are based on essential questions, which may be repeated with different activities so as to deepen students' understanding. Students need knowledge not only about the "how to," but also about the big idea and subject matter that they will be using. (See Chapter 3 for more about building a knowledge base.)

Supportive Activity A

Essential Questions

- How might objects acquire meaning?
- How might objects have multiple meanings?

Collect a large number of household objects, and have students group them into four categories, such as by function, gender, age level, social status, aesthetic qualities, and economic value.

Learning Purpose

The purpose of the activity is to generate a discussion about the meaning of objects. Students might consider such questions as: What do the categories reveal about the objects? Which category seems most important? How would our understanding of an object change if we placed it in another category?

Supportive Activity B

Essential Questions

- What are hidden meanings in objects?
- How can objects change their meanings?

Provide students with reproductions of several of Lipski's sculptures, and ask students to interpret them for hidden and changed meanings. The following questions can guide class discussion and interpretation:

- How did Lipski combine the objects in each of the sculptures to appear as though they belong together?
- Is each of the sculptures beautiful? Ugly? Electrifying? Why?
- What other words describe each sculpture? Why?
- What obvious meanings do you associate with the objects in each sculpture?
- What hidden meanings are revealed? Why, do you think?
- What meanings about the objects have been changed?

Learning Purpose

This supportive activity engages students with Lipski's work so as to deepen their understanding about meaning in objects. Viewing Lipski's unusual object combinations allows for thinking about everyday objects from new perspectives.

Supportive Activity C

Essential Questions

- How might objects acquire meaning?
- How might objects have multiple meanings?

Have students organize an assortment of household objects into a continuum ranging from beautiful to ugly. Use the continuum to discuss the aesthetic qualities divorced from the functions of the objects. Once the continuum is complete, students might be allowed to reposition objects and talk about their reasons for doing so.

Learning Purpose

The purpose of the activity is to focus on a single category for understanding objects, i.e., aesthetic qualities. Often, an object's function dominates thinking about the object and aesthetic qualities are not considered.

Supportive Activity D

Essential Questions

- How might objects acquire meaning?
- How might objects have multiple meanings?

Collect an assortment of household objects. Have students brainstorm a list of characteristics about objects such as the following list generated by art teachers in Virginia Beach.[6]

Object Characteristics

- Objects have specific functions, but can acquire new functions.
- Objects have social status.
- Objects result from specific production processes.
- Objects can be temporary or permanent.
- Objects have different meanings and functions according to context.
- Objects have economic value.

Following the brainstorming activity, ask students to write a description for one particular object, place the objects in a group, trade descriptions, and find the object that matches the description.

Learning Purpose

The purpose of the activity is to help students realize the multiple ways of thinking about objects and how objects can have layered meanings.

Supportive Activity E

Essential Questions

- What are hidden meanings in objects?

Students should work in pairs to select an object from an assortment of everyday objects, and generate obvious and hidden meanings for the object. Obvious meanings could be qualities related to an object's function or economic value, while hidden meanings are related to implied qualities such as social status, lifestyle, values, and beliefs. For example, the obvious meaning of sneakers is that they are clothing for human feet, but hidden meanings relate

to social status among teenagers, or sports figures, fame, and commercialism.

Object		
Obvious meanings		Hidden meanings

Students present their objects with obvious and hidden meanings for a general class discussion.

Learning Purpose

The purpose of the activity is to develop students' understanding that, in addition to more obvious meanings, objects also carry symbolic meanings. This activity should prepare students for interpreting the hidden meanings in Lipski's sculptures.

3. Artmaking Activity

The artmaking activity for the unit builds upon the knowledge and understanding that students have acquired in the supportive activities.

Essential Questions

- What are hidden meanings in objects?
- How can objects change their meanings?

Activity

Have students each use simple joining techniques—such as tying, wrapping, and gluing—to create an object-based sculpture from two or three household objects.

Problem Solving

The artmaking problem is to join two or three objects that are not usually linked by their meaning, but also to visually combine them so that they appear as though they belong together. As explained in Chapter 4, the design of the artmaking problem

Frequently-Asked Questions

Can a unit have more than one artmaking activity?

Teachers often don't consider this option. Sometimes, students may be better served by creating several short artmaking projects than a single more time-consuming project. Or, a unit may include a short artmaking project that leads to a more in-depth project. Think of ways to structure a unit that vary from the norm of having students create one artwork at the end of a unit.

Object sculpture combinations created by students include:

- A candlestick with a carrot replacing the candle. (university undergraduate)
- A brass basin filled with water and several hundred pennies. (high school student)
- A vise with an apple placed in its jaws. (university undergraduate)
- A toy car attached to a belt and set of keys. (elementary student)
- A toaster bulging with protruding knives, forks, and spoons. (high school student)
- A bugle stuffed and entwined with plastic roses. (high school student)
- A battery charger wrapped with a red ribbon and a large pair of scissors. (high school student)
- An alarm clock bound with a coat hanger and gravy ladle. (high school student)
- A baseball wrapped in a CB cord. (high school student)[7]

begins with a big idea; the artmaking problem then becomes an extension of the big idea. A good artmaking problem either explicitly or implicitly incorporates key concepts derived from the big idea.

The big idea for this unit is changed meaning in objects, and the key concepts are that objects can have personal and social meanings; multiple meanings that relate to function, economic value, social status, and aesthetic qualities; and hidden meanings. The artmaking problem is one of making an object sculpture that subverts the normal meanings of the objects, and that creates new meanings or reveals hidden meanings.

By constructing artmaking problems with contradictory or diverse elements, artists are able to think differently about big ideas. Creativity research contends that problems with a wide range of diverse and inconsistent elements will produce a wider range of responses than problems with more consistent elements.[8] The implication for the classroom is that designing artmaking problems with divergent elements can motivate students toward more innovative thinking.

Setting Boundaries

Number of Objects: Lipski usually limits his sculptures to two or three objects. For students, a limitation to two or three objects for the sculpture will result in a stronger dialogue between the objects.

Size of the Objects: Size is important: restrict students to objects that can be placed on a table. Note: objects that are pencil-size or smaller are too small to achieve the necessary visual impact.

Condition of the Objects: Unlike 1950s assemblage sculptors (such as Rauschenberg and Kienholz), Lipski prefers new objects to worn, nostalgic, discarded items. Because most of the items that students find

will be used objects, limitation to new objects is not practical.

Real Objects: It is important to use real objects. If real objects are not used, the outcome is radically different. For example, a middle school art teacher used Lipski as inspiration for a collage project with images from magazines. Many of the collages included images of people. The artmaking problem became one about creating surreal personages, rather than one of irrational groupings of objects. Further, the collage approach had students simply overlapping forms instead of having to physically fit them together. The results resembled dream imagery. Creating surreal situations that could occur only in dreams or the imagination is quite different from Lipski's reality-based objects.

Personal Connections

By finding their own objects, students may personalize their object-based sculptures. Students need not locate objects to which they have a personal attachment; what is more important is that they find objects that they personally find visually interesting and appealing. When instructing students about selections for their sculpture, remind them that Lipski searches for objects that he considers visually stimulating and intriguing.

Interpreting the Artworks

Encourage students, as they create their object sculpture, to focus on selecting object combinations for their disparate qualities and then physically combining these objects in a visually convincing manner. Guide students not to interpret the meaning of their sculpture as they work, and explain that artists do not usually preconceive meaning. Instead, artists generally leave meaning open, letting it evolve while

6.3 Ryan Blank, Untitled (after Lipski), 1996. CB cord, baseball, wire, approx. 4" x 5" x 7" (10 x 13 x 18 cm). Cardington High School, Cardington, Ohio. Rebecca Hartley-Cardis, art teacher.

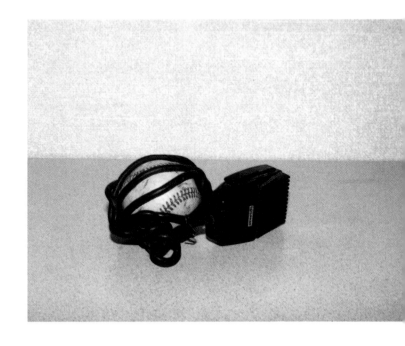

Student Talk

Interpretation is an essential part of the artmaking process. It can occur both while the works are being produced and after they are completed. The following interpretations demonstrate the students' abilities to find changed meanings in four unusual combinations of objects: a baseball wrapped with a cord, a vase of dead leaves, a handsaw chained to a globe, and a plastic glove filled with dirt. The interpretations were written by classmates of the student artists, following a study of Donald Lipski's object sculptures.

Object Sculpture: Baseball and CB Cord (middle school student)

The sculpture consisted of a baseball intricately wrapped with the cord from a citizen's band radio. A classmate interpreted:

"This is about communication around the baseball strike. The ball is trapped inside of all the arguing, denying its function of producing the game and play is tied up."

Object Sculpture: Glass Container with Dead Leaves (high school student)

In a photography course, students made object sculptures and photographed the results. A classmate interpreted a photograph of a container tipped over with leaves spilling out of its mouth:

"Man cannot contain, stifle or limit nature although he tries to control it. Everything dies, you cannot contain death."

Object Sculpture: Handsaw, Chain, and Globe (high school student)

In the same photography class, a student interpreted a photograph of a saw chained to the side of a globe:

"The saw represents the destruction of the earth by disease, war, man's technology or any ill...The chain is the force holding the world together."

Object Sculpture: Yellow Glove Filled with Dirt (undergraduate student)

The sculpture consisted of a yellow plastic glove filled with dark brown dirt. A classmate interpreted:

"I believe this is making a statement about housewives. Since the hand is hard and cold to the touch, it appears to be dead. So in a sense, it could be saying that housewives are not really living because they do not live outside their house. Their lives are only about taking care of their house and family, and not taking care of themselves. ...Visually, this piece has a lot to offer. Its bright yellow color jumps out at you. Its brightness penetrates your eyes and reaches your soul. Your eyes get lost in the tiny bumps on the palm and on the bottoms of the fingers. Aside from its visual aspects, the physical aspects are quite creepy. The glove feels as if a dead hand is within it."[9]

6.4 Elizabeth Czekner, Yellow Glove *(after Lipski). Rubber glove, dirt, 1996, Art-education undergraduate student at The Ohio State University.*

6.5 *Michael Thomas Gromley,* Untitled *(after Lipski), 1996. Metal vise, organic apple, 5" x 3" (13 x 7.6 cm). Art-education undergraduate student at The Ohio State University.*

working through the artmaking process—and even after the works are completed. This approach is more likely to produce innovative, unusual results; so, if students begin the object sculptures with preconceived new or hidden meanings, much of the play and inventiveness is eliminated from the process, and they are more likely to produce prosaic results.

Assessment

The assessment for the art unit derives from students' understanding of the big idea, changed meanings; and the assessment is guided by the unit's essential questions (see page 103), which students should be able to explain or interpret. Teachers must construct unit-specific criteria—usually culled from a generic rubric and restated—for evaluating the level

Frequently-Asked Questions

When should assessment occur?

Assessment should occur throughout the unit—whether it is informal assessment, self-assessment, or formal assessment.

Frequently-Asked Questions

How do you assess student artworks?

Often teachers are perplexed about assessing student artworks. It is not enough to have a vague idea of what counts as a successful work. Both teachers and students need to work with specific criteria.

Generally, criteria for assessing artworks fall into four categories: 1) formal requirements, 2) technical skill and craftsmanship, 3) originality, and 4) content. Each of these categories can be adapted to a particular project. Further, the categories should be weighted, depending upon the project. Sometimes originality is the primary goal and technical skill is not nearly as important while in other instances technical skill will be weighted more heavily.

Teaching Tip

When evaluating the content of an artwork, it is necessary to have student reflection (verbal or written) to assess. That is, students should describe the inspiration and process that resulted in their final artworks.

of students' understanding (see page 10 for a rubric using specific criteria).

Having several (usually, two to four)—but not too many—criteria for each level of understanding and performance is critical. A limited number of criteria allow students to focus on particular skills throughout the unit. If confronted with an overwhelming number of criteria, students will likely lose focus, and the intended function of the criteria will be lost.

Assessment criteria should not be a hidden from students; rather, they should be fully aware of the criteria before beginning the unit. For instance, if students know from the beginning of the object-sculpture unit that they will be assessed on their ability to interpret the meanings of objects, how the meanings can change, and the conditions that create change, they will more likely achieve such objectives than if they are revealed only at the conclusion of the unit.

Assessment Rubric

Excellent	Good	Fair	Needs Work
• fully supported explanation/interpretation • summarizes important points and makes connections • makes inferences, suggests implications • gives illuminating examples • investigates subject matter widely and deeply • compelling explanation/interpretation • makes perceptive comparisons, striking contrasts • offers new insights • produces imaginative, unpredictable solutions • deep and broad explanation/interpretation • critically analyzes options • raises significant questions • employs multiple perspectives • extends well beyond the information given	• reasoned, convincing, complete explanation/interpretation • supports with reasons, evidence • states main ideas • gives examples • personalizes knowledge • offers insight	• incomplete explanation/interpretation • states with limited support • makes sweeping generalizations • lacks complexity	• inadequate explanation/interpretation • describes without evident purpose • employs symbols in a literal manner • applies ideas in a disconnected manner

Further, if we present these criteria in levels of achievement—such as excellent, good, fair, and needs improvement—students will have an even better idea of how to meet the criteria. For instance, if students know that "innovative ideas supported by reason and evidence" will produce an excellent interpretation and serve as evidence of their understanding of how meaning can be changed in an object sculpture, they will have the specific objectives to work toward.

Understanding is an abstract notion. However, if teachers are armed with specific behaviors and strategies that illuminate what constitutes understanding and how it is achieved, they can better instruct for understanding. Such preparation prevents the vagueness that often accompanies this desirable, but often illusive, goal of meaning making in the artroom.

If an assessment is to focus on students' production of the object sculpture, other criteria and rubrics are necessary. For teachers to assess student artworks fully, students must provide both the visual product and a written or verbal statement. Teachers might adapt the generic rubrics for assessing students' statements, but also use the criteria and rubric for the visual products. (Generic rubrics such as the one on page 110 for assessing student expressions may be adapted for this unit or for other artmaking projects.)

Formal assessment occurs primarily at the conclusion of the unit, as a summative activity. Assessing each individual activity can be overwhelming, although teachers may conduct informal assessments during class activities, noting student verbal and written responses as the unit progresses.

An artmaking unit's primary components—conceptual framework, supportive instructional activities, artmaking instructional activities, assessment—comprise a general plan for designing artmaking instruction for students' understanding and in-depth learning. The big idea, and its related essential questions, is the conceptual key of the unit plan, and all instructional activities are directed toward students' understanding of it. Key artistic concepts about artmaking, interpretation, and the context of artworks are part of a framework that maintains that art instruction, to attain relevance and meaning, must be presented in the context of larger ideas—those related to universal human concerns.

Within the supportive instructional activities, essential to the richness of the artmaking process as a meaning-making endeavor, students are introduced to the big idea and develop a knowledge base for their own artmaking. The knowledge base is wide-ranging: it may encompass the big idea; artists who use the same big idea; and subject matter, media, and techniques that will be used by students in their artmaking. If students fail to adequately develop the needed understanding, they cannot apply such in-depth knowledge to their own artmaking.

Although the design of the studio activity does not mimic the featured artist's work, it does serve as a model of possibilities. For simplicity, the units of study in this text focus on a single artist. However, including more than one artist in a unit is advantageous in that students will be able to compare different approaches to the big idea. Regardless of the number of artists presented, primary focus should rest on examination of one or two; otherwise, students will likely gain only a shallow understanding of how the big idea can be interpreted through art-

making. Teachers must select artists who strongly represent the big idea; they must then research to gain a clear understanding of what the artists are about. Weak or misunderstood examples of a big idea are not helpful to student learning: they will confuse rather than enlighten.

Changing the artist's subject matter or finding a new perspective for the subject matter is often necessary in order to personalize the artmaking for students. This type of change usually does not interfere with the big idea. Hence, it is the big idea that is crucial: media, formal choices, techniques, styles, and subject matter reinforce its exploration.

This approach toward artmaking instruction—through big ideas and supportive instructional activities—requires considerable time for research, planning, and implementation. Teaching for understanding is time-consuming—in teacher time and in instructional time. Cramming a single class period with as many big ideas, artists, media, techniques, or artmaking problems as possible is not the goal; rather, the goal is to teach students a process. If students internalize the process of exploring big ideas, using key artmaking strategies for exploration and meaning making, they can transfer this process to other big ideas, artists, artworks, and artmaking beyond the context of the artroom.

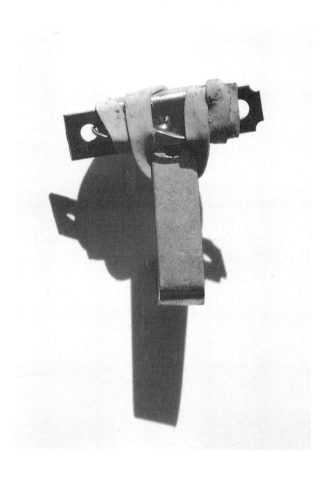

6.6 Untitled *(after Lipski), 1998. Leather belt, metal picture hangers, rubber bands. Grade 5 student at Plew Elementary, Niceville, FL. Jim Castleman, classroom teacher; Dee Van Dyke, art teacher.*

Notes

1 Nancy Princethal, "Donald Lipski at Paul Kasmin and Lennon, Weinberg," *Art in America*, (July 1990), 164-165.

2 Eleanor Heartney, "Donald Lipski, Germany's van Eck," *ArtNews* (November 1985).

3 Ibid.

4 Ibid., p. 124.

5 H. H. Jacobs, "Redefining the Map Through Essential Questions," *Mapping the Big Picture: Integrating Curriculum and Assessment, K–12* (Alexandria, VA: Association for Supervision of Curriculum, 1997).

6 Teachers were participants in a graduate art-education course, Artmaking with Contemporary Art, taught by the author at Ocean Lakes High School in Virginia Beach.

7 The college students were Ohio State University art-education undergraduates. The high school students were from Cardington High School in Cardington, OH; Canal Winchester High School in Canal Winchester, OH; and Ocean Lakes High School in Virginia Beach, VA. The elementary student was from Rosemont Elementary School in Virginia Beach.

8 Ronald A. Finke, Thomas B. Ward, and Steven M. Smith, *Creative Cognition: Theory, Research, and Applications* (Cambridge, MA: MIT Press, 1992).

9 The middle school interpretation was written by student in an art class taught by Ms. Rebecca Hartley in Cardington, OH. High school students were in a photography class taught by Ms. Sandra Packer at Canal Winchester High School. The undergraduate interpretation was written in an art-education methods course taught by the author at The Ohio State University.

Chapter

7

Ways of Working: Artists' Practices

"I write as much to discover as to explain."[1]

—Arthur Miller, in his notes for *Death of a Salesman*

Artists pursue artmaking as an investigation, exploration, and discovery of meaning. Although artists' works may be quite different, many of their artmaking practices reveal strong similarities, and it is these artmaking practices that teachers may use with students to promote artmaking as inquiry. The following are among the practices that are crucial in the pursuit of artmaking as a meaning-making endeavor:

- purposeful play
- risk taking
- experimentation
- postponement of final meaning
- searching; questioning

Frequently-Asked Questions

How do artists discipline themselves to get their work done? What are their rituals for "getting down to work"?[2]

• Sean Scully says a long soak in the bathtub with a newspaper or book is a requirement before facing the studio. He stays in the tub around forty minutes—it's a daily ritual.

• Robert Moskowitz comments that the rituals take place between paintings, not on a daily basis. One of these rituals is cleaning up the studio when he has finished one work so he can go onto the next. He says the cleaning up process clears his head.

• Installation artist Mike Bidlo remarks that it doesn't hurt to go to the gym before starting to work in the studio.

• Many artists such as Donald Belcher and Vija Celmins feel they have to warm up to the task, and use newspaper reading as one of their rituals for getting into the studio.

Inside the Artist's Head

Painter Terry Winters says for him the thinking process goes on all the time, inside or outside the studio.

Three artists are examined in this chapter; their ways of working demonstrate the importance of engaging in inquiry, and speak to the ways that art instruction may be implemented. Many of the inquiry practices can be duplicated in the artroom, primarily through teacher attitudes and practices.

Students instinctively look to teachers for cues about what is expected in artmaking: Is there a particular answer to the artmaking problem, or are there multiple appropriate responses? Is it all right to experiment and take risks? If students are overtly encouraged to question, take risks, experiment, and so forth, they will more likely follow a discovery process when creating artworks.

A Preview of Three Artists' Practices

In the fall of 1994, artist Sandy Skoglund spent considerable time in her SoHo studio playing around with strawberry jam, orange marmalade, and honey. A silly idea? Skoglund eventually created an entire installation, *The Wedding* (1994), with a bride and groom treading across a sticky strawberry-jam floor surrounded by orange-marmalade walls.

In 1968, sculptor Claes Oldenburg recorded notes for creating a reservoir in the Hollywood Hills from a glowing black flashlight. The flashlight would contain hot yellow water that would be lighted at night, providing all of Hollywood with a persistent sunset glow. A silly idea? In 1978, Oldenburg created a monumental sculpture, in a plaza at the University of Las Vegas, in the form of a black flashlight almost 40' tall.

In 1980, graffiti artist Keith Haring took a large black magic marker and drew rows of crawling babies on the snowy landscape of a Johnny Walker advertisement in the New York City subways. A silly idea? Five years later, Haring had produced over 5,000 drawings in the New York subways.

To move from the kernel of an idea to its realization, artists might use the practice of purposeful play, as demonstrated in Skoglund's studio experiments, Oldenburg's notes, and Haring's graffiti. Even though artists might seem to be engaged in a kind of frivolous play, their behavior is motivated by serious purposes. Skoglund remarked about her artmaking process: "Yes, it's play, but it's intellectual play because if you don't intellectualize it to some extent to get some distance on it, then I think it just falls into pure fantasy and pure self-indulgence…"[3]

Skoglund's Artmaking Practices

Finding Ideas

For Sandy Skoglund, the evolution of meaning is a gradual process; the ideas for her installations often germinate for four or five years before she has a clear vision of a final piece. She generally works on a single installation at a time, taking at least six months to complete it.

Skoglund noted that *The Wedding*, a commission from the Columbus Museum of Art, evolved from "fooling around in the studio with this very deep-seated desire to have people stuck in stuff."[4] At that initial stage, Skoglund had no idea that the final tableau would represent a wedding. In an interview at the museum, Skoglund explained about evolving her ideas for *The Wedding*:

[W]hen I was in Europe and having a show there in Paris… talking to people there about what was going to be my next work… I just said, "Well, I want the floor to be viscous." And that led me into honey and oil, questioning does it have to be food…

So that led me to getting a lot of substances, honey, strawberry jam, marmalade. The honey could have been anything actually. I mean honey is beautiful; but it also looks like a lot of other things actually. It's a color, but not a lot of texture… for the time

What Do You Think?

What could you learn about Seurat's "ways of working" when he created *Le Grande Jatte*?

- Seurat was twenty-four years old when he started the painting in 1884. (He died at age thirty-one.)

- This was Seurat's second-largest painting, almost seven by ten feet. The largest was *Bathing at Asinieres,* created in 1883.

- May 22, 1884: Seurat begins sketches for *Le Grande Jatte* on site and in his studio. He visits the Island of Le Grande Jatte during the summer and fall of 1884 to make many studies, sometimes on cigar box lids. He makes over eighty studies: forty on small wooden panels, three large oil sketches on canvases, thirty conté crayon drawings for the monkey. Seurat went to the zoo and sketched monkeys.

- December 1884: Seurat completes studies for *Le Grande Jatte.* He populates the scene with over fifty figures. Of the eighteen largest figures, fourteen are female. Four of the females are children.

- March 1885: Seurat completes the work to exhibit with the Independents, but the show is postponed.

- October 1885: Seurat reworks *Le Grande Jatte,* altering the contours of the major foreground figures. He uses some unstable oil pigments and six years later the greens, yellows, and oranges dulled. He reworked the large painting twice.

- May 1886: The artist finishes his revisions.

- May 15–June 15, 1886: Seurat exhibits the painting in the Impressionist's eighth (final) exhibition.

- August 21–September 2, 1886: Seurat exhibits *Le Grande Jatte* in the Independents' exhibition.

- 1888: He paints a border directly on the canvas of *Le Grande Jatte,* in contrasting hues.

Fascinating Facts

Sandy Skoglund once created an installation with eighty pounds of raw hamburger. The work, *Spirituality in the Flesh*, was commissioned by *Artforum* magazine in February 1992. Skoglund created a grisly photograph of a woman and her environment almost entirely covered with raw hamburger. Needless to say, this was a temporary work which Skoglund constructed, photographed, and removed all in the same day.

being, it seemed to me that jam had a sort of jewel-like quality that I found really exciting...

I really have to say I just wanted to make a pretty piece with The Wedding. Just plain pretty, and that I would make the decisions based on that value. I wouldn't sort of build in a kind of deliberate negative underside, at least consciously. I mean things like that sometimes creep into one's work. It's not like we're ever in control of actually what our work means. I don't think. But in the case of this piece that was another very clear way for me to decide what to do. I wanted to keep it very beautiful and the glossy surface of the jam, the texture of the fruit and everything about it sort of led me to make a commitment actually to marmalade and strawberry jam.[5]

7.1 Sandy Skoglund, The Wedding, *1994. Installation. Photo courtesy of the artist.*

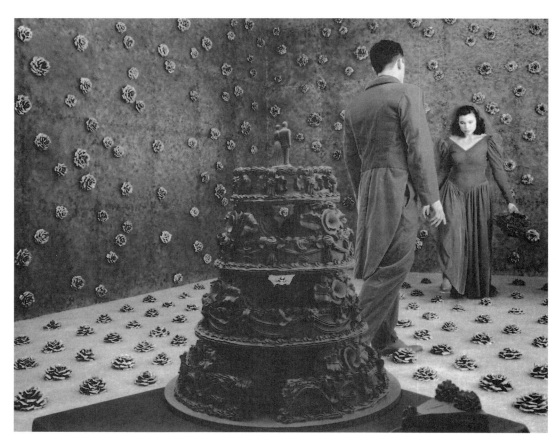

In this same interview, Skoglund observed that the notion of people stuck in stuff was, for her, about something very beautiful and awful at the same time. "Sort of like flies stuck in honey and that whole idea of attraction towards beautiful things, but then it's trapping you," she explained.[6]

Development of Ideas
Building on her initial notions and the results of studio experiments with the oil, honey, jam, and marmalade, Skoglund determined that her installation would depict a wedding. Her choice of red, rather than the traditional wedding white, was definitely a considered decision that occurred after Skoglund began to create the work. About this decision, she said: "I just wanted it [The Wedding] to be beautiful, but I'm sure the color red is a kind of insidious thing to add to a wedding…"[7]

To complete the installation, Skoglund contracted a costumer to make a red velvet wedding gown for the bride and a red velvet tuxedo for the groom; purchased a wedding cake and painted it red; sculpted, fired, and glazed 300 silvery-gray ceramic roses; and hired two actors to pose as the bride and groom for the photograph of the installation. (Skoglund photographs each installation in her studio, with human subjects, before installing it in a gallery or museum space; and she regards the photographs, 4- or 5-foot Cibachrome® prints, as separate artworks from the installations.) For the gallery or museum installations, Skoglund often substitutes mannequins for the human actors. In the case of *The Wedding*, she used a mechanized bride and groom: the bride slowly lifted her red bridal bouquet up and down; the groom repetitively turned his head from side to side.

Fascinating Facts

Skoglund poses the human actors in her installations with their faces turned away from the camera. She does this to avoid self-consciousness and to allow the work's energy to derive from the formal elements, not the human subjects.

Frequently-Asked Questions

What does an artist actually do to produce an installation?

Just as artists work very differently with any medium, so installations are not produced from a set of rules and procedures. Generally, unlike with other media, installation artists have to play various roles. For example, Sandy Skoglund produces an installation over a period of about six months. For more about Skoglund's process, see The Artist and Her Roles, on page 152.

Inside the Artist's Head

How did Sandy Skoglund decide how many cats, foxes, squirrels, or fish to put into her installations?

In constructing *Radioactive Cats*, for example, how did Skoglund know when to stop making cats? Skoglund relates that she has a certain "look" in mind, and there is a limit in terms of numbers. [8]

Inside the Artist's Head

Skoglund redirected her installation *Walking on Eggshells* (1998) three times, changing from a birthday party theme to monkeys cavorting in a laundromat to its final form, snakes and rabbits populating a bathroom. This was not capriciousness on Skoglund's part, but a sincere search for significance.

Play

Skoglund's depiction of people moving arduously over a jam-coated floor is humorous and playful; and her consideration of and experimentation with jam and marmalade as serious art media connotes absurdity. As Skoglund remarked, a red wedding can signify insidiousness, but it also can indicate a playful sense that things are just a bit "off."

Postponement of Meaning

Skoglund's practices reveal her effort to postpone final meaning. For instance, Skoglund began *The Wedding* without knowing the precise situation she would ultimately depict. After photographing the installation in her studio, she decided to reverse the colors of the floor and walls in the museum installation: the photograph depicts strawberry-jam walls and an orange-marmalade floor; whereas the museum installation has orange-marmalade walls and strawberry-jam floors.

Skoglund's practice of letting meaning evolve, postponing closure throughout the artmaking process, has been consistent over her career. For instance, thirteen years prior to *The Wedding*, Skoglund created *Radioactive Cats*, which began with her observations of the stray cats who scurried around the alleys near her SoHo studio. At the time, she wanted to create a work with a single cat; she had no idea that she would produce an installation with twenty-five lime-green cats. The desperate circumstances of the strays appalled Skoglund, and, growing to appreciate their survival skills, she began to play around with the idea of an installation with a cat. The final installation of a drab gray tenement kitchen with the twenty-five cats and an elderly couple was unknown to the artist at this time. All of these decisions occurred during the process of making the installation. [9]

Risk Taking

Skoglund exhibited risk taking in laboriously sculpting twenty-five chicken-wire-and-plaster cats without knowing exactly what she would do with them, and in choosing to use foods—raisins, strawberry jam, orange marmalade, cheese doodles, raw hamburger, and bacon slabs—as artistic media in many of her installations.

In itself, creating highly entertaining artworks as serious art is venturesome. When Skoglund's installations first appeared, art critics and other artists were unsure of her intentions; later, however, art critics read the installations as social commentary. *Radioactive Cats*, for instance, has been interpreted as having themes of poverty, aging, and nuclear threat; and *The Wedding* as expressing a cloying sweetness that raises questions about the superficial and unrealistic social expectations of marriage today.

Experimentation

Skoglund commented on the time she invests experimenting and investigating with media:

There's a long period of time when I'm working on the stuff, the ingredients. Sort of like grinding my own pigments if I were a painter. The activities that I get involved in. A lot of them are parodies of things that are actually going on in the real world, forms of scientific research that have a sense of the absurd about them when carried out. For example, just the whole idea of the jam drying and certain kinds of research like that. With a piece called Atomic Love, *I found out about raisins and directly through doing that piece all the different shapes and colors of raisins. So there's a period where I'd say the concern is very sculptural, involved with things and stuff and just gathering all my nuts together so to speak.*[10]

To explore ideas, Skoglund searches, plays, changes her mind, questions, takes risks, and experiments; and it is these practices that allow her to discover ideas rather than execute preconceived notions. Viewers frequently overlook this aspect of artmaking, and, instead, think that the artist knew from the beginning the exact form of the final product.

Artmaking Practices à la Skoglund

Overtly incorporating play, postponement of meaning, risk taking, and experimentation into art instruction can strongly influence whether students engage in artmaking as an inquiry activity. The following two artmaking accounts, both derived from a study of Skoglund's installations, demonstrate this point. In the first, undergraduate art-education students created installations from predetermined meanings; in the second, undergraduate students produced installations without predetermined meanings. The two approaches yielded very different results.

Although these accounts describe artmaking at the undergraduate level, the same artmaking problem—creating fantasy installations based on social problems in everyday situations—can be, and has been, used at the elementary, middle, and high school levels, because Skoglund's work is so adaptable. For example, first-grade students who examined Skoglund's *Revenge of the Goldfish* and were asked why fish might want to take revenge on humans, explained that "some people kill fish to eat them." Fourth-grade students interpreted this same installation as a conflict between humans and animals, and commented that the animals seemed to be in control.

Frequently-Asked Questions

How might students be encouraged to seek deeper meaning while creating art?

Creating more than one artwork about the same subject—working in a series—sets up a dialogue for the artist that generates inquiry: "What more can I say? How can I say it more complexly or deeply? What can I say that is different?" Butterfield remarks that her greatest challenge is finding new things to say, after creating more than one hundred sculptures of the same subject. She observes that when an artist works with the same subject matter, "...the fear of repetition is greater and the challenge [is] of being new and going deeper."[11]

Time constraints are always a factor, but it is worthwhile to consider the benefit of having students work in a series. Individual and group critiques while the series is in progress can help to keep students focused. For example, elementary or middle school students might select a Keith Haring theme such as television, power, computers, worship, or money and create at least six drawings on the chosen theme. The repetition of subject will challenge students to produce works of depth.

Inside the Artist's Head

How do artists deal with the anxiety of creating?

Sculptor Joel Shapiro admits that "getting to work can be difficult...one time, instead of confronting the issue, I built dozens and dozens of drawing tables and then threw them out. It was a way of casting off anxiety."[12] Today, the sculptor starts sticking pieces of wood together. There may be many false starts in this ritual but Shapiro explains that the forms locate his thoughts and suddenly he is immersed in the work.

A Student Installation[13]

Following a visit to view Skoglund's work at The Columbus Art Museum, students in an art education studio-methods class worked in small groups to derive their own installations. The students were instructed to select a social occasion and juxtapose reality and fantasy in a manner that questions the situation.

One student group selected an art gallery opening as their social occasion. They produced a life-size installation all in black—black walls, black sculptures on black pedestals, black wine glasses and hors d'oeuvres, and art patrons dressed in black attire. The only color to be found was in the pink, green, and yellow letters spelling the word "culture," a word repeated in a long, snaking line extending from one of the sculptures across the gallery floor, and up over the shoulder of an art viewer. The work was dramatic in appearance, but not highly provocative in stimulating questions and interpretations about this particular social occasion. Why not? The students were too intent on defining the message and its interpretive meaning for viewers with the inclusion of the repeated term "culture" which left little to the viewer's imagination. The all-black art gallery could have had greater impact through inclusion of a more provocative fantasy element.

The art gallery installation was not an exceptional example of artmaking based upon Skoglund's work. Frequently, when students create artworks based on other artists' work that contains social commentary, they begin with a particular message and produce results that are similarly contrived. The students' limited exploration of ideas was certainly not in the spirit of Skoglund's artmaking behaviors. Skoglund does not begin her installations with a specific message in mind, and she has strongly asserted that her work is not about teaching the world how to live.

When asked, in 1995, whether she creates her installations with specific messages she strongly reacted: *Well, you're asking a question that I'm very targeted on. As an artist, I don't try to think of myself as teaching people how to live better. I mean, I don't really like the sense of museums being classrooms. I think that's like setting up the artists as knowing more than the public, and personally that's not my philosophy. My philosophy is basically to be dumb, and to be a participant in the society and to just sponge, just sort of let it all come in and enjoy it or be disgusted by or whatever but not to sort of assume a perception of the artist as deliberately outside society or... deliberately creating a kind of self-alienation from ordinary life. I personally have tried to rework that whole theory for myself.*[14]

This account of the students' work demonstrates the importance of understanding the behaviors and practices that inform an artist's artmaking. Knowledge of Skoglund's big idea was not enough to engage students in artmaking about inquiry and a search for meaning. Experimentation, for instance, was missing from the students' installation: the students too readily accepted the obvious, rather than pushing their ideas further. Skoglund's artmaking practice of postponement of final meaning was also absent: the students became fixed on depicting a specific message.

A Minibox Installation[15]

After studying Skoglund's installations, undergraduate students in groups of five or six were instructed by the professor to select a familiar public space to depict in a minibox installation. They chose a fast-food restaurant, gas station, beach scene, ski resort, movie theater, and baseball stadium. To build a knowledge base about these sites, the students answered a written questionnaire compiled by the

Psychologist Talk

Cognitive scientist Ronald Finke finds that creative ideas are not preset, but evolve.[16] Psychologist Rudolf Arnheim reports similar findings and describes this evolutionary process as nonlinear. He refers to Picasso's creation of *Guernica* in which the artist did not start from a small element of the work and continue to add piece after piece.[17] The artist's process, according to Arnheim, does not proceed in a steady growth of complexity but sometimes contains sudden reversals.

7.2 Elana Goodale and Sheri M. Nordman-McNamara, The Nickels and Dimes of Beep, Beep! *(after Skoglund), 1998. Minibox installation. Dollar bills, coins, yarn, construction paper, tempera, 12" x 18" x 10" (30 x 46 x 25 cm). Elementary education graduate students at The Ohio State University.*

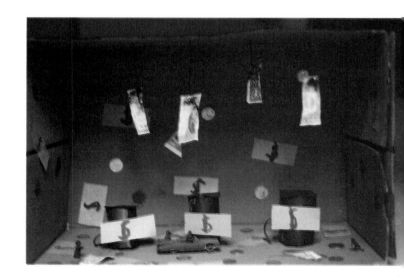

Frequently-Asked Questions

How might an artist's technique be part of the meaning of the artwork?

Consider collage as an example. Understanding collage as a technique entails comprehending more than the physical act of adding found material to an artwork. Howardena Pindell constructs autobiographical paintings by incorporating bits of photographs and other materials that reference her personal experiences, culture, and ancestry, into thick layers of paint. Pindell must carefully assemble her images to develop a meaningful object. Her process represents a powerful metaphor for identity.

Pindell's use of collage is uniquely suited to expressing her big idea of identity. On a more general level, what are the conceptual ramifications of collage? First, previous associations attach themselves to collage materials and these meanings become part of the artwork. Secondly, materials don't stand alone—they are contextualized, and placing the collage materials within the context of the artwork creates new meanings.

It is unlikely that students will independently arrive at understandings about collage as a meaning-making technique. Encourage them to consider two primary questions. First, "What past meanings are attached to the collage materials?" and secondly, "What new meanings are created as a result of placing these materials into a new context?"

instructor. The questions were: How would you describe the space? Who is usually there? How do they dress? What happens in this space? What are the most telling visual clues?

The students selected a public space for their minibox installations, one which was well known to each person in the group. To prepare for creating the minibox installation, the students wrote about past personal encounters with the selected space. The variety of students' past experiences with a particular space provided the groups with a rich knowledge base for recreating their chosen sites. The responses varied: some students primarily recorded factual data; others related more personal accounts, such as leaving a husband at a gas station as a joke, apprehension about a stranger sitting in the next seat at the movie theater, and fear about the overwhelming power of the ocean.

Comments that the students wrote after the art-making project confirmed the importance of these preparatory instructional activities. One student wrote: "We were not led to just copy or mimic Skoglund's work. The knowledge building activity, writing about a personal experience in the place, got us personally involved and motivated to construct the mini-installation." Another student remarked: "Writing about a familiar place helped me to draw a personal connection and to further explore my own box once it was complete to see if my creation of a fantasy really conveyed reality."

The professor instructed the students to depict their chosen site in a cardboard box by using found media and only two colors, and to include a fantasy element related to the scene. Importantly, the students were not instructed to begin with an interpretation or particular meaning, although the instruction to relate the fantasy element to the particular situation is noteworthy. Students were

instructed not to include the more obvious types of fantasy elements such as monsters, giant spiders, or outer-space creatures, but instead to utilize fantasy elements related to the specific sites that could motivate meaningful interpretations, in much the same way that Skoglund relates the fantasy elements in her installations to the specific situations that she depicts. For example, *The Green House* contains an overpopulation of blue and green dogs, and the living room and its contents are covered by well-manicured grass, aspects of which are typical of a suburban environment. Although Skoglund does not have a particular reading of her installations in mind, she establishes definite connections between fantasy and reality: the fantasy elements generate satisfying interpretations because they are linked to the installation situation.

The students followed the fantasy requirement by flooding the gas station with giant-size dollar bills, coins, and money symbols; elaborately adorning the movie theater with a glut of popcorn and gummy bears; substituting large black-and-white heifers for customers in the fast-food restaurant; and levitating baseball players over the baseball field. None of the fantasy elements was totally unrelated to the depicted scene.

The students interpreted the meaning of their completed installations in a large-group discussion, and each student interpreted another group's work in writing. Following Barrett's recommendations for studio critiques, the creators of each installation waited to respond until the other groups had offered their interpretations.[18] Instead of shutting down discussion with the artists' explanation of their intent, this strategy opens up interpretations; that is, once the intent has been revealed, viewers have a difficult time creating their own interpretations. As a group, the students' interpreted the mini-installations with

What Do You Think?

Mierle Laderman Ukeles is an unpaid artist-in-residence with the Department of Sanitation in New York City. She promotes appreciation of the heroic efforts made by trash collectors, and showcases their contributions to the health of the urban environment. Ukeles has constructed temporary tributes from recycled materials, such as *Ceremonial Arch Honoring Service Workers in the New Service Economy*. At her suggestion, the new marine transfer station at Fifty-ninth Street (Manhattan's west side) has been constructed with catwalks and observation decks so the public can watch garbage being loaded onto barges bound for the Fresh Kill Landfill on Staten Island.

Ask students: *How is Ukeles's way of working like and not like the traditional studio artist?*

7.3 Paul Dragin, Larry Gallick, and Susanna De La Garza, Heifer Heaven (after Skoglund), 1998. Minibox installation. Plastic figures, tempera, marker, posterboard, 12" x 18" x 10" (30 x 46 x 25 cm). Elementary education graduate students at The Ohio State University.

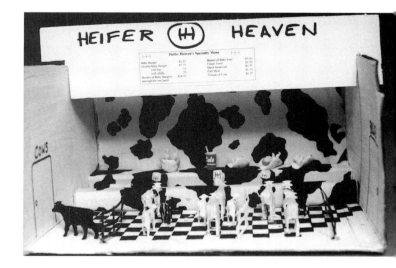

Student interpretations of minibox installations *The Nickels and Dimes of Beep! Beep!* (fig. 7.2) and *Heifer Heaven, A Fast-Food Restaurant* (fig. 7.3).

The Nickels and Dimes of Beep!, Beep!

"The significance of money makes me think about how money is the 'driving force' in our culture. People pale in comparison. The diminutive stature of the people in the installation and the large signs of money everywhere alert me to the idea of our culture being driven by material greed."

Heifer Heaven, A Fast-Food Restaurant

"It makes me stop and truly consider what we are eating and the way in which we are making it barbaric. I mean looking at it from the cow's perspective, as this piece seems to encourage, it seems perfectly natural to want to stroll up to a counter and order a Double Baby Burger. [In its reversal of animals and humans, the installation had shelves of tiny toy babies stacked as waiting burgers.] On the surface this seems inhumane to us humans that we should be bred for the sole purpose of some cow's extra value meal. Yet, most Americans don't think twice when they order a super size Big Mac Meal."[19]

social problems and issues in contemporary America—our diet, commercialism, unrealistic dreams, corporate power, visual pollution, and consumerism.

One artmaking practice encouraged in this mini-box project was to leave meaning open throughout the artmaking process and delay interpretation until after the artworks were complete. The students were instructed to create a mini-installation about a specific site—not an installation with a specific message. The strategy of initiating the installations with only a germ of an idea was successful in avoiding clichéd results. The practice of play was also present in the project—using toys and snack food as media for creating a miniaturized version of a real space framed the project in a playful mode (the day of the construction of the installations, the students brought in found objects, snack foods, fabric, glitter, and plastic toys).

Without the pressure to create meaning for the installation until it was complete, students were freer to experiment. However, the project requirements—create a representational depiction, include a fantasy element related to the scene, and create the scene in only two colors—ensured that there was direction and focus.

The mini-installation project elicited thoughtful solutions. Although all the mini-installations were not extremely unusual, they were strong enough to motivate substantive interpretations—and none was clichéd. One student commented: "The interpretations were the most interesting part of the artmaking because by trying to understand others' expressiveness in their installations, we create new and deeper interpretations." Another student expressed a similar notion: "The idea of fantasy revealing reality was really driven home when we analyzed each box. With this activity, we drew our

own conclusions, and then I learned more by sharing and exchanging ideas as a class."

The instructional plans for the two installation projects were quite similar; however, in the second (minibox) project, searching for meaning and postponing closure to meaning produced a very different kind of learning. The students in the first project failed to learn that artmaking is about evoking meaning rather than presenting meaning, whereas the students in the second project gained important insights about how artists discover meaning.

Oldenburg's Artmaking Practices

Sculptor Claes Oldenburg creates monumental sculptures derived from everyday objects (see Chapter 4). To realize these, he works collaboratively with technical designers, fabricators, patrons, transporters, and installers; in the past two decades, he has also worked closely with Coosje van Bruggen, his wife, a writer and art historian.

Finding Ideas

For their commissions, Oldenburg and van Bruggen compile case histories by recording technical information, various stages of idea development, conversations, personal reflections, working plans, drawings, and other relevant materials. In 1978, Oldenburg was commissioned by the University of Las Vegas to create a monument for a plaza between a concert hall and a theater.

In the case history for the monument, Oldenburg recorded that the project was closely tied to the magic of Las Vegas lights, especially the huge luminous neon signage. He recalled that when viewing Las Vegas at night from an airplane, the city looked like "a patch of light."[20] His first idea for the Las Vegas sculpture was a stainless-steel diamond ring that would sparkle from reflected daylight.

Student Talk

"Skoglund's key ideas are that fantasy can reveal reality and that individual and group beliefs, values, or needs must be negotiated. This was brought into the classroom artmaking without us even being aware of it. We were instructed to put a fantasy element in our installation after we had generated a topic. Yet many people interpreted the mini-installations as though that was what drove us to create.

Skoglund also dealt with social issues, but oftentimes this was not her intent. However, it was evidently there, just as it was mysteriously present in our art projects."

7.4 Claes Oldenburg and Coosje van Bruggen, Flashlight, 1981. *Steel painted with polyurethane enamel, 38' 6" x 10' 6" diameter (11.73 x 3.2 m). University of Nevada, Las Vegas. Photograph by Attilio Maranzano.*

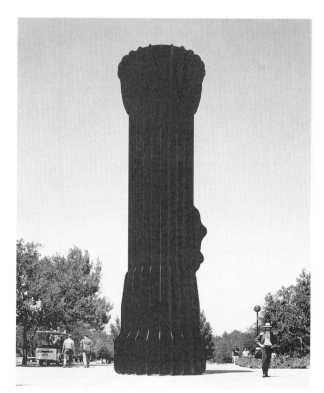

Fascinating Fact

Claes Oldenburg's and Coosje van Bruggen's monu-
mental sculpture, *Spoonbridge with Cherry*, was so
large it had to be made in two different shipyards:
in Boothbay, Maine, and Bristol, Rhode Island. The
pieces were brought to a factory in North Haven,
Connecticut, joined, and taken on a flatbed truck
1,262 miles to the sculpture garden of the Walker
Art Center in Minneapolis.

What Do You Think?

Rimma and Valery Gerlovin are husband and wife
collaborators and conceptual artists from Russia. In
their twelve-work "Photoglyphs" exhibit, they
posed for the camera with words and signs painted
on their faces and arms. The results are what they
call "still performances." *Tic-Tac-Toe* (1990) shows
Valery's face with a tic-tac-toe game of X's and O's
painted on it; his mouth, open as if he were about
to speak, forms the winning O in the bottom row of
the grid. For the Gerlovins, the body becomes a can-
vas with conundrums that viewers must decipher.
Their ways of working go beyond gimmickry. They
use the body in metaphorical terms that contribute
to the meaning of their work.

*How can you challenge students to find ways of
altering the uses of traditional media?*

Fascinating Facts

Claes Oldenburg admits he often gets ideas for
his colossal sculptures when he is eating. He takes
out his sketchbook while still at dinner, to record
his ideas.

Oldenburg later decided upon a flashlight "which
seemed to suit the mood of anticipation of audi-
ences gathered in the plaza, about to be ushered to
their seats."[21] In general, when creating his sculp-
tures, Oldenburg engages in continual self-question-
ing about historical and cultural connotations. In
this particular situation, Oldenburg was dealing with
two different contexts—a university arts plaza and
an American city noted for its glamour and enter-
tainment.

Oldenburg's involvement with everyday objects
characterizes his entire career. His first reference to a
flashlight is in notes written in 1968: "The flashlight
is imagined as a modest dam for a reservoir in the
Hollywood Hills... the flashlight is specifically a black
one and . . . the escaping water is colored a hot yel-
low and is lighted at night... It gives all Hollywood
the persistent sunset glow of far northern cities in
summertime." This idea was never realized, but the
Las Vegas commission had its beginnings with it.

Development of Ideas
Once he became committed to the flashlight,
Oldenburg sought out a real flashlight to use as a
prototype. He selected a waterproof version covered
with a rubberlike plastic molding that softened the
flashlight's contours. In his case study, he recorded
the following about the flashlight: "Purchased on
Canal Street in New York, the flashlight was given to
J. Robert Jennings [a technical designer] so that he
could render an elevation [an elevation drawing
shows an object from the front, side, and rear],
which was then modified, leading to the final form
of the sculpture."[22]

Oldenburg next made drawings to analyze specif-
ic factors, such as weight, wind resistance, safety, and
relation of the monument to its context. He further
questioned the physical features of the flashlight

monument in terms of its impact as a signifying object on the campus. Oldenburg designed the flashlight in an upright position as a grandiose tower and, in response to the university's request that he create an attention-getting object, the sculptor related the scale of the flashlight to a lighthouse on Roosevelt Island in New York's East River.

Coosje van Bruggen, who collaborated with Oldenburg on this project, objected to the design's eroticism, believing that it was too charged with the commercial energy of Las Vegas and its blatant exploitation of sex and wealth. Van Bruggen convinced Oldenburg to change the form of the flashlight to communicate a different message and feeling. She argued:

The [Las Vegas] Strip is just a smudge under the silhouettes of vast desert mountains, particularly at dusk when preparations for the theatergoers commence. The Flashlight is too mechanical, lacking in mystery and does not reflect an overwhelming presence of the desert.[23]

Agreeing, Oldenburg inverted the design for Flashlight and placed the head of the flashlight toward the ground. The inversion illuminated the ground surrounding the sculpture with a subdued ring of light. He predicted that the intimate glow around the sculpture would contrast with the garish illumination of the Strip, and harmonize with the stage-like construction of the plaza.[24] Following Jennings's technical designs, the piece was constructed at Lippincott (an industrial fabrication company), transported, and installed in 1981. Flashlight, which is almost 40' tall, is welded to a base plate bolted to a foundation 18" below the plaza floor. In the well that surrounds the sculpture's base are twenty-four fluorescent lights.

Similarities in Oldenburg's and Skoglund's Artmaking Practices

Although Skoglund and Oldenburg each create very different kinds of works—room-size installations and colossal-size public sculpture, respectively—the artmaking practices of both refer to ideas that have been mentally stored for a number of years.

Skoglund and Oldenburg both experimented with concrete materials early in their processes—Skoglund with media and Oldenburg with an actual object that he explored through drawings and models. Contact with the real object is highly important to Oldenburg's methods. For instance, when considering the baseball bat for his Chicago monument, he purchased an assortment of baseball bats and had them cut in half lengthwise to study their forms.

Oldenburg constantly questions the visual and connotative aspects of his sculptures (he radically altered the form of Flashlight based upon a rethinking of connotative implications); Skoglund, the connotations of media (jam, marmalade, honey), subject matter (stray cats versus house cats), and color (red for a wedding, neon green versus red for the cats).

Risk taking—by the artists' creation of works that appear to have less-than-serious intents—is also common to both Oldenburg's and Skoglund's practices, as is a strong element of purposeful play. Oldenburg's playful description of the flashlight as a reservoir for a Hollywood dam is similar in essence to Skoglund's whimsical idea about "people stuck in stuff." Playfulness allows Oldenburg and Skoglund to generate the absurdity and ridiculousness necessary to take advantage of chance encounters and new possibilities, and is responsible, from the beginning stages of a project, for the inventiveness during the artmaking process all the way to the final product.

The similarities in Oldenburg's and Skoglund's practices are not coincidental: these are important

Fascinating Facts

One of Keith Haring's best-known public projects was *Crack Is Wack,* a mural painted in 1986 on an abandoned handball court. Haring created the mural in response to the death of one of his assistants who had become addicted to drugs.

Artist History

- Keith Haring was born in 1957 in Kutztown, a rural Pennsylvania town two hours from New York City.

- While trying to establish himself as an artist in New York City, Haring worked as a bicycle messenger and a busboy.

- Haring's first works were his subway drawings and during this time he invented most of the images he was to use later—dancing figures, flying saucers, spaceships, computer monsters, barking dogs, radiant figures, and crawling babies.

- By the 1980s, Haring and his symbols were world famous.

- Haring opened a store in 1986, the Pop Shop. He designed and sold shirts, bags, stickers, hats, and watches, made ads, and gave performances.

- Haring was into the party scene and frequently visited New York clubs, although he produced a prodigious amount of work.

- At age twenty-eight, Haring learned that he had AIDS, but continued to work. He died in February 1990. Thousands came to his funeral.

behaviors that many artists employ. Another artist, Keith Haring, displayed very similar behaviors in his search for a personal vocabulary.

Haring's Artmaking Practices
Finding Ideas

Arriving in New York City in 1978, graffiti artist Keith Haring was a nerdy-looking young kid with wire-rimmed glasses from Kutztown, Pennsylvania. He attended the School of Visual Arts, studying art with Joseph Kosuth and Keith Sonnier, and semiotics (the study of words and signs as elements of communication) with Bill Beckley.

Haring was drawn to graffiti writing, the art of the New York City streets, and it reminded him of Chinese and Japanese calligraphy and stream-of-consciousness—the uninterrupted flow of ideas from mind to hand. He was impressed by the graffiti writers' techniques with spray-can paint, which he considered a very difficult medium; and by the hard-edged black lines that tied everything together. In the journal that he kept sporadically from age eighteen until his death from AIDS in 1990 (at age thirty-one), Haring wrote: "It was the line I'd been obsessed with since childhood."[25]

Haring absorbed the 1980s New York art scene, and noted that performance, videotape, and writing were replacing the traditional artmaking modes of painting and drawing. He learned of text-based artists like Jenny Holzer, whose work consists entirely of language; became a close friend of Andy Warhol; admired the work of graffiti painter and friend Jean-Michel Basquiat; and was introduced to the work of writers William Burroughs, Allen Ginsberg, and René Ricard. Burroughs, a controversial writer of the 1950s Beat Generation, had developed "cut-ups," an experimental technique that fragmented written text into a montage of individual pieces, thereby destroying

the unity of the text. Burroughs's cut-ups later became significant in Haring's drawing development.

Under these influences, Haring felt pressured to question the value of his own abstract drawings and paintings: "More than anything I wanted to communicate!"[26] He wanted to create on paper but knew he no longer wanted to produce abstractions. He tried various methods of public art, photocopying words from the *New York Post* to make fake headlines and plaster them on New York City lampposts, newsstands, and building façades; and developing a tag, the graffiti writer's "signature." However, he still wanted to draw.

Haring conceived his drawing practices at a time of personal artistic crisis, when his abstract forms no longer communicated sufficiently. His crisis erupted from an attentiveness to new art forms—graffiti, language art, video and performance art—that made painting and drawing seem obsolete.

Experimentation

After struggling to find his artistic identity for some time, Haring borrowed a studio from a friend for one day. There, he cut up a roll of 4'-wide oak tag, placed the pieces on the studio floor, and, using black sumi ink, began to draw. Haring related that he reverted to his abstractions, but some drawings contained new images, such as flying saucers zapping animal and human figures. He described the flying saucers as looking like Mexican sombreros

7.5 Keith Haring, Untitled (Subway Drawing), *1983. ©The Estate of Keith Haring. Photo: Ivan Dalla Tana.*

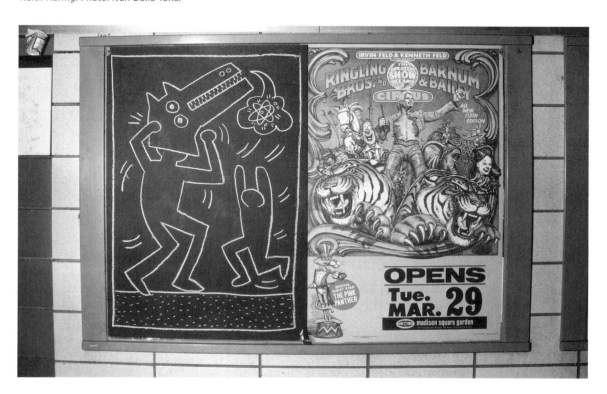

Fascinating Facts

When Keith Haring was creating his subway drawings in the early 1980s, if anyone happened to catch him in the act, he would hand them a button. Soon people all over New York City were wearing buttons depicting crawling babies and barking dogs.

Artist Talk

" I knew there had to be a whole other reason for making art besides looking for success within the artworld."

—Keith Haring

Artist Talk

"So much information can be conveyed with just one line, and the slightest change in that line will create a totally different meaning."

—Keith Haring

with rays coming out: "They were my archetypal vision of what I thought a mythical flying saucer would look like."[27]

During this memorable drawing session, Haring repeated the flying saucers from drawing to drawing, creating different contexts for them. He stated: "Out of these drawings, my entire future vocabulary was born. I have no idea why it turned out like that. It certainly wasn't a conscious thing. But after these initial images, everything fell into place, after that it all made sense."[28]

From his semiotic studies, Haring saw the zapping flying saucers as images that could communicate different meanings at different times, depending upon how he combined them. He remembered the lesson he had learned from Burroughs's cut-ups—that every image cross-referenced other images; thus, single drawings were related to all the other drawings.

Risk Taking

One day at his subway stop, Haring noticed empty black panels on the wall. Paper had been used to cover over old advertisements. He recorded in his journal: "Immediately, I knew I had to draw on them… The panels were covered with a soft matte black paper which was dying to be drawn on. If it had been shiny paper, none of this would have happened."[29] He bought white chalk for drawing on the black papered panels, knowing that a white marker couldn't provide the visual crispness and texture of the chalk. Haring began to notice many of the blank black subway panels. He realized he could communicate with the public and participate with the graffiti artists without really emulating them—or having to sneak into the train yards at night to draw on the subway trains.[30]

At first, Haring got off the subway train every time he chanced upon a station that had an empty

black panel, but later he began to change his subway route just to find more panels. Subway riders noticed the drawings and would question Haring and comment on what he was drawing.

Development of Ideas

At times, over the five years that he drew in the subways, Haring made as many as forty drawings a day. He developed a personal vocabulary of signs—a crawling baby, a barking dog, TV sets, telephones, flying saucers, gyrating figures—and drew them in simple bold outlines, without shading them, filling them in, or adding many details.

Haring had firm ideas about drawing: never pre-plan and never erase, not even for huge murals; and he recognized that images become more significant through redundancy. His TV sets, for instance, appear in many contexts—floating in the sky with wings attached; mounted on a crucifix with huge serpents framing each side; invaded by barking dogs jumping through the picture screen. As the TV set is repeated from drawing to drawing, the complexity of its meaning increases.

When I drew, I drew in the daytime which meant there were always people watching. [T]here were always confrontations, whether it was with people that were interested in looking at it or people that wanted to tell you you shouldn't be drawing there. . . Having this incredible feedback from people. . .is one of the main things that kept me going so long. . .from little kids to old ladies to art historians. The subways in New York are filled with all kinds of people . . .You had to do these things fast and you couldn't erase. So it was like no mistakes. You had to be careful not to get caught. And dealing with drawing in places that might be freezing cold or... being in all these weird positions to draw, there were all kinds of factors that made it interesting.[31]

Fascinating Facts

The lines that often radiate from Keith Haring's figures have been interpreted as empowering the figures. The "radiant child," for instance, has the power to protect itself.

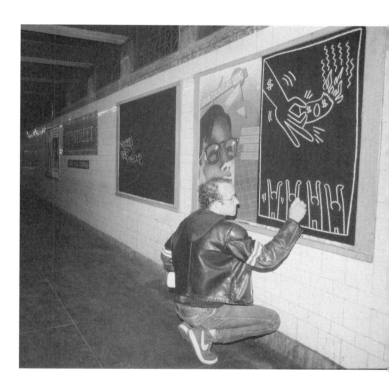

7.6 Untitled (*Haring creating drawing in New York City subway*), 1981. °The Estate of Keith Haring. Photo: Chantal Regnault.

Inside the Classroom

Following a study of Keith Haring's subway-drawing symbols, elementary education students at The Ohio State University used the big idea of power and three symbols to create their own series of drawings. The instructor built on the students' knowledge of ancient Egypt by having them compare the role of power in that society with the role of power in contemporary American culture.

To develop the symbols for their drawings, the teacher engaged the students in timed drawings with white chalk on black paper. They began by quickly drawing all the symbols of power they could think of in a series of thirty-second drawings. Following this, students made a series of three-minute drawings using one of the symbols from their first series. A third exercise had the students create a new symbol of power that was unique, and explain how their image was about power. Based on these preliminary drawings, students chose three symbols and created a final set of six drawings that expressed ideas about social power in America today.

Fascinating Fact

In 1986, Keith Haring was invited to Germany to paint on a section of the Berlin Wall that had divided East and West Berlin.

Play

Aspects of play during Haring's studied reflection about his artistic direction took form in his borrowing of the studio for a day; drawing on the floor, not on an easel or even a wall or table; and moving quickly back and forth between drawings, with no particular plan. And yet, Haring was driven by an underlying purposefulness in this playful endeavor. He was intently searching for a way to communicate, to make art that was personally and publicly significant.

The act of drawing freed Haring to release stored-up images. As he later wrote:, "I have no idea why it turned out like that. It certainly wasn't a conscious thing."[32] Importantly, Haring recognized the significance of these images. He intuited how they could communicate, connecting them to his semiotic studies and to Burroughs's cut-ups, which informed his repeated rows of babies and zapping flying saucers.

Seeking Meaning

Haring's practices (the studio drawing session and his subsequent subway drawings) paralleled Skoglund's and Oldenburg's purposeful play, experimentation with media as a strategy for discovering ideas, constant questioning of works created, and postponement of final meaning.

Cognitive research into creative behavior supports artists' practices of not predetermining meaning but letting it occur during the artmaking process and even after artworks have been completed. For instance, Finke finds that creative ideas are not preset, but evolve, and his research discloses that ideas are more innovative when people are instructed to create forms and associate them with a function rather than when they are instructed to specify functions and create related forms.[33] This parallels the notion that artists produce more inventive responses

when specific meanings are postponed rather than predetermined. Psychologist David Perkins contends: "[I]nstead of always being preoccupied with the final product, the maker often addresses means as an end in itself...[End] products are vaguely and tentatively conceived, groped for, caught at, discovered in process."[34]

The two mini-installation classes based on Skoglund's work demonstrated the significance of postponing closure. Although this instructional approach appears somewhat at odds with itself, the classroom accounts showed that meaning does evolve—in increments. The students in the second class did not lack ideas while working: instead, they postponed final meanings, not meaning altogether.

Meaning through Open-ended Problems
With open-ended artmaking problems, students must search for solutions during the artmaking process and/or after the work is completed. Encouraging students to postpone meaning depends on the nature of the artmaking problem. Consider two ways of structuring an artmaking problem about self-portraits. One approach is to instruct the student to create a self-portrait that expresses his or her identity; another is to instruct the student to create a self-portrait to find out more about him- or herself.

Both approaches will result in self-portraits, but the student's intent in each would be different. In the first, the student would be engaged in expressing what he or she already knows: meaning is predetermined. In the other, the student would be invested in finding new meaning: the outcome would be unknown until the work was completed. The self-portrait boxes described in Chapter 4 are an example of the second approach: the artmaking problem was

What Do You Think?

Jennifer Bartlett approached the creation of a suite of twenty-four 7'-square canvases in a most unusual manner. She worked in her own Greenwich Village house, shooting a roll of film per hour. For instance, at 3:00 a.m. she would go to the garden, shoot a roll, and go back to bed. When she was ready to begin painting, she stretched twenty-four canvases and worked from pinned-up photos in her studio. The result was the series *Twenty-four Hours*, which was exhibited at the Paula Cooper Gallery in SoHo.

How might you overtly incorporate the element of time into students' ways of artmaking?

Inside the Classroom

Performance arts are seldom practiced in the art-room. Yet this form of art offers rich experience for students. The following guidelines for teaching performance art, provided by art-education professor Stephen Carpenter, offer specific guidance for those wishing to delve into this area.[35] See page 153, Teaching Performance Arts, for a complete description of the seven points presented here.

1. The human body must be an essential component of the performance artwork.

2. All actions must be real, not pretend.

3. Performances must have a specific beginning and end and should last for a designated length of time.

4. Preparatory sketches and scripts should be presented to the teacher for approval.

5. Evidence of research is essential.

6. Use explicit and implicit symbols, movements, and words.

7. Rehearsal and practice are essential and required.

Inside the Artist's Head

Robert Motherwell's reason for working in series stems from his feeling that he never has fully resolved the series problem. Thus, he continues to explore the problem with more and more works. He compares his approach to Cézanne's continuous painting of Mount Sainte Victoire, not to paint a mountain, but to get down exactly how he felt.

Inside the Classroom

A strategy for encouraging the search for deeper meaning is having students work on a number of artworks at the same time, as when Haring laid out the twenty or so pieces of oak tag on the studio floor. This method requires a different mode of thinking than working in a series (when one completes a single work before moving to the next). Both approaches set up a dialogue between artworks, but it is a less linear dialogue when concurrent works are ongoing. Due to space constraints, it may be that this method is best conducted with small-scale projects, or classes with fewer students.

structured to prompt students to find out more about their identity as they created their box. They had to consider how others might perceive them, and had to make decisions about what they would reveal and conceal about themselves. The structure directed students through development of meaning rather than reproduction of meaning already known. Thus, one key in designing an artmaking situation that encourages students to find or develop meaning is to construct open-ended problems.

Meaning through Series

Another strategy that encourages students to seek meaning is creating a series of works about the same subject. Creating a series generates such inquiry as: What more can I say? How can I say it more complexly or deeply? What can I say that is different? Sculptor Deborah Butterfield has remarked that her greatest challenge is finding new things to say after creating more than 100 sculptures of the same subject: "[T]he fear of repetition is greater and the challenge [is] of being new and going deeper."[36] The graduate students described in Chapter 3 (see pages 41–45) were challenged to push for further meaning in their ten abstract paintings on a single theme. In an elementary or middle school situation, students might select a Keith Haring theme—such as television, power, computers, worship, or money—and use white chalk on 9" x 12" sheets of black construction paper to create at least six drawings. The repetition of drawings about the same subject will challenge them to pursue deeper meanings.

Meaning created in a series generally becomes more complex, since students must think harder to find new ways of approaching a subject. Although class time may be a constraint, the benefit of having students work in a series is stunning, as it challenges

in ways quite different from making a single art-work about a subject. Individual and group critiques while students work on their series can help keep them focused.

Cultivating an Attitude of Play

What kinds of instructional strategies can infuse a sense of play into classroom artmaking? Purposeful play—with emphasis on purposeful—is a significant factor in the work of Skoglund, Oldenburg, and Haring. However, too frequently, artrooms are char-acterized by familiar processes and procedures instead of by a spirit of play; play becomes the exception rather than the norm.

Andy Goldsworthy remarked that he was both-ered when viewers referred to his work as child's play—until he realized how intently and earnestly children play. Play involves experimenting, pretend-ing, and trespassing boundaries, but seems always to be conducted in an atmosphere of great seriousness. By framing artmaking as play, both professional and student artists psychologically remove threat and are thereby better able to tackle difficult projects, break boundaries, take risks, and become more inventive.

Play through Unusual Conceptual Frameworks

Chapter 4 presented several unusual approaches that can encourage a playful attitude: transformation, as in Oldenburg's colossal sculptures; disruption, as in Barbara Kruger's enigmatic photomontages; and concealment, as in Lucas Samaras's self-portrait boxes. By engaging students with these artmaking strategies, we can offer opportunities for infusing their artmaking with a sense of purposeful play.

For instance, students might use the concept of transformation to change the meaning of an every-day object by altering only one aspect—perhaps its texture, scale, or form. Or students might change the meaning of an everyday object by transforming its usual context, perhaps by placing a dumpster in a formal dining room. However, the presentation of the problem is what is key: in these examples, stu-dents are instructed to use a playful strategy, trans-formation, to change an everyday object for a purpose (so as to change the object's meaning), not simply to make the object as bizarre or strange as possible.

An instructor's attitude toward artmaking is crucial to how his or her students learn to understand the artmaking process. When art teachers include such artmaking practices as purposeful play, manipulation of media, risk taking, and experimentation, they communicate that artmaking is about searching for and discovering meaning. Such strategies encourage deeper levels of thinking and allow students to hold meaning loosely, leave it open, discover it, reconsider it, reinvent it, and develop it. However, these prac-tices do not occur spontaneously: they must be planned for as overtly as the more obvious aspects of artmaking instruction. As art teachers, we must instruct, encourage, and give students permission to play, experiment, take risks, change their mind, and raise questions.

Notes

1. J. Lahr, "Making Willy Loman," *The New Yorker* (March 1999), p. 42.
2. P. Gardner, "Waking Up and Warming Up," *ArtNews* (October 1992), 114–117.
3. Sandy Skoglund interview at The Columbus Museum of Art, Columbus, Ohio, March 1995. The interview was conducted by Ohio State University art-education professors Sydney Walker and Don Krug, and graduate student Anne Burkhart. Available on ArtsEdNet, www.artsednet.getty.edu.
4. Ibid.
5. Ibid.
6. Ibid.
7. Ibid.
8. Information about *Radioactive Cats* is from a telephone interview between the author and Skoglund on December 12, 1995.
9. Ibid.
10. Skoglund, 1995 museum interview.
11. Marcia Tucker, "An Interview with Deborah Butterfield," in *Horses: The Art of Deborah Butterfield* (Coral Gables, FL: Lowe Art Museum, University of Miami, 1992), p. 30.
12. Gardner, p. 114.
13. The studio methods class was conducted by the author at The Ohio State University. The Skoglund lesson was peer-taught by undergraduate students in the course.
14. Skoglund, 1995 museum interview.
15. Art for the Elementary Classroom was conducted by the author at The Ohio State University. Her approach was influenced by investigations of Skoglund's actual art-making practices and experimentation with incorporating these practices into the classroom.
16. Ronald A. Finke, Thomas B. Ward, and Steven M. Smith, *Creative Cognition: Theory, Research, and Applications* (Cambridge, MA: MIT Press, 1992), p. 69.
17. Rudolf Arnheim, *The Genesis of a Painting: Picasso's Guernica* (Berkeley: University of California Press, 1962).
18. Terry Barrett, *Talking about Student Art* (Worcester, MA: Davis, 1997).
19. *Nickels, Dimes of Beep, Beep:* student interpretation by Paul Dragin; *Heifer Heaven*, student interpretation by Crissie Hanje. Both interpretations were written in a studio methods course conducted by the author at The Ohio State University.
20. Germano Celant, *Claes Oldenburg, Coosje Van Bruggen* (Milan: Skira, 1999), p. 376.
21. Ibid., p. 376.
22. Ibid., p. 377.
23. Ibid., p. 377.
24. Ibid., p. 377.
25. John Gruen, *The Authorized Biography* (New York: Simon & Schuster, 1992), p. 44.
26. Ibid., p. 56.
27. Ibid., p. 57.
28. Ibid., p. 57–58.
29. Ibid., p. 68.
30. The subway trains were a favorite target of the graffiti writers, who spray-painted tags and images on the inside and outside of the cars. This activity was a major problem for New York City, which spent large amounts of tax money to remove the graffiti.
31. Jason Rubell, "Keith Haring: The Last Interview," *Arts Magazine* (September 1990), p. 59.
32. Gruen, 57–58.
33. Finke, Ward, Smith, p. 69.
34. David Perkins, *The Mind's Best Work* (Cambridge, MA: Harvard University Press, 1981), p. 276.
35. Stephen Carpenter is an assistant professor of art education at Old Dominion University in Norfolk, Virginia.
36. Tucker, p. 30.

Appendix

Contents

A Starter List of Big Ideas and Artists (p. 3)

Big Ideas	Artists
identity	Chuck Close, William Wegman, Howardena Pindell, Richard Avedon, Duane Hanson, Edgar Heap of Birds, Deborah Butterfield, Frida Kahlo, Lucas Samaras
power	Barbara Kruger, Leon Golub, David Hamonds, Keith Haring
fantasy and reality	Sandy Skoglund, René Magritte
meaning and objects	Fred Wilson, Donald Lipski, Claes Oldenburg/ Coosje van Bruggen, Robert Rauschenberg
alienation/loneliness	George Segal, Edward Hopper
questioning art	Andy Warhol, The Starn Twins, Christo, Roy Lichtenstein, Judy Pfaff, Deborah Butterfield
human emotions	Jim Dine, Sean Scully, Robert Motherwell, Mark Rothko
nature and culture	Andy Goldsworthy, Sandy Skoglund, Meg Webster, Mel Chin, Walter DeMaria, Stan Herd, Christo and Jeanne-Claude, Nancy Holt

Inside the Artist's Head (p. 11)

What big ideas are embedded in Seurat's depiction of Parisians enjoying a leisurely Sunday afternoon on the island of Le Grande Jatte? During the time period of the painting, there was much public discussion about the right to a day of rest. Further, morality and respectability were connected to the proper use of Sunday as a family day. This notion of "proper use" was a sign of middle class (bourgeoisie) values. However, changes in Parisian family life resulted from the legalization of divorce in 1884.

Questions to Focus Students on the *Grande Jatte* as a Social World

What social types are represented in among the more than fifty figures depicted on the island of Le Grande Jatte? Can you find these types?

1. A boatman
2. A dandy
3. A nurse and an aging patient
4. Three soldiers
5. A mother and a child
6. A father
7. A working-class figure

What does the *Grande Jatte* tell us about Parisian:

• dress in the 1880s?
• social behavior in the 1880s?
• family life in the 1880s?

Starter Lists of Key Concepts for Big Ideas (p. 12)

Big Idea: Heroes

Key Concepts

• Heroes can be personal or cultural.
• Heroes are often publicly honored.
• Heroes are not the same as celebrities.
• Heroic characteristics change over time.
• Heroes can be god-like.
• Heroes represent moral values.
• What makes a hero is not uniformly agreed upon nor who is a hero.
• Heroes are often associated with strength, youth, beauty, and immortality.

(generated by a group of K–12 arts, classroom, subject-area teachers, and art-education professors)

Big Idea: Power

Key Concepts

Power is about:

- excess
- scarcity
- recognition
- privilege
- fear
- inclusion and exclusion
- control
- voice
- change
- insiders and outsiders
- rules
- disruption

(generated by graduate students in the course *Art for Elementary Teachers*)

Big Idea: Identity

Key Concepts

- Identity can be about reinvention.
- Identity is about status.
- Identity is about assimilation.
- Identity is about the inside and outside.
- Identity can be about the fear of loss.
- Identity is about stereotypes.
- Identity can be about pecking order.
- Identity can be about insecurity.
- Identity is about change.
- Identity is physical.
- Identity is about models.
- Identity is a tension between self and others.
- Identity can be about internal demons.
- Identity is a search.
- Identity is about occupation.
- Identity is about mimicry.
- Identity can be about denial.

- Identity is about multiplicity.
- Identity is about contradiction.
- identity is both public and private.

(generated by K–12 art teachers in Virginia Beach)

Big Idea: Nature and Culture

Key Concepts

Humans assume a variety of attitudes toward nature such as:

- Nature acts as a background for human events.
- Nature is fragile and in need of protection.
- Nature is ruthless and powerful.
- Nature is nurturing.
- Nature is controllable and can be made to be submissive.
- Nature can become a collaborative partner with humans.
- Nature can inspire.

(generated by the author)

Food As a Big Idea (p. 13)

What are some key cultural factors that inform this topic?

- overabundance of food in America and other developed nations while some nations go hungry.
- prevalence of eating disorders such as anorexia nervosa and bulimia.
- American obsession with weight loss.
- highly developed interest in various types of foods and the "Americanization" of many ethnic foods.
- talk shows that highlight frank discussions about weight problems.
- psychological and emotional meanings associated with food—food as an emotional crutch.
- the American phenomena of junk food, now spreading internationally.

Reflective questions to guide students using food for artmaking:
- Why am I selecting this particular food for my artwork?
- What cultural meanings and issues are associated with this food?
- What practical problems will I have to resolve?

Some artworks exploring food as content and art medium:

Lynn Aldrich, *Bread Line*, 1991, sliced bread, 35' long.

Aldrich created *Bread Line* at an abandoned bakery in Los Angeles's Chapman Market. The artwork consists of bread slices from forty-five different loaves of bread (white, dark, pumpernickel) laid in a single line across the floor grid of the former food production space. Aldrich has always been interested in the accumulation of materials that represent a double meaning. Critic Jude Schwendenwien comments, "On one hand, it represents a primal sense of safety, both as a stockpile of food in case of emergency, and as an emotional crutch. On the other hand, such an abundance of food cannot possibly be eaten before it begins to rot. In abundance there is implicit waste." (Schwendenwien, Jules. "Cravings: Food into Sculpture," *Sculpture*, Nov/Dec 1992, p. 45.)

Doug Hammett, *Finger Licks*, 1994, vanilla and chocolate frosting and stretcher bar, 72 x 6 x 3".

Los Angeles artist Doug Hammett uses cake frosting as a key element in his sculptures. In *Finger Licks,* Hammett takes a stretcher bar that one would use as part of a paint frame and covers it entirely with vanilla and chocolate cake frosting. He then runs his finger down the entire length to comment on the "artist's signature." Hammett, explains

Schwendenwien, began working with food on a whim, but has become involved with exploring parallels of food consumption and art consumption. (Schwendenwien, 46–47.)

Janine Antoni, *Chocolate Gnaw*, 1992, 600 pounds of chocolate before biting.

Antoni addresses our compulsive relationships to food. Her recent sculptures are created from mounds of pre-chewed chocolate and lard. *Gnaw* is a mound of 600 pounds of solid chocolate resting on a low marble stand. In the chewed sculptures Antoni chewed off pieces of chocolate and lard from a 600-pound block and created lipsticks and heart-shaped candy. Schwendenwien observes that "these compelling but disgusting objects simultaneously shatter all the romantic association of chocolates as gifts of affection while serving as succinct monuments to the devastating conditions stemming from low self-esteem and emotional deprivation, for which food becomes a substitute." (Schwendenwien, p. 45.)

Identity As a Big Idea: A New Way to Create Self-Portraits (p. 16)
Students select a household object and make a drawing or painting of the object as a self-portrait of themselves. The object should have a personal connection to the student and they should use color that is expressive of themselves, not necessarily the actual colors. Students also should employ a drawing or painting technique that expresses personal qualities and place the object in a physical space that expresses personal qualities about themselves.

Reflective questions to guide student artmaking:
- Why did I choose this object to represent me?
- What does this object tell and not tell about me?

- How might I use color, technique, and location to further express my identity?
- How much complexity about my identity can I express with this object?

Knowledge Building Activities for Artmaking
Have students study the van Gogh paintings *Vincent's Chair* and *Gauguin's Chair,* as examples of expressing identity through material objects. Van Gogh painted images of chairs as a means of expressing identities (his own, and that of his artist friend Paul Gauguin). Van Gogh's chair is an unadorned ladderback wooden chair while Gauguin's is a comfortable, cushioned, fancy armchair.

Students may also study contemporary artist Jim Dine's self-portraits which use a bathrobe as a surrogate for the artist's identity. Dine has explicitly stated that the bathrobe is a self-portrait and has produced many such works, for example *The Cardinal* and *A Veil of Tears.*

To further their knowledge before creating a self-portrait, students should complete a booklet entitled *You.* Details about the *You* booklet can be found in Chapter 3, page 45.

Self-Assessment
Upon completing their self-portraits, students should write a response to these questions:
1. How does the object in my artwork personally connect to myself?
2. How did I depict the object with colors and technique that express my identity?
3. One new thing I learned about myself while making the artwork was _____ .
4. My artwork relates to van Gogh's self-portraits, *Vincent's Chair,* or *Gauguin's Chair* in the following manner: _____ .

Interpretation of the Self-Portraits
Conduct a class discussion to interpret the artworks. Critique questions might include:
- What does the artwork tell about the identity of the artist?
- What questions does the artwork raise about the artist's identity?
- How well does this artwork represent the complexity of the artist's identity?
 Note: The artist should be a listener while other students interpret his or her artwork.
 (See Terry Barrett, *Talking About Student Art,* Worcester, MA: Davis Publications, 1997.)

Frequently-Asked Questions (p. 38)
How do artists build a knowledge base for their artmaking?

Peta Coyne
Installation artist Peta Coyne remarks that traveling feeds her work, maybe more than anything else. She says, "I usually travel alone, and just wander without specific plans other than choosing the country. . . I generally don't speak the language. I love just being in a place where I am not at all involved, because I can just observe, see and experience things new to me; I try to relate to what I see by grounding myself in the country's literature. . . It's very important to me to release myself from my studio practice so that when I come back home I see my work in a totally different way." (C. Przybilla, *Peta Coyne: Interview,* Washington, DC: The Corcoran Gallery of Art, 1996, 27–39.)

Mel Chin
Environmental artist Mel Chin had to become somewhat of an expert in botany for a project he developed with scientist Rufus Chaney, a heavy-

metals expert in the Environmental Chemistry Laboratory at the USDA's Agricultural Research Service in Beltsville, Maryland. *Revival Field* began when Chin happened upon an article about hyperaccumulators—plants that selectively absorb heavy metals from toxic soils as they grow. With the help of Chaney, Chin acquired sufficient expertise to create test plantings of hyperaccumulators on toxic landfills as an art project. Chin remarks that *Revival Field* relates to "my interest in alchemy and my understanding of transformative processes and the mutable nature of materials. The contaminated soil is transformed back into rich earth capable of sustaining a diverse ecosystem." (J. Beardsley, *Earthworks and Beyond: Contemporary Art in the Landscape.* New York: Abbeville Press, 1988, 168–169.)

Cindy Sherman

In general, photographer Cindy Sherman prepares herself for working by visiting galleries to see what is currently being done, reading reviews of her last show to help sort out what she wants to say, and visiting flea markets and thrift shops looking for props that might inspire an idea.

Sherman has invented characters based upon female stereotypes. In her *Film Stills* series, Sherman used personal knowledge of 1950s movies to create stereotypical women characters from that time period. She remembered and mimicked poses, fashions, and social values from films she had seen. (G. Morzorati, "Imitation of Life," *Art News*, September 1983, 80–87.)

Stuart Davis

Abstract painter Stuart Davis was influenced by his knowledge of jazz. Art historian and critic Brian O'Doherty remarks that Davis was "the first artist to find in jazz a model for extended improvisation and to appropriate the style and lingo of the jazz milieu." He further comments, "At the end, Davis was still thinking of jazz. 'I think jazz is very important,' he said during his last stay in the hospital. 'Over in Europe they had art for years. Over here they hadn't. Jazz isn't folk art. It's an art of the city and therefore sophisticated.'" (B. O'Doherty, *American Masters: The Voice and the Myth.* New York: Random House, 1973, 47–49.)

Keith Haring

Graffiti artist Keith Haring arrived in New York City as a young aspiring artist. He absorbed the 1980s New York art scene, noting that performance, videotape, and writing were replacing traditional artmaking modes of painting and drawing. He learned of text-based artists as Jenny Holzer (whose work consists entirely of language), became a close friend of Andy Warhol, admired the work of graffiti painter and friend Jean-Michel Basquiat, and was introduced to the work of writers Allen Ginsberg, René Ricard, and William Burroughs.

Burroughs, a controversial 1950s Beat Generation writer, developed an experimental writing technique that became quite significant in Haring's drawing development. He called his technique "cut-ups"— fragments of text made into a montage of individual pieces that destroyed the unity of the text. Chapter 7 describes Haring in more detail.

Mary Miss

Sculptor Mary Miss remarks that she spends time with many books that are connected with what she is working on at the time. She comments, "I'm a reflective researcher, putting ideas together." The books might have to do with engineering, Italian gardens, South Pacific artists, or other topics. (P.

Gardener, "Waking up and warming up," *Art News*, October, 1992, p. 114.)

Frequently-Asked Questions (p. 52)
How can I adapt artmaking problems for the classroom?

The following artmaking problems, centered around the work of sculptor Donald Lipski, offer an opportunity to consider this issue. Each scenario adapts Lipski's artmaking problem. Some of the adaptations seem successful while others do not. What do you think?

Background
Seventh-grade students have been studying Lipski's object sculptures. The students have learned that this sculptor's artmaking problem is physically joining two or three unrelated objects in a visually convincing manner. For instance, Lipski may join a lighted candle to a wax-coated trumpet, or embed a baseball in a wax-filled ladle. The purpose is to change the meanings of the objects and consider them in new ways.

Artmaking Problem 1
Students will cut objects from magazines and combine them into new object combinations.

Comment: This project was taught in a high school art class and the teacher found that creating new objects from magazine cutouts, rather than combining the physical objects, failed to engage students in deeper thinking about the objects. It was simply too easy to cut out objects and glue them together. Students needed the physical challenge of combining real objects to slow them down and consider the objects' meaning. (Ms. Rebecca Hartley, Cardington High School, Cardington, OH.)

Artmaking Problem 2
Students will make paintings depicting three household objects combined into a single object.

Comment: In producing a two-dimensional representation of their objects, students may focus mostly on their rendering skills and neglect the primary idea of changing the objects' meaning. Further, the impact of the finished product as a two-dimensional illusion is less compelling than the creation of an actual new object.

Artmaking Problem 3
Students will make object sculptures by combining candles with other household objects.

Comment: Lipski frequently uses candles in his sculptures and in 1992 produced an entire exhibition at the New York Gallerie Lelong of various candle/object combinations. However, the use of candles is not central to understanding Lipski.

Artmaking Problem 4
Students will make a ceramic object sculpture by combining parts of two different objects to make a new object.

Comment: This artmaking problem is unlike Lipski's. He is interested in retaining the integrity of each object he uses. This produces a tension between the old and new meanings of the objects. When only parts of each object are represented, this tension is absent.

Artmaking Problem 5
Students will use found objects to create a three-dimensional object that can protect a person from rainfall.

Comment: Specifying a function for the new object changes the nature of Lipski's artmaking problem. He produces new objects with changed mean-

ings, but function is not part of the equation. Having to produce an object with a particular function redirects the purpose of the object sculpture. Instead of focusing on creating new meanings, students would be concentrated on a practical consideration.

Artmaking Problem 6

Students will make a convincing object sculpture from combining two or three objects with cultural significance to create new meanings for the objects.

Comment: This artmaking problem is similar to Lipski's, other than the requirement for choosing objects with cultural significance. All objects are embedded with cultural meanings, but choosing objects which appear culturally significant would most likely help students to focus on meaning as they created their object sculptures. The only caution would be to simultaneously guide students toward visual considerations as well. The term "convincing object sculpture" should alert students to this aspect of the problem.

Inside the Classroom:
A Starter List of Artists, Big Ideas, and Problem-solving Strategies (p. 60)

Big Idea: The Self

Artist	Problem-solving Strategy
Frida Kahlo	Creating the self through personal and cultural symbols.
Lucas Samaras	Presenting the self through concealment as well as revelation.
Howardena Pindell	Creating the self with layered and fragmented biographical information.
Robert Arneson	Presenting the self with exaggeration and humor.
Jim Dine	Presenting the self through surrogate personal objects.

Big Idea: Stereotypes

Artist	Problem-solving Strategy
Richard Avedon	Photographing subjects in decontextualized settings.
William Wegman	Substituting dogs for humans.
Duane Hanson	Presenting humans in hyperreal detail.
Edgar Heap of Birds	Altering text.
Fred Wilson	Presenting artworks with strategic display techniques.

Big Idea: Urban Alienation

Artist	Problem-solving Strategy
George Segal	Contrasting humans with their physical environments.
Edward Hopper	Placing humans in isolated urban situations.

Frequently-Asked Questions (p. 64)

What makes some artmaking problems better than others?

Criteria:

1. Does the artmaking problem originate with a big idea?
2. Does the artmaking problem include divergent elements that provoke meaning beyond its apparent and obvious aspects?
3. Does the artmaking problem extend beyond cleverness and novelty?
4. Is the artmaking problem directed toward meaning?
5. Is the artmaking problem flexible enough to incorporate individual responses and shaping of the problem?

Rate the following four artmaking problems.

Problem 1. Choose a Magritte object (apple, key, clouds, bird) and create a drawing of the object in an unusual situation.

Problem 2. Create a drawing of an everyday scene with everything transformed into stone.

Problem 3. Create a drawing of a dream world.

Problem 4. Create a drawing that includes both reality and unreality.

Comments:

Problem 1 meets all of the criteria except that it is weak in regard to question 5. It would be stronger to allow students to select their own object rather than one of Magritte's.

Problem 2 is really more about cleverness and novelty since the students are merely reproducing one of Magritte's transformative techniques of translating the world into stone. A much stronger problem would allow students to create their own ways of transforming the world.

Problem 3 lacks a divergent element. The creation of a dream world focuses on a big idea of creating the world differently than we know it, but it needs more structure to challenge the students to think more deeply about this idea.

Problem 4 is a good choice because it contains a divergent element, reality and unreality. However, the language in Problem 3 is more appealing to the imagination. A good idea would be to combine them and state the problem as: *Create a drawing of a dream world which includes both reality and unreality.*

Frequently-Asked Questions (p. 74)

Do titles count as part of an artist's work?

A discussion among art teachers who were planning to teach Sean Scully's paintings demonstrates that titles are significant. The teachers questioned whether to conduct interpretation with or without the use of Scully's titles for his large abstract paintings. A high school teacher related her experience of teaching Scully's painting *Union Grey*. She explained that she divided her class into several small groups and distributed reproductions of *Union Grey* along with its title. Here she describes the class discussion that followed the small-group work.

High School Teacher: I didn't tell them very much about Scully's work except that he was a contemporary painter and his paintings were large canvases eight feet or more. Each group had about five minutes to discuss the painting and then the whole class talked about it.

Elementary Art Teacher: What were some of their interpretations for *Union Grey*?

High School Teacher: Some of them saw the life/death thing and the war. One girl immediately saw the Civil War conflict, the use of grey throughout the work, the blending of the different tones of grey. She also saw the white and black rectangles as the oppositions in the Civil War, the struggle of the Yankees or the Union soldiers to end slavery and try and infiltrate the problem. It took awhile for them to see that line down the middle, but they finally did see it and related it to the North/South thing. All in all, I was pleased with the discussion.

The students' responses to *Union Grey* indicate that the title prompted them to bring prior knowledge to bear on their interpretation.

(from a graduate art-education course, *Teaching Contemporary Art,* conducted by the author at The Ohio State University, Columbus, Ohio.)

Inside the Artist's Head (p. 77)

Deborah Butterfield finds ways to let the discards of society speak. Art critic Donald Kuspit views Butterfield's horse sculptures as "the waste products of human industry." Kuspit further characterizes the sculptures as "rotting metal" which "seems to be rotting from some disease that infects machines and the modern materials out of which they are made." (M. Tucker, *Horses: The Art of Deborah Butterfield*, Coral Gables, FL: Lowe Art Museum, University of Miami, 1992, p. 68.)

Butterfield very consciously selects the materials for each horse sculpture, allowing the materials to express the horse's identity. *Hoover's* rusted, paint chipped, crumpled surface succinctly states this horse's ungainly, less-than-polished appearance. It is primarily the artist's selection of materials and the horses' postures which account for the fact that each horse retains an individual personality. *Rex,* for example—constructed from many short, straight, narrow, orange-hued chunks of steel—is electrifying while *Riot* and *Verde,* composed of well-formed geometric steel scraps, personify elegance and almost sleekness. In the early 1980s thinking that perhaps the mud and sticks made her horse sculptures "too pretty" (Tucker, *Horses: The Art of Deborah Butterfield*), Butterfield changed her media to scrap sheet steel and discarded metal. By changing from organic to industrial materials, the artist dramatically altered her horse sculptures' expressive qualities. Mud, dirt, and sticks evoked associations of the horses' oneness with nature and the natural environment while scrap metal produced associations with the discards of an industrial society.

Although Butterfield scrounges for scrap materials, she is very selective. She chooses to limit each sculpture to primarily a single material. The range of descriptive terms used by critics to describe Butterfield's horses—gentle, loving, dignified, vulnerable, graceful, powerful, erotic, ungainly, haunting, and commanding—evidences the extent to which this artist has successfully exploited her media.

Inside the Classroom (p. 92)

Before embarking on a full-scale installation, involve students in a mini-project creating displays of personal objects. Ask students to bring five or more personal, tabletop-size objects. Set aside display areas in the artroom. Have students work with their objects to create a meaningful display about themselves. Ask students to:

- consider the physical arrangement of the objects.
- consider the aesthetic qualities of their display.
- write interpretations of other students' displays.

Creating the Installation

Installations do not have to consume entire rooms. Students can work in groups, and do not have to install their work simultaneously. The installations can last for short amounts of time and can be documented with video or photographs.

Reflective questions to guide student artmaking:

- What is the purpose of your work? What big idea are you exploring?
- What will be the focus of the installation?
- How will you make the most of the space?
- How will you produce a work that is aesthetically interesting?
- Will you include human subjects? If so, will you costume them? Pose them?
- What practical considerations must you consider?
- What props will you need? What objects will you need to construct?

- How will you separate your installation from the surrounding environment?
- How will you treat the background space, wall space, overhead space, and floor space?
- How might you use color? Lighting? Sound?

Interpreting and Evaluating the Installations
Following the construction of an installation, have other students interpret the work. Students might create appropriate criteria for judging the success of the installations and construct an assessment instrument for evaluating the installations. This criteria could be based upon issues such as the aesthetic impact, expressive content, overall interest, technical quality, and originality.

Creating Proposals for Environmental Artworks (p. 102)

The following classroom scenario has students role-playing board members of a large corporation. As they role-play, students learn about environmental artworks: the "board members" must investigate four different environmental artworks to determine which one to commission. The purpose of the commission is to promote an understanding of the relationship between humans and nature.

Part Two of the scenario provides background information about three artists who work with the big idea of humans and nature. Part Three engages students in creating a proposal for an environmental artwork to be sited in an outdoor location that is familiar to them. In Part Four, students present their proposals and discuss them.

Part One
Role-Playing Scenario
The following is a starter list of environmental and earthwork artists to consider for the role-playing scenario. Tell students that although the works from these artists have been completed, students should approach them as though they are proposals for future works. Inform students that artists almost always make visual renderings of proposed works and often they present past works as evidence of their general intentions.

Say to students: "You are on the board of directors for a large company that has decided to commission an outdoor artwork, a work that will promote an understanding of the relationship between humans and nature. Four artists have submitted proposals for the commission. Your job is to work with your fellow board members to select one of the four proposals. You will have to justify your decision, based upon the quality of the artwork and its power in promoting an understanding of the relationship between humans and nature."

Artists to consider:
Environmental Artworks, Earthworks
- Christo, *Wrapped Coast*, Little Bay, Australia, 1968–69.
- Nancy Holt, *Sun Tunnels*, Lucin, Utah, 1973–76.
- Walter DeMaria, *The Lightning Field*, Quamado, New Mexico, 1974–77.
- Robert Morris, Earthworks: Land Reclamation as Sculpture, *Untitled* reclamation project, after seeding, King County, Washington, 1979.
- Agnes Denes, *Wheatfield*, Battery Park Landfill, Manhattan, 1982.
- Andy Goldsworthy, *Yellow Elm Leaves Laid Over a Rock, Low Water,* Scotland. October 15, 1991.

- Mel Chin, *Revival Field*, Pig's Eye Landfill, St. Paul, 1990–93.
- Stan Herd with Leslie Evans, *The Circle*, Haskell Indian Nations Univ., Lawrence, Kansas, May 1992.
- Maya Lin, *Wave Field,* University of Michigan, Ann Arbor, 1995.
- Dominique Bailly, *Moss Tumulus*, TICKON Sculpture Park, Langeland, Denmark, 1995.
- Nils-Udo, *Red Rock Nest*, Red Rock Canyon, California, 1998.
- Chris Drury, *Coming Full Circle*, Stacksteads Community Woodland, Lancashire, UK, 1999.

Part Two

In order for students to role-play in a meaningful way, they need to be informed about the artworks under consideration. The following examples of Walter DeMaria, Mel Chin, and Maya Lin represent the type of information that students will require. For each work, ask: "What could students learn from this artwork that would help them understand the interaction of humans with nature and the ways that artists work with nature to produce art?"

Walter DeMaria, *The Lightning Field,* Quamado, New Mexico, 1974–77.

This artwork is located in a sparsely populated New Mexico desert. The 400 steel poles are designed to attract lightning, and documentations of this occurrence show an awe-inspiring experience: wide open spaces, darkened sky, and bright lightning bolts illuminate the scene.
- 400 stainless steel poles, 2" diameter.
- average height of poles: 20', 7 1/2".
- all tops of the poles are level.
- arranged in a grid: 16 rows of 25 poles (east to west).
- poles are 225' apart.

- east to west, the piece is exactly one mile.
- north to south, the piece is exactly one kilometer.
- barely populated area with a high incidence of lightning.
- work is planned to attract the lightning.
- work is neither of the earth or the sky, but of both.
- work "disappears" in the bright noonday sun, only visible at dawn and dusk.

Lightning Field demonstrates that it is possible to design artworks that are not only about nature but collaborate with nature. The steel poles are purposefully designed to attract lightning and the work is sited where there is a high incidence of lighting.

An artist can choose to express one or more of the many facets of nature. *Lightning Field* focuses on the dramatic, awe-inspiring, threatening side of nature.

Artists can use the elements of nature as their palette. For example, nature is always changing and the perception of *Lightning Field* is altered by the actions of nature during a twenty-four-hour period. Noon light and heat alter the work, making it appear very differently than it does at dusk, early morning, or during a lightning storm. As a minimalist artist, DeMaria has created a highly rational, calculated, conceptual artwork; yet, he evokes drama and emotion by harnessing forces of nature to become part of the artwork.

Mel Chin, *Revival Field*, Pig's Eye Landfill, St. Paul, Minnesota, 1990–93.

Revival Field is a rectangular, chain-link fence enclosure planted with hyperaccumulator plants arranged in a circular pattern at the center of the rectangle. The work, situated on a hazardous-waste landfill, combines science and art by using hyperaccumulator plants to absorb heavy metals from the toxic

soil. The overall appearance of the work is more industrial than aesthetically inviting.

- plants and industrial fencing on a hazardous-waste landfill contaminated with cadmium, zinc, and lead.
- developed with scientist Rufus Cheney, an expert on heavy metals.
- Chin became well informed about botany and plants. He began his project by reading about hyperaccumulators—plants that selectively absorb heavy metals from toxic soils as they grow.
- a test site for the use of hyperaccumulators as a low-tech form of decontamination.
- between 1900 and 1993, annual plantings of six hyperaccumulators were set out in a circular pattern divided by two walkways.
- at the end of each growing season, plants were harvested and tested for heavy metals.
- at the end of the three-year period, it was determined that the plants were removing the contaminants from the soil; however, the rate of removal was not fast enough to achieve significant cleansing.
- work has begun on the next phase of the project to develop high-biomass, high-uptake "superaccumulators" that would remove heavy metals at a much faster rate.
- also the possibility is being explored that the superaccumulators could be harvested and burned to recover the metals for recycling.
- Chin views his *Revival Field* series as part of a landscape in transformation.

It is possible to view nature from artistic and scientific perspectives. An artist and a scientist worked collaboratively to produce *Revival Field*. Nature is often valued for aesthetic reasons, but there is more to know and understand about this subject. The motivation for Chin was not the natural beauty of nature, but knowledge about hyperaccummulator plants to revive the land.

Artworks that incorporate nature can be organic and ongoing. For example, the hyperaccumulator plants are harvested at the end of the growing season and replanted.

Maya Lin, *Wave Field*, University of Michigan, Ann Arbor, 1995.

Wave Field, a large expanse of low-rising, undulating grassy mounds set in a gently rhythmic pattern, is visually very appealing. The green waves rise and fall in a lyrical fashion, suggesting restfulness, harmony, relaxation, and peace.

- earth and grass.
- 100 x 100'.
- commissioned for the Francois Xavier Bagnoud Aerospace Engineering Building.
- relates to fluid dynamics which is central to the physics of flight.
- Lin was inspired by a photograph she saw while reading about aerodynamics—a close-cropped image of an ocean wave pattern.
- Each wave in the artwork is a slightly different height or breadth, like ocean waves.
- *Wave Field* is designed so you can sit inside a wave and read a book.

Nature has certain visual forms which generally produce a positive reaction in humans. Humans find rhythmic wave patterns soothing and restful. Although humans can find nature to be powerful and threatening, it can also be very inviting and restorative to the human spirit. Lin has purposefully emphasized these aspects.

Part Three

After studying the environmental artworks and role-playing as board members to commission one of the artworks, students work in groups to create their own proposal for an environmental artwork that promotes the interaction of humans and nature. Students should visit the proposed site to take notes, make sketches, and document with photographs. Using this information, students create a visual display of their proposal along with a written argument as to why it should be funded.

Part Four

Students present their proposals and the class must decide which proposal should be funded and why. They should consider *content*, the power of the artwork to promote human awareness of nature and an interaction with nature; *aesthetics*, the visual appeal of the artwork; and *context,* the connections between the artwork and the site.

The Artist and Her Roles (p. 120)

During the six months it takes Sandy Skoglund to create an installation, she plays numerous roles. In *Fox Games* (1989) she depicts a herd of lively red foxes leaping about a quiet urban bistro while an older couple dines at a rear table. While making *Fox Games,* Skoglund took on the following roles.

- Researcher: She investigated foxes. She studied their gestures, anatomy, and visual characteristics, primarily from books. She sought scientific knowledge, and especially an overall feeling for the creatures. She describes foxes as "cartoon-like" and conjectures that this impression derives from her childhood experience of animated films.
- Sculptor: Skoglund sculpted twenty-six foxes, 5–6' long and about five pounds each. She made molds from plastalene, an oil-based clay used by automobile designers for model making. She created various poses to suggest leaping, pouncing, watching, and other fox-like activities. She cast the foxes in plaster, painted them gray, and then repainted them red for a second version of the installation.
- Set Designer: She purchased eight restaurant tables and sixteen restaurant chairs. She made a last-minute purchase of the chandelier, to fill space at the top of the installation. She painted the furniture, walls, floor, and ceiling with a matte pigment. She arranged the set with foxes and furniture. She had a difficult time organizing the large foxes in the small set space. She hung some foxes with invisible wire to make it look like they are floating and moving through space. She placed other foxes on the floor, tabletops, and chairs.
- Prop Person: Skoglund purchased and painted bread baskets, bread loaves, bread sticks, tablecloths and napkins, salt and pepper shakers, bud vases, roses, a waiter's tray, and wine glasses.
- Director: Skoglund selected actors. She persuaded a male and a female friend and her father-in-law to be a part of the installation. She scripted the action: *The waiter serves a seated couple in the rear of the restaurant. The waiter stands next to the female and the male sits across from the female. The male brings from a wine glass, and the female and waiter make eye contact. No one looks directly at the camera.*
- Costume Designer: She dressed the couple and the waiter in gray attire. The couple is well-dressed and the female has a fox fur draped on the back of her chair. The female wears a gray wig.
- Photographer: She experimented with lighting the set and made Polaroid photographs for about

two weeks without the actors present. After she finalized the lighting, she positioned the actors and shot the scene with an 8 x 10" view camera. She made about sixty shots over four hours. She had 47 x 60" Cibachrome prints made of the installation.

- Art Handler: Skoglund packed and shipped *Fox Games* to the Centre Georges Pompidou in Paris, France, and to the Denver Museum of Art.

Teaching Performance Arts (p. 135)

1. *The human body must be an essential component of performance artwork.* As when a painter uses paint on canvas to depict symbols and images, a performance artist uses his or her body, and sometimes the bodies of other people, to depict symbols and imagery. Related to this point are the clothes, the movements, and the words of the performers.

2. *All actions must be real, not pretend.* The artist (and the other people in the performance, if any) should actually do what we see and not pretend to do what we see. For example, if a component of the performance requires that the artist drink a beverage from a cup, the artist should actually drink a real beverage from a real cup. The cup should not be empty and the artist should not hold a "make-believe" or invisible cup. Performance art and performing arts are not the same.

3. *Performances must have a specific beginning and end and should last for a designated length of time.* Just as a painting can be thought of as a visual depiction of a narrative, a performance artwork is also a form of visual narrative. Like all good narratives, performances by students should have a recognizable beginning and end. Also, the teacher should provide students with a minimum and maximum length of time for performance works. The length of time serves a pragmatic function in that there may be a set amount of time in which teachers and students have to perform their works.

4. *Preparatory sketches and scripts should be constructed and presented to the teacher for approval.* As in the creation of any artwork, student performances should be preceded by a series of sketches or drafts. These preliminary plans may take any format designated by the teacher. Students should script their performances. Performance scripts can come in several forms including storyboards and stream-of-consciousness writings. In addition, students should not overlook the use of formal design principles, such as repetition, contrast, and balance, when planning a performance artwork. The teacher should be aware of the progress and direction of student performances throughout the planning stages and should approve the developments at predetermined intervals.

5. *Evidence of research is essential.* Works of art are reflections of the times and cultures in which they are produced, and often reference those contexts directly. Students need to reach beyond superficial, naïve, stereotypical, and trite symbols and imagery. They should seek more substantial and meaningful means of conveying important content and relationships through the components of their performance art. To encourage such behavior, teachers should require students to conduct, and present evidence of, research in preparation for their performance.

6. *Use explicit and implicit symbols, movements, and words.* A performance work is a means of presenting information, thoughts, and ideas to viewers. Students should include specific symbols in

their works. These symbols can be conveyed through the use of props, body movements, or spoken and written words.

7. *Rehearsal and practice are essential and required.* Performance works of art can be complex and may contain difficult maneuvers or actions. In order to present the most effective performances, students should rehearse as many times as possible prior to audience viewing. Rehearsal should take place in a setting similar to the one in which the work will be publicly performed. If at all possible, at least one full-speed rehearsal should be conducted in the actual space in which the work will be presented.

Index

coded images, 64–65
collage, 107, 125
collections, 66
comprehensive art education, xii, xiv
concealment, 50, 51, 59–65, 137
conceptual
 frameworks, 96, 103, 137
 problems, 49, 50
connections, personal, xii, 16, 19–35, 107
connotations, 128–129
consistency, 16
constructed problems, 51
constructed truth, 33
constructivist teaching, xiv
context
 artistic, 97–98, 100–102
 of proposals, 152
 social, 98–99, 101–103
contextual knowledge, 40, 43
Coyne, Peta, 143
creativity, xii, 52–53, 74, 106, 123, 134
criteria
 for artmaking problems, 146–147
 for assessment, 10, 109–110
critique, 126
 See also assessment
Cubism, 55
cultural factors in artmaking, 13, 75, 128, 140–141
cultural knowledge, 46
curatorial choices, 33

D
Davis, Stuart, 144
death, 40
decision making, 74, 120
DeMaria, Walter, 150
design
 of studio instruction, 95–113
development of ideas, 128–129, 133
Diamondstein, Barbaralee, 38
difficult relationships, 84–86

Dine, Jim, 22, 143, 146
discipline, artists', 116
disclosure, 65
disruption, 50–51, 65–70, 137
disturbing feelings, 79
divergent thinking, 52–53, 106
drawing, 130–137
dreams, 25
Duchamp, Marcel, 50, 100–101

E
earthworks, 149
 See also environmental artwork
elementary school art, 11, 103–112
emotional maturity, 85
emotions, 140
environmental artwork, 28–31, 102, 149–152
essential questions, 6–8, 103–105
evaluation
 of installations, 149
 of student learning, 8, 10, 96, 109–112
 See also assessment; critique
excess, 91
experiential instruction, 57
experimentation, 30, 115, 121–129, 131–132
explicit messages, 69
expressive consequences, 92

F
fantasy, 26, 122, 125–126, 140
feedback, 133
food, 13, 60, 141–142
formal assessment, 111
formal choices, 45, 79
format
 of instructional unit, 96

G
garden
 as subject matter, 4–8
Gauguin, Paul, 143

knowledge transfer, 14
Kruger, Barbara, 65, 67–70

L
language
 as imagery, 82
LeWitt, Sol, 66
Lin, Maya, 77, 151
Lipski, Donald, 20–24, 51, 99–112, 145–146
literal representation, 85
loneliness, 140

M
McEvilley, Thomas, 60
Magritte, René, 54
Marden, Brice, 11, 38
Matisse, Henri, 3, 49
maturity, emotional, 85
meaning
 and artmaking problems, 59
 changed, 99–113
 postponement of, 120
 seeking, 134–137
 and series, 136–137
media, 75, 77
Meier, Richard, 74–75
memory, 27
methods
 of artmaking, 30
middle school instruction, 84–87, 103–112
mimicry
 of artist's style, 16
minibox installations, 123–127
Miss, Mary, 144–145
mixed-media installations, 31–34
Mondrian, Piet, 80
monumental sculpture, 54–55, 98, 116, 127–130
Moskowitz, Robert, 116
Motherwell, Robert, 2–3, 39, 40–47, 73–75, 136
multiple meanings, 104–105
museum practices, 31–34

N-O
nature, 28–31, 140, 141
objectives, 30, 31
objects, 22–23, 140
object sculpture, 34, 99–112
Oldenburg, Claes, xiii, 50, 54–55, 98, 116, 127–130
on-site installations, 37
open-ended problems, 135–136
opposition, 52

P-Q
painting
 autobiographical, 85
 See also individual artists
performance arts, 135, 153–154
personal connections, xiii, 16, 19–35, 107
Pfaff, Judy, 91
physicality, 80, 86
Picasso, Pablo, 37
Pindell, Howardena, 85, 124, 146
plaster figures, 87–92
play, purposeful, 115, 120, 127, 129, 134, 137–138
postmodern painters, 79–80
postponement of meaning, 115, 120
power, 67–70, 140–141
practical considerations
 and media, 77
practices, artistic, xiii, 115–138
Princethal, Nancy, 102
problem construction, 51, 52
problems, artmaking, xiii, 49–71, 105–106
 adaptation of, 145–146
 criteria for, 146–147
 open-ended, 135–136
process, artistic, xiii, xv, 46, 88, 95–113
professional artists, xiv, 1, 20, 53
 See also individual artists
proposals
 for artwork, 149–152
purpose, learning, 104–105

About the Author

Sydney Walker is an associate professor of art education at The Ohio State University, where she teaches studio methods and contemporary theory. She has developed an online graduate course based upon *Teaching Meaning in Artmaking,* which will be available beginning in the fall 2001.

Before becoming a professor, Walker taught K–12 art, was an art supervisor for The Atlanta Public Schools, and earned an MFA in painting at the University of Alabama. She has written about teaching artmaking, art criticism, and contemporary art in *Studies in Art Education, The Journal of Art Education, Arts Policy Review,* and *Conceptual Issues in Art Education*, a NAEA publication. She co-authored a web site devoted to teaching and learning about the work of artist Sandy Skoglund, which can be found at http://www.artsednet.getty.edu. Recently, she has been involved with interdisciplinary curriculum work for a national curriculum project funded by the Getty Education Institute for the Arts and the Annenburg Challenge. She also acts as a curriculum consultant for the Virginia Beach City Schools.